The Lady and The Unicorn

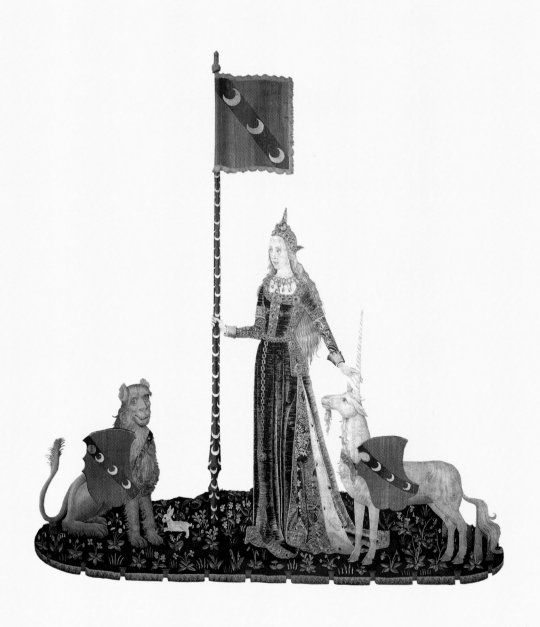

LIST OF MUSEUMS

Abbey of Marmoutier; Albertina, Vienna; Bayerisches Nationalmuseum, Munich; Bibliothèque Municipale, Châteauroux; Bibliothèque Municipale, Tours; Bibliothèque Nationale, Paris; Bibliothèque Royale Albert I, Brussels; Brancacci Chapel, Santa Maria del Carmine, Florence; Bodleian Library, Oxford; British Museum, London; Château d'Angers ; The Cleveland Museum of Art, Cleveland; Collection Dario Boccara; Collection of the Veste, Coburg; Dom zu Erfurt; St. Marien, Erfurt; Fitzwilliam Museum, University of Cambridge, Cambridge; Galleria dell'Accademia, Florence; Galleria degli Uffizi, Florence; Galleria di Palazzo Pitti, Florence; Heimatmuseum, Wolfegg; The Hermitage, St. Petersburg; Historisches Museum, Basle; Kupferstichkabinett, Basle; Landesmuseum, Mainz; Landesmuseum, Zürich; Marienkirche Gelnhausen; Library of the Rijksuniversiteit, Utrecht; Metropolitan Museum of Art, New York; Musée de Cluny, Paris; Musée du Louvre, Paris; Musée du Petit Palais, Paris; Museo Correr; Venice; Museo Diocesano, Cortone; Museo del Prado, Madrid; Musée d'Unterlinden, Colmar; Museum of Fine Arts, Boston; Narodowe Museum, Cracow; Nationale Cabinet des Estampes, Paris; National Gallery, London; National Gallery of Victoria, Melbourne; National Library, St. Petersburg; Österreichische Nationalbibliothek, Wien; Öffentliche Kunstsammlung, Basle; Pinacoteca di Brera, Milan; Pinacoteca del Vaticano, Rome; The Pierpont Morgan Library, New York; San Francesco Church, Arezzo; Rijksprentenkabinet, Koninklijke Bibliotheek, Amsterdam; Schloß Friedenstein, Gotha; Städelsches Kunstinstitut, Frankfurt; Staatliche Museen Preussischer Kulturbesitz, Kupferstichkabinett, Berlin; Vatican Museums, Rome; Victoria and Albert Museum, London; Württembergische Landesbibliothek, Stuttgart.

Publishing editor: Jean-Paul Manzo
Subeditor: Mike Darton
Text by: Sutherland Lyall

Design by: Russell Stretten Consultancy

Publishing assistants: Paula von Chmara,
Amélie Marty
Cover and jacket: Cedric Pontes

ISBN 1 85995 519 3

© Parkstone Press Limited, London, England 2000

The Lady and The Unicorn

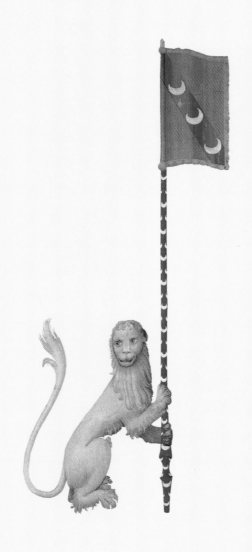

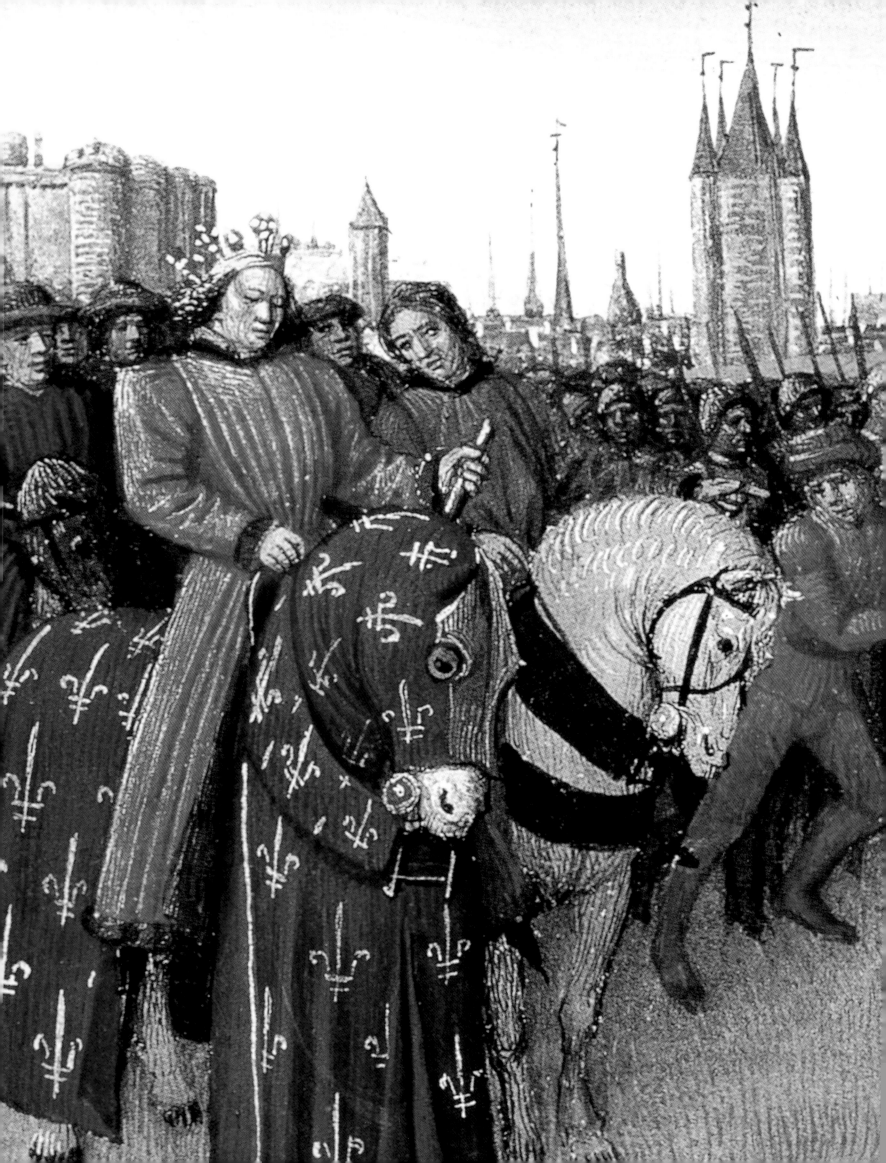

Introduction

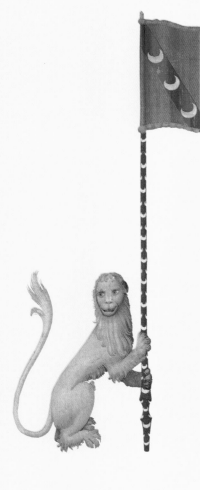

One of the most enduring and intriguing themes in mediaeval art is that of *The Lady and the Unicorn*. It is a subject riddled with complexity, contradiction and inconsistency. She is the Lady of many aspects: a woman among women, and yet an ideal. The unicorn – that fabulous beast of legend – has attributes of virtue, godhead and universal being. Together they combine both profane and spiritual implications.

Images of the Lady and the Unicorn are to be found in mediaeval art and design in and on an astonishing range of materials, from German ivory jewel-boxes (fig. 3) to marginal illustration in English illuminated manuscripts, and from small Netherlandish engravings to great French tapestries. In fact, one of the most important series of mediaeval tapestries to survive to this day tells a narrative, *The Hunting of the Unicorn*, and now hangs at The Cloisters branch of the Metropolitan Museum, New York (fig. 4). But an even more fascinating series of tapestries dates from almost exactly the same period – around the beginning of the 1500s – is called *The Lady and the Unicorn*, and hangs in six panels at the Musée de Cluny, Paris.

1 Unknown artist,
The Virgin traps the
Unicorn., Paris (?),
ca. 1320-30
Medallion, enamel and
silver, diam. ca 7 cm,
Bayerisches
Nationalmuseum,
Munich.

Academic controversy continues to rage over the precise meaning, message or symbolism conveyed in both these series of tapestries. The two of them nonetheless together serve to focus our minds on the strangely enduring theme of the Universal Woman and the Universal Mythical Beast, their relationship to each other (fig. 5), and what its portrayal in art might fundamentally signify.

2 Switzerland,
unknown artist,
XVth century
lateral face of a jewel-
box (Minnekästchen),
Ivory,
Landesmuseum,
Zurich.

Apart from its heraldic function, the Unicorn is symbolic of such virtues as purity and chastity. In some manifestations it represents Christ; in others the eternal Lover. The Lady, meanwhile, is both serene and passive. In some cases hers is the serenity of the Virgin Mary, and often those illustrations of the Lady and the Unicorn together represent allegories of the relationship between Christ's mother and her Son or of Christ's Passion. But simply as a virgin, the Lady has the power to tame the savage beast, to lull it into a sense of security in which it may be captured by the huntsmen — and then, quite possibly, slaughtered. In which case the Lady is both

3 Switzerland,
unknown artist, XVth
century
Back of a jewel-box
(Minnekästchen),
Ivory,
Landesmuseum,
Zurich.

pure and duplicitous, passive but powerful. At the same time the Unicorn may be Christ and the Lover, bewitched by the Lady, his heart captured and even pierced by Love with his hunter's bow and arrow.

In exploring the story and the meanings of great themes in our cultural heritage, we learn something about ourselves as

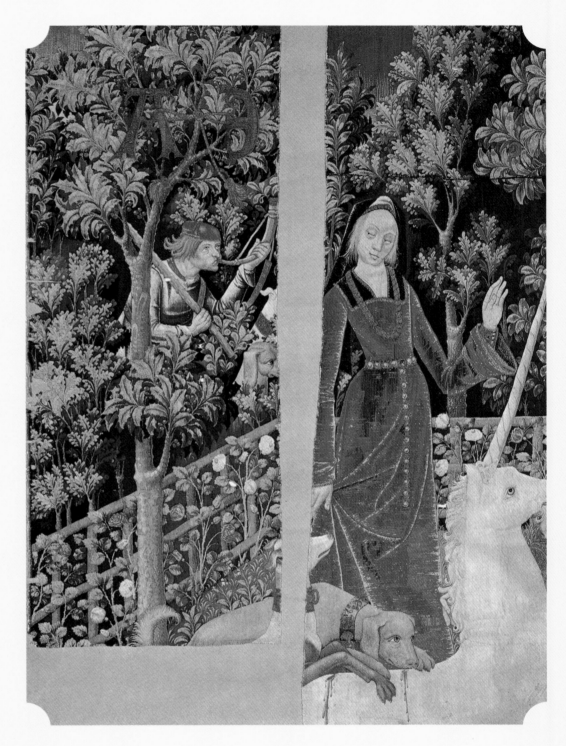

well as about the eternally fascinating collective mind-set of the past. But it is of the past: we must be very careful not to apply to it the mind-set of the present. The mediaeval world was not only physically different from our own but in many ways it also perceived and thought about things quite differently from the way we do today. Moreover, knowledge of the past is necessarily sketchy. The sources of much of the historical evidence that remains themselves profoundly affect our interpretation of the period. A great deal of it is monastic or clerical in origin.

Happily for us, just enough raw information from the ordinary, everyday, secular world has survived to assure us that the mediaeval world was not entirely centred on the cloister or on laborious scholastic interpretations of obscure theological points. People ate, slept, made love, fought wars, hated, died —

4 Unknown artist, The Capture of the Unicorn, Mille-fleurs tapestry, two fragments of The Unicorn is Tamed by the Maiden,, Wool, silk, silver, 169 x 65 cm and 199 x 65 cm The Cloisters, Metropolitan Museum of Art, New York.

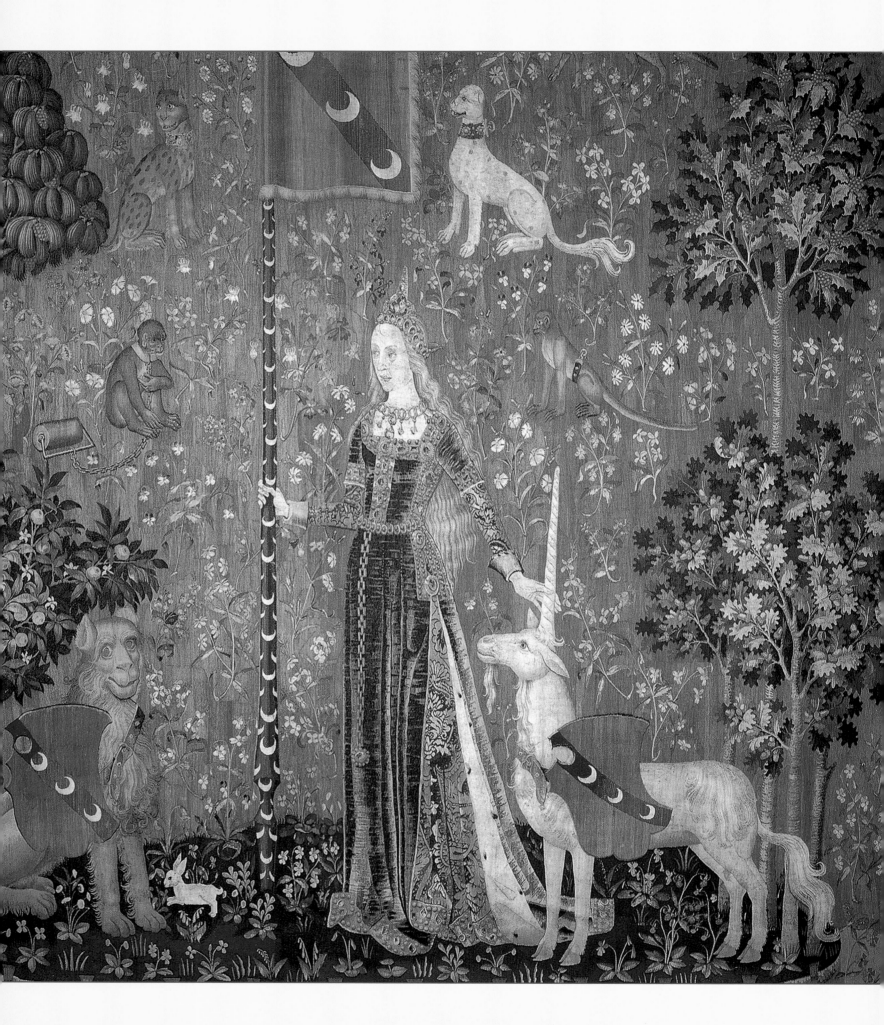

5 (left) French, unknown artist, Touch, detail of fig. 28, 1484-1500 tapestry from the series The Lady and the Unicorn, Wool and silk, 369 x 358 cm, Musée de Cluny, Paris.

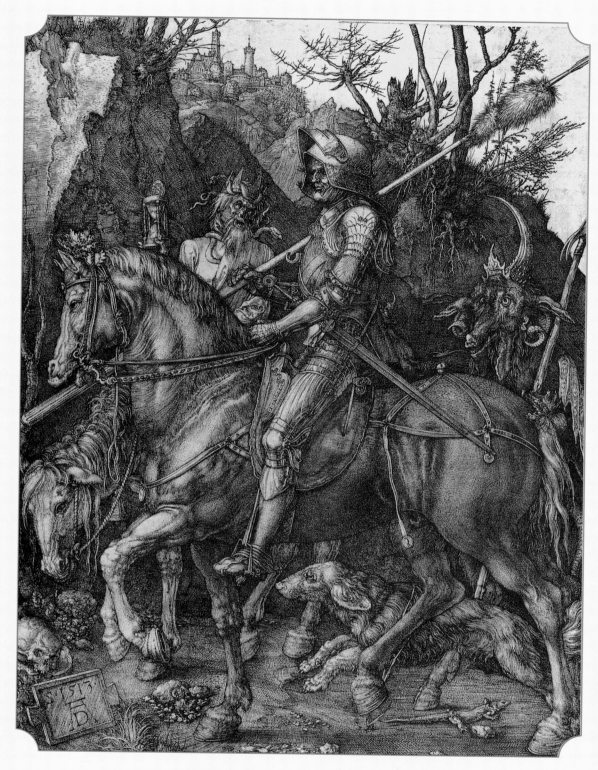

6 Albrecht Dürer, Knight, Death and the Devil (Ritter, Tod und Teufel), 1513 Engraving, 24.4 x 18.7 cm, Staatliche Museen Preussischer Kulturbesitz, Kupferstichkabinett, Berlin.

but all according to the standards of their own contemporary culture and environment.

The Mediaeval World

For many, if not most, people of the Middle Ages — even in the royal or ducal courts — life was short and brutal. With its recurrent famines and epidemics, its interminable and

7 (left) Unknown
artist, Apocalypse of
the Trinity,
Apocalypse 12 : 3-4,
XIIIth century
English manuscript.

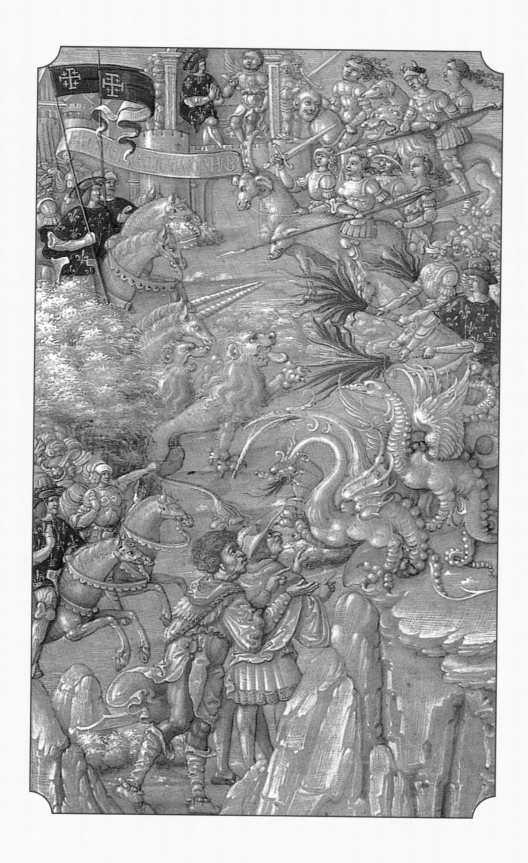

8 *Jean Thénaud,*
The Triumph of
Fortitude and
Prudence, France,
1522-25
Illustration to chapter
VIII, F. 162 v,
National Library,
St Petersburg.

unspeakably cruel wars, its ignorance, religious bigotry and persecution, the mediaeval world was, in the words of historian William Manchester, a 'world lit only by fire'. The artist Albrecht Dürer's extraordinarily pessimistic *Ritter, Tod und Teufel* (fig. 6) of around 1513 features three grim figures who are not quite Horsemen of the Apocalypse – a subject darkly illustrated elsewhere by Dürer – but they

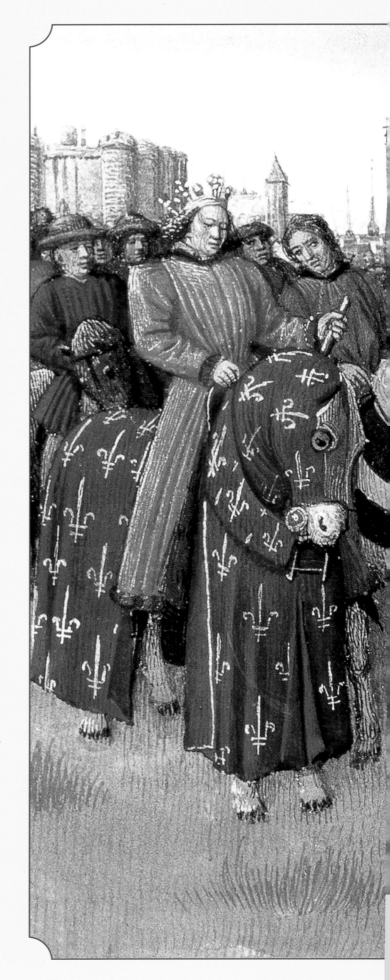

9 detail

are not far removed. Here are Death, the Devil and a grim knight, who come not from the artist's sketchbook but from deep in the the satanic collective memory of European gothick and are simultaneously a commentary on the horrors of contemporary war.

In the Europe of 1500 – generally accepted as the end of the mediaeval period – villages were tiny: mostly collections of fewer than 100 people located in small clearings perhaps 20 miles (32 kilometres) or so apart in a vast, bandit-infested forest which covered almost the whole of the continent. The only other landmarks within the forest were the occasional Roman roads, arrow-straight, that joined the

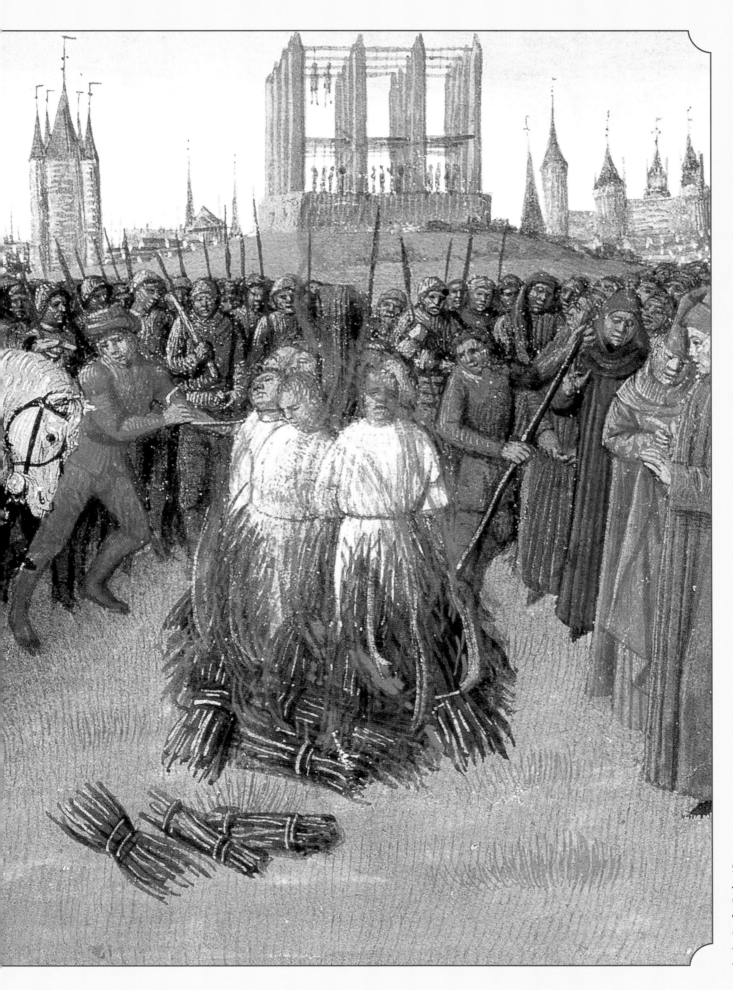

9 France,
Jean Fouquet
(1420-1477), The King
of France sends the
Heretics to the Stake,
XVth century
Miniature.

*10 Flanders
Miniature in Charles
d'Orléans' Poetry,
ca. 1490-1500
Ms Royal 16 F 2,
F. 73,
British Library,
London.*

very few significant urban centres surviving from the old Empire. Major cities would now seem to us more like large, fortified towns, although with the introduction of artillery

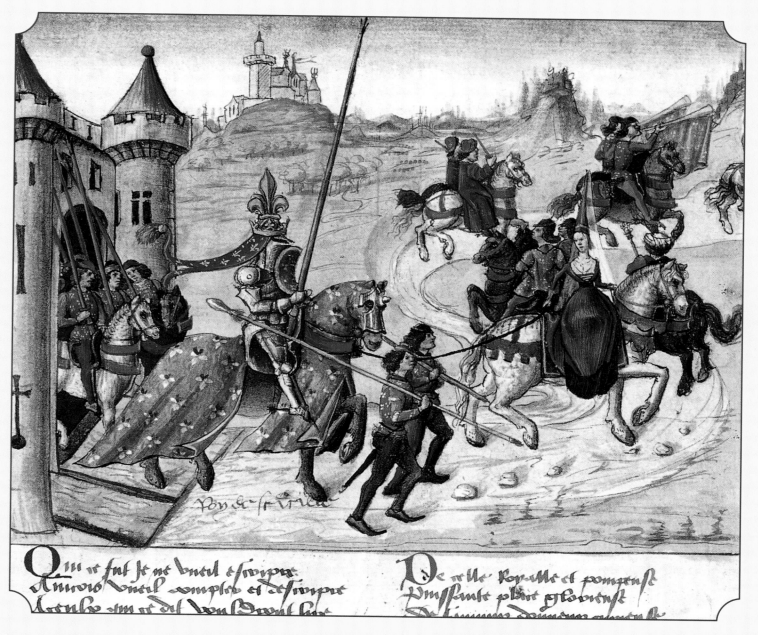

cannon, fortifications began to go out of fashion. In 1500, Paris, Venice and Naples were the only European cities to house a resident population of 150,000. The trading centres of Milan, Genoa and Seville had 100,000; Florence 70,000; London, Barcelona, Cologne, Pisa and Montpellier had 50,000 or fewer. Most Europeans, however, were neither townsfolk nor clergy but tilled the sparse soil for a meagre living in their settlements within the great forest.

11 French, King René d' Anjou leaves for the joust with the Duke of Alençon, Account of a tourney of the King René in Saumur in 1446, called Pas du Perron Miniature in Poetry description of a tournament of 1446, ca. 1470-1480 National Library,

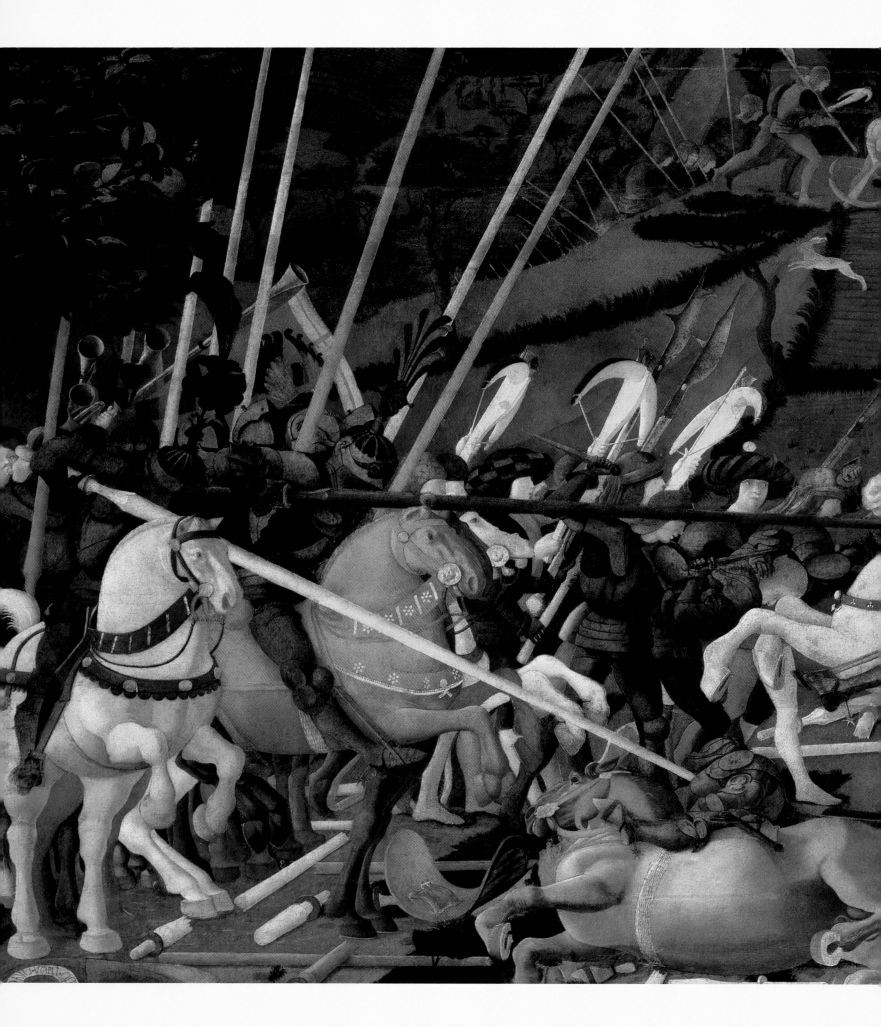

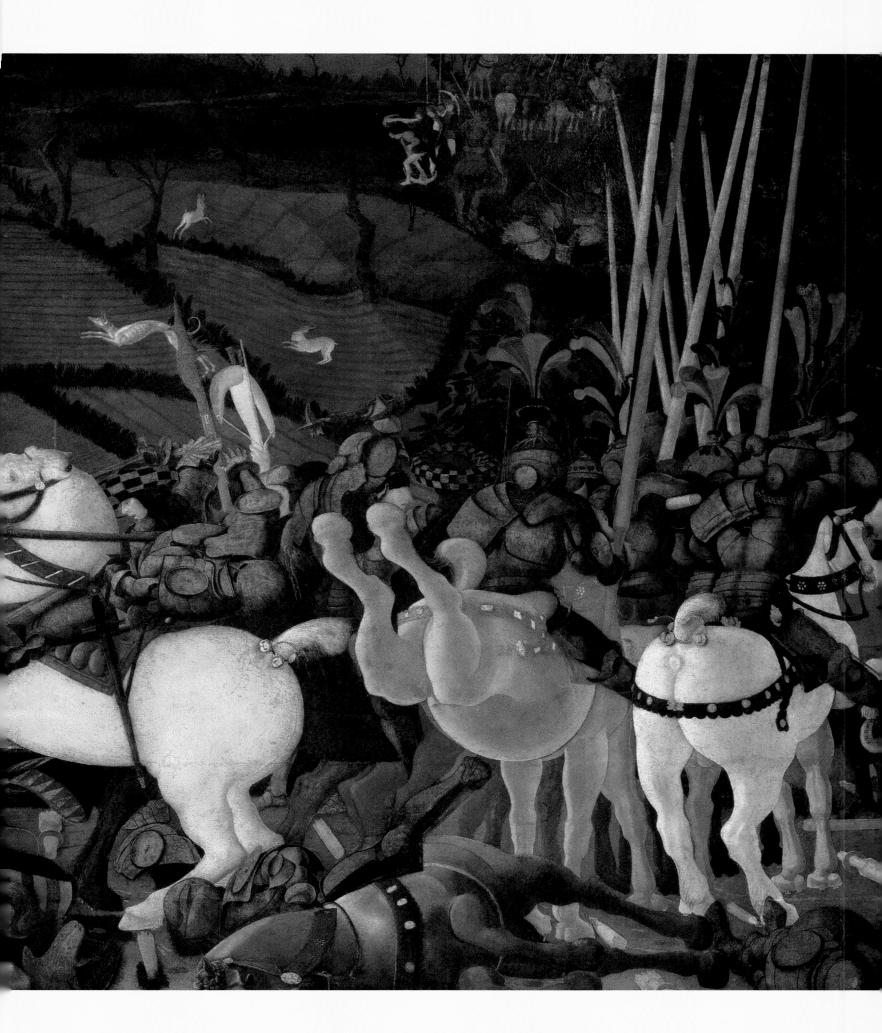

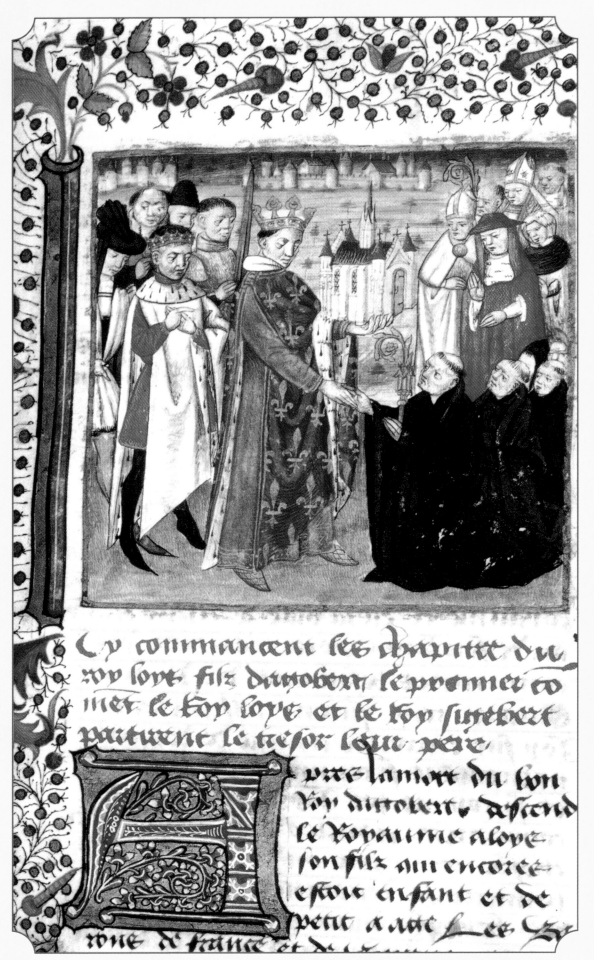

12 (previous two pages) Paolo Uccello, The Battle of San Romano, ca. 1440-1450 Tempera on panel, 182 x 323 cm Galleria degli Uffizi, Florence. (Photo: Grifoni, Nicola, Florence)

13 France (Anjou or Poitou), unknown artist, miniature in Grandes Chroniques de France, c. 1460 : Foundation of the Abbey of Saint-Denis, Ms. 5, F.ol 76, Bibliothèque Municipale, Châteauroux.

A man's world

Europe was a world of increasing social stratification: of defining social rituals and social hierarchical levels. For all

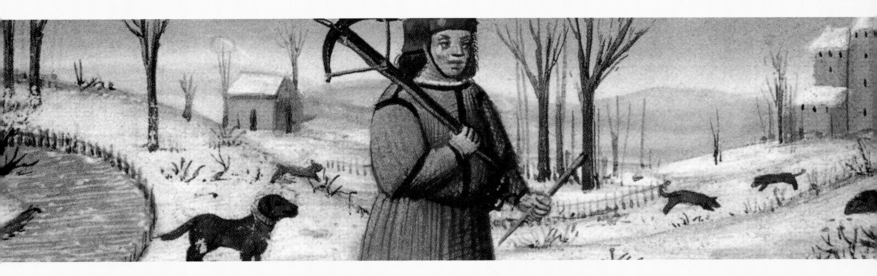

that two rival popes had reigned for much of the fourteenth century, it was an overwhelmingly Christian world, managed by a Catholic Church which by the beginning of the sixteenth century had descended so far into venality and corruption that the reaction that constituted the Reformation could only be a matter of time. It was also a man's world. Marriages were arranged. Although slavery had been abolished in most of Europe, half the population (women) were effectively the property of the other half (men), quite often of men the women had never seen before their wedding day. Before they were married, women were even more strictly subject to the authority of their parents, who could certainly seek pecuniary advantage from their daughters' nubile state and could force them into wedlock to benefit their own personal or family finances. We should not be too surprised at this in a society in which the Church taught as a dogmatic truth that Eve – the first woman, and mother of all others – was not created from the basic

14 French (Tours), *The February Hunt*, *ca. 1510* *Miniature in Horae ad Usum Romanum* *(Book of Hours)*, *Ms. 2283, Fol. 2* *Bibliothèque* *Municipale, Tours.*

13 detail

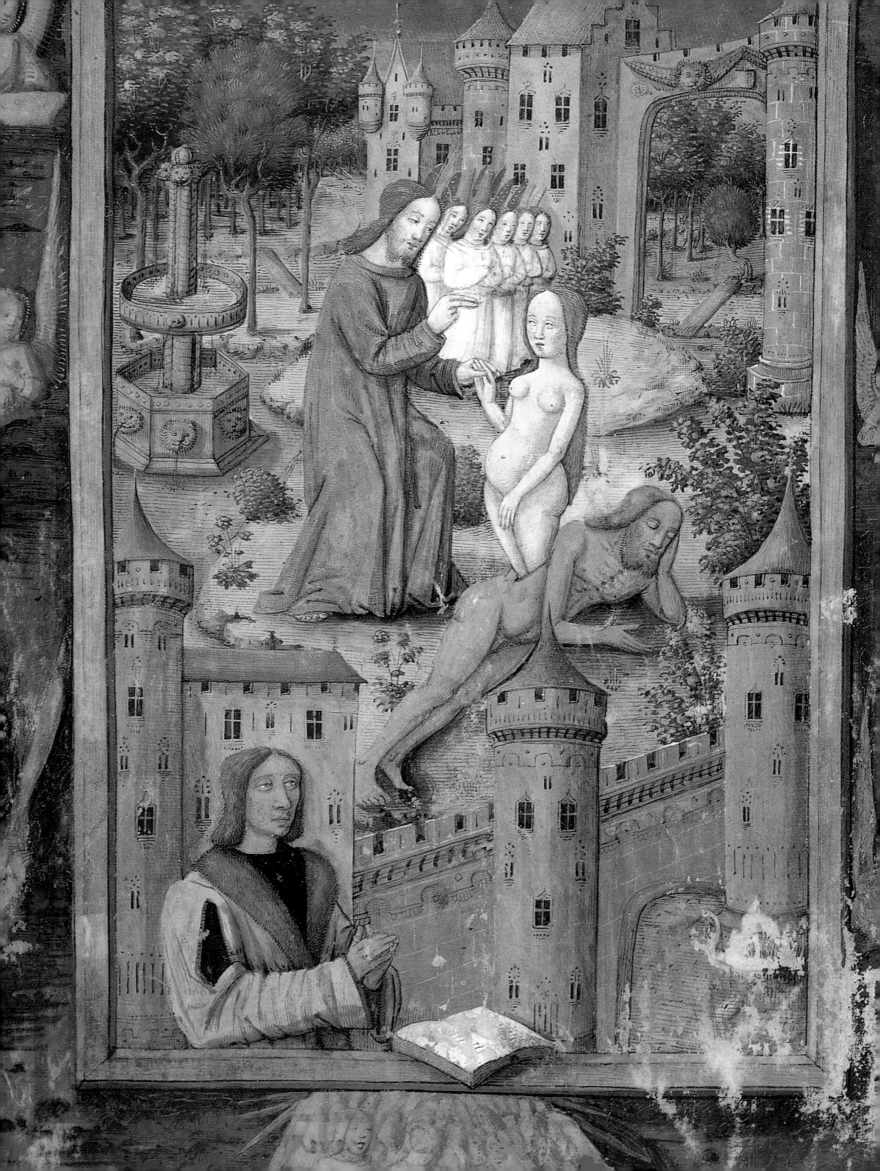

*15 (left) France,
Toulouse and
Bourges The
Creation of Eve,
ca. 1490
Miniature in Horae
ad Usum Romanum
(Book of Hours) of
Louis d'Orléans,
Fol. 11
National Library,
St Petersburg.*

substance of the universe as Adam had been, but fashioned as a kind of afterthought from one of his ribs. In the fifteenth-century *Book of Hours* created for Louis d'Orléans (fig. 15), Adam is depicted lying asleep in a walled garden while God

*16 Housebook
Master, Pair of
Lovers, ca. 1484
Oil on panel
(limewood),
118 x 82.5 cm
Schloß Friedenstein,
Gotha*

17 *Master of the City of Women, miniature:Christine de Pisan, author of La Mutacion de Fortune, offering her book to her protective, the Queen Isabeau of Bavière, wife of the King Charles VI. ,1410-12 from The Complete Works , Christine de Pisan Ms 4431, Fol. 1r BL Harley British Museum, London.*

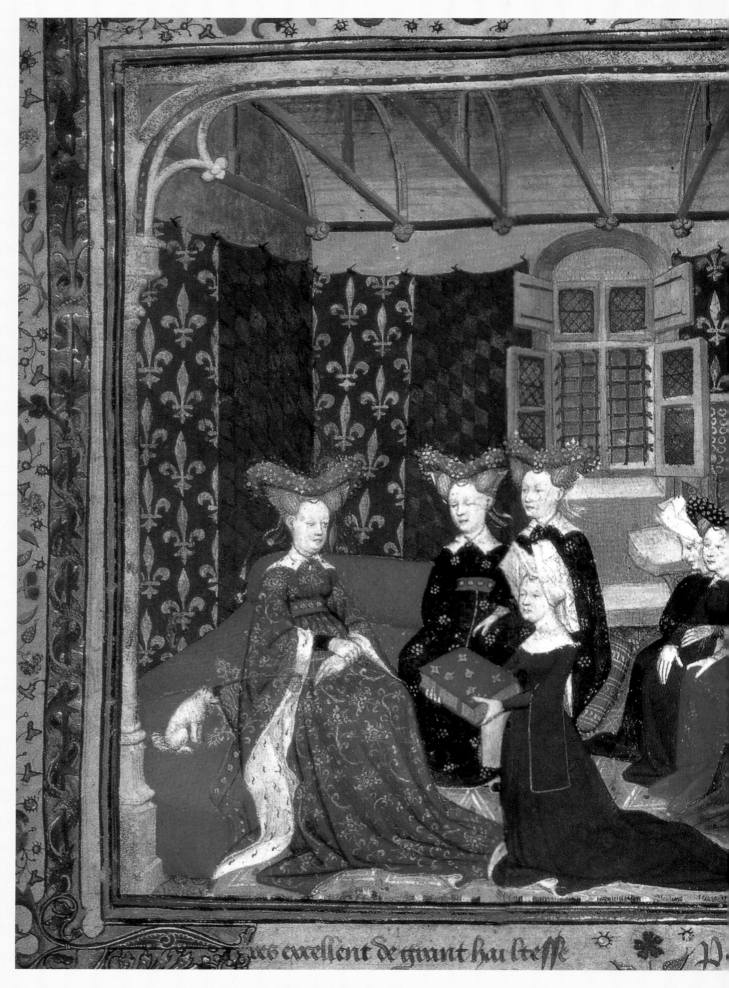

e liure cr que ie tiens

draws the naked Eve from an incision in his side. Behind, five angels sing in adoration from a location on a kind of island

surrounded by a stream which seems to be fed from a curiously phallic fountain. Through a tall gateway an orchard of fruit trees is visible – possibly intended as a reminder that Eve is destined to eat of the Tree of Knowledge and so bring about the expulsion of humankind from the Garden of Eden.

In the social environment engendered by that kind of theology, divorce was pretty well out of the question. Annulment of a marriage was very difficult

18 detail.

18 Unknown artist, Sire Geoffroi Luttrell's wife and daughter are giving him his weapon and shield. Miniature.

– and only for the rich. There were harsh penalties for
adulterous women.
Crime of any kind
was punishable not
solely by prison but
by execution,
mutilation, beatings
and/or public
humiliation.
Compulsory
pilgrimage was a
standard forms of
punishment for
lesser offenders, as
was banishment to a
nunnery for those
women who had
sinned against the
prevailing mores,
most of which were
subject to officious
regulation by a
male-dominated
Church.

This is of course
a gloomy present-day
Western view. Then,
as ever, people got on
with their lives. Because there was nothing else to do and no
fashionable examples to follow, their own day-to-day existences
were all they could imagine life to be about. Not everything
was wretched. Arranged marriages, then as now, could be very
satisfactory. The literature of the time suggests that despite the
penalties the primary sin involved in adultery among the
nobility was not to engage in it but to be so careless as to be
caught. The Church was oppressive – but it was also corrupt

*19 France,
unknown artist,
early XVIth century
Miniature in Poetic
Epistles of Anne of
Brittany and
Louis XII,
Illustration to
Epistle 2, F. 20v,
National Library,
St Petersburg.*

*20 France,
unknown artist,
early XVIth century
Miniature in Poetic
Epistles of Anne of
Brittany and
Louis XII,
Illustration to
Epistle 1, F. 1v,
National Library,
St Petersburg.*

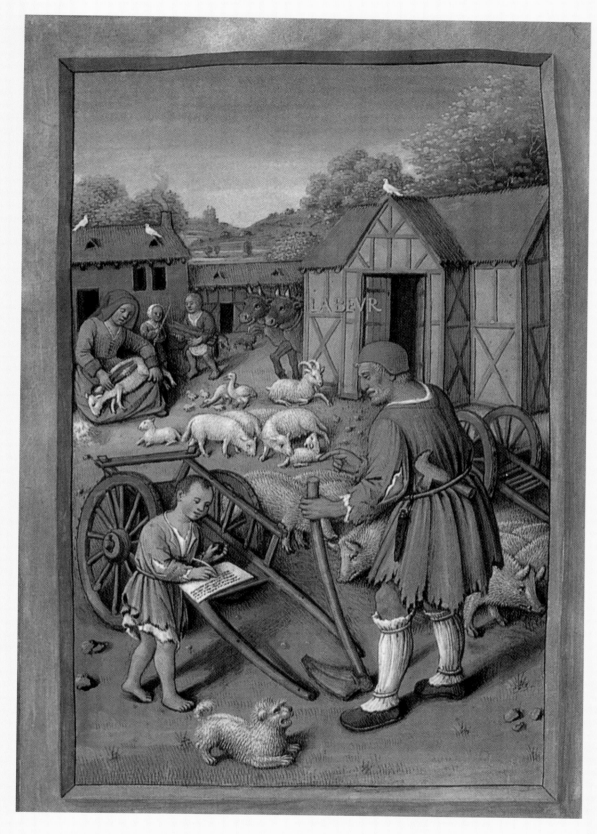

*21 France,
unknown artist,
early XVIth century
Miniature in Poetic
Epistles of Anne of
Brittany and
Louis XII,
Illustration to
Epistle 2, F. 31v,
National Library,
St Petersburg.*

and often totally inept in maintaining the standards of its own
clergy, let alone those of the lay population.

It has been said that the Church survived this period
despite itself and because of the credulity of its people. Yet

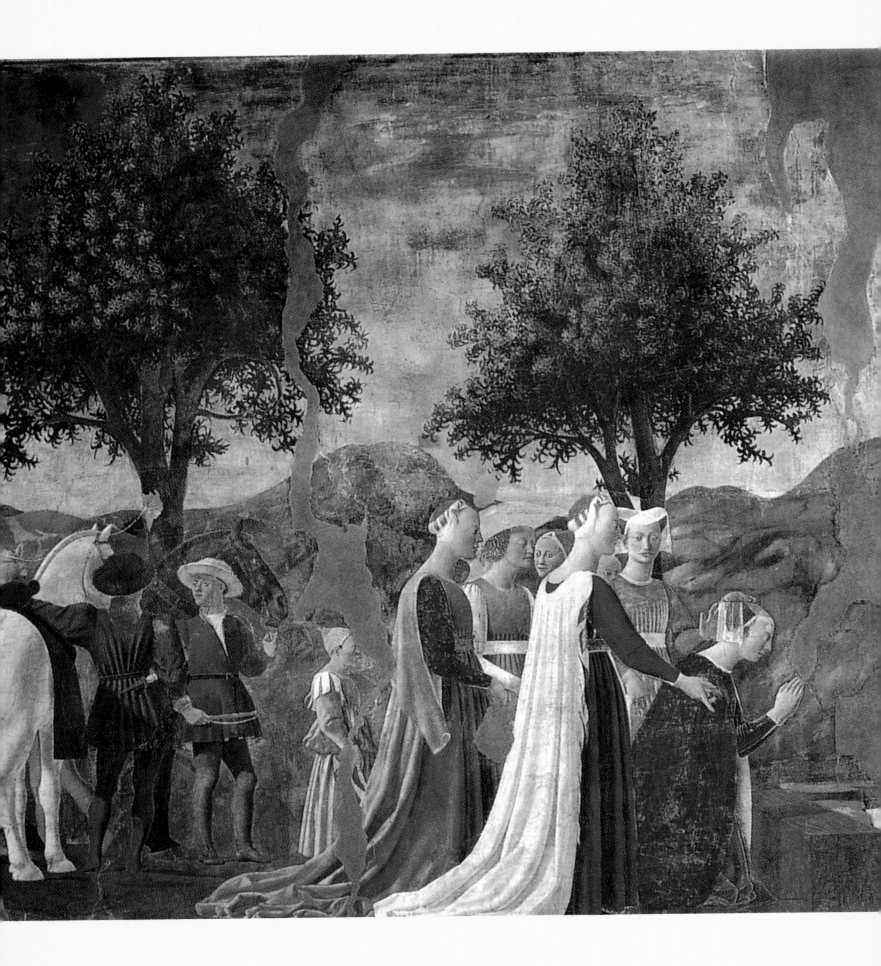

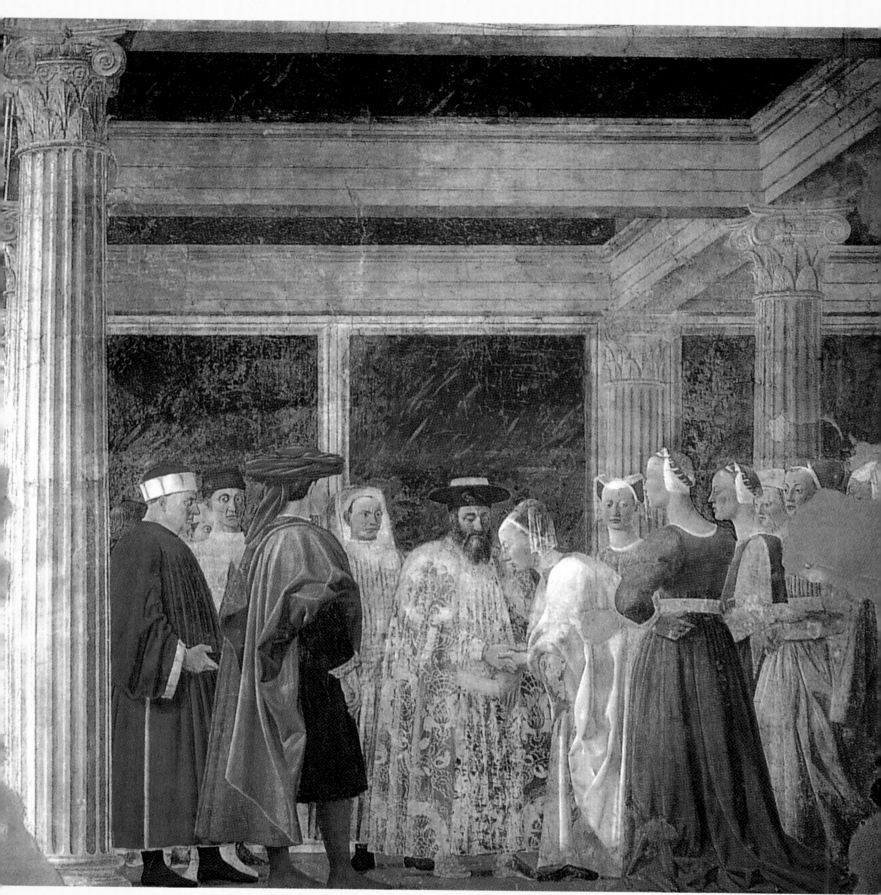

22 Piero della Francesca, *Worship of the Cross by the Queen of Saba and*
Encounter between the Queen of Saba and Salomon, after 1458
Fresco, 336 x 747 cm,
San Francesco Church, Chapel in the central choir, Arezzo.

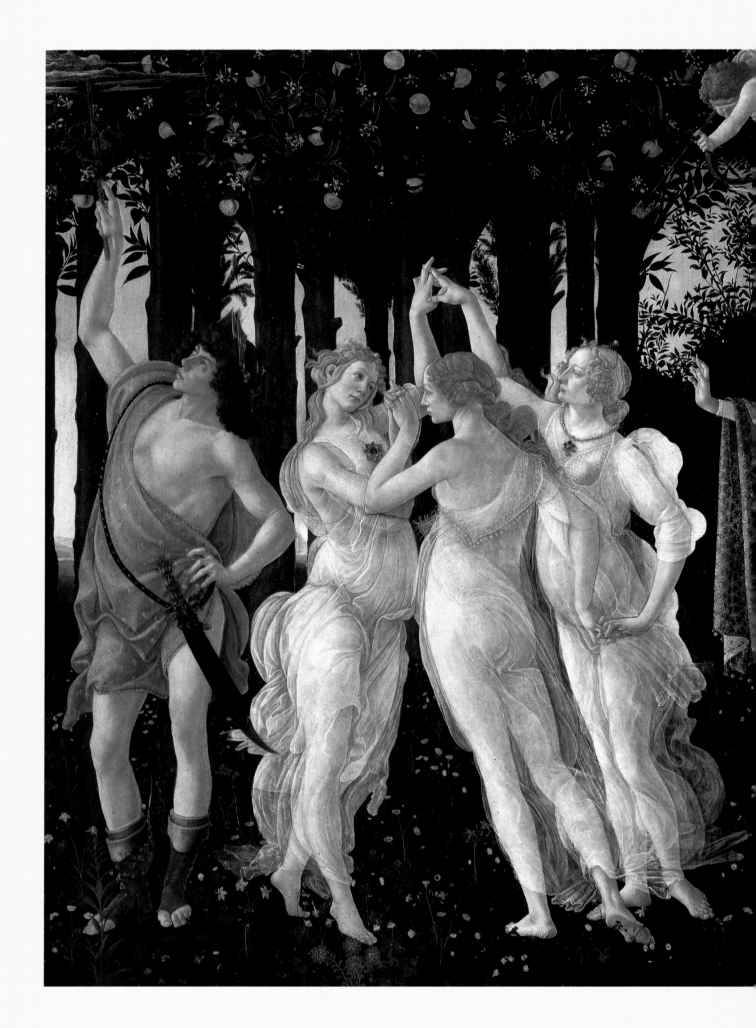

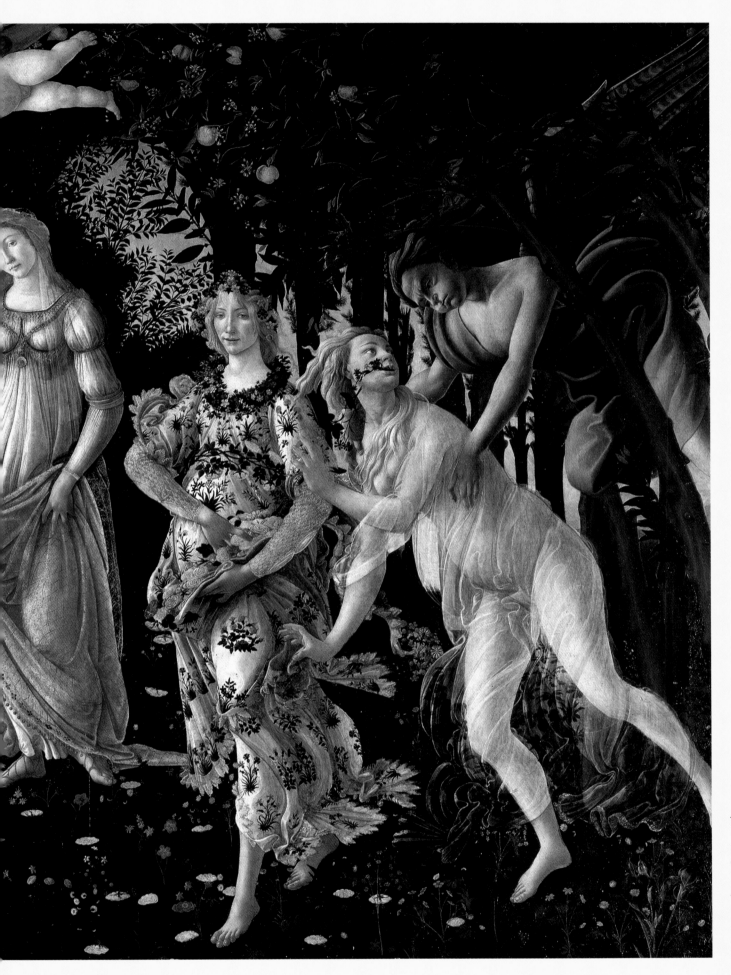

*23 Sandro Botticelli,
The Spring
(La Primavera),
ca. 1482
Tempera on panel,
203 x 314 cm,
Galleria degli Uffizi,
Florence
(Photo: Grifoni,
Nicola, Florence)*

the grey mist of ignorance was slowly dissipating thanks to the invention of the printing press and movable type – which encouraged people to learn to read – and thanks also to the rediscovery and translation of classical texts which the Arab world had preserved for nigh on a millennium.

We know of few remarkable mediaeval women, but there were some: Lucrezia Borgia, for example. Joan of Arc, the Maid of Orléans, is rightly still a folk heroine to the French. Inevitably, she had to pay the ultimate price for stepping out of her ordinary role – she was interrogated and condemned by the Church, and burned by the English with the connivance of the local French authorities. Centuries earlier, the heiress Heloïse – having inspired the monk Peter Abelard to renege on his vows of celibacy – became one of the great figures of early mediaeval French literature.

23 detail

Art and design

The end of the 1400s, when the Cluny tapestries were woven, represents a turning-point in art. The schematic arrangement, the static quality of the poses, the flat style of illustration of this series of tapestries all indicate that they are still essentially mediaeval works – although the Renaissance had already begun in France and was well under way in Italy, where Sandro Botticelli's landmark painting of around 1480 known (from at least 60 years later) as *Primavera* (fig. 23) still has the mediaeval qualities of two-dimensionality in arrangement but presents characters who have a wonderful three-dimensional roundness of depiction, appropriate enough in a painting which apparently portrays allegories of the world of classical mythology involving that ambiguous character, the goddess Aphrodite/Venus.

The change between two- and three-dimensionality may seem to be pinpointed between the works of Botticelli and his contemporaries, but it is less true of illumination painting, carving and sculpture – and indeed tapestry design, which had

24 King James saying his prayers, from the Book of Hours of King James IV. of Scotland, Flanders, ca. 1505 Ms.1897, fol. 24v Österreichische Nationalbibliothek, Vienna

in any case to pass through the hands of several kinds of (traditionally conservative) craftspeople including the pattern-maker and the weavers at the looms between the artist's original conception and the production of the tapestry several years later.

The allegories of the Renaissance proper are essentially those of the classical world. Virtues and vices had from the Dark Ages until then been – perhaps more accurately – portrayed allegorically as saints and sinners, as angels and demons, or as representations of the historical figures, both good and bad, involved in the Biblical tales, though often attired in costumes contemporaneous with those of the artist. Increasingly the new truths and virtues were represented as characters of classical mythology. For the Renaissance in art and conception represented a synthesis of classical and Christian ideals set in the external trappings of a classical environment which began to be perceived as lending more authority to whatever message the painting contained.

A caution

In the period of transition, around 1500, art was still rife with icons, symbols, visual clues directed at a largely illiterate audience. The result is that for us today there is an almost irresistible temptation to look for complex meanings in these images – a natural enough wish to believe that there might be a consistent iconographic vocabulary from which a modern viewer can confidently assign significance to elements in the composition. One or two themes in contemporary art even lend themselves to this heady desire. For example, in late mediaeval and Renaissance arts it is very obvious who the Virgin is in a painting because she wears a blue cloak; St Luke is often seated at a desk; Venus clothed is Love in a profane sense, naked she represents divine Love. And you can be reasonably confident that in a painting of that sort of time the classical figure with a net is Vulcan, the youth or boy-child with the bow and arrow is Cupid.

But there is no single, clear, consistent set of rules. Objects depicted – especially plants and animals – frequently have more than one asymbolic value and may even stand for quite opposing concepts. The Unicorn, for example, often represents Christ – but it can alternatively represent Death. The apple may symbolize Christ too, but it is also associated with evil. Sometimes the context clarifies the meaning of individual elements. In this way the depiction of an apple and a gourd together in a painting might represent the Resurrection (symbolized by the gourd – something that springs up from the ground and is useful well after its 'life' is over, while it also represents the opposite to – and therefore the antidote for – the apple that is the agent of evil, as in the story of the Fall). We should not forget, either, that as the Dark Ages merged into the Renaissance, what may now seem to be rather worldly images could then have purely religious significance, and vice versa.

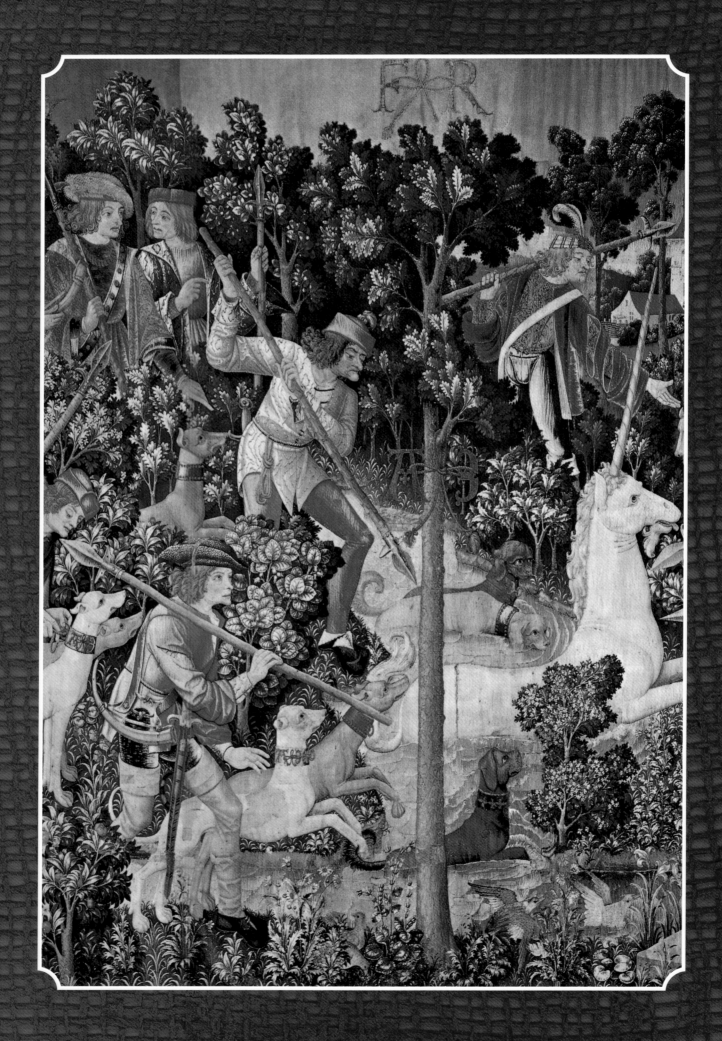

 # Masterworks

The most important surviving mediaeval representations of the Lady and the Unicorn are the six tapestries that make up the series of that name at the Musée de Cluny, Paris, and the seven tapestries that comprise a sequence called *The Hunting of the Unicorn* at The Cloisters, part of New York's Metropolitan Museum.

The Lady and the Unicorn at Cluny

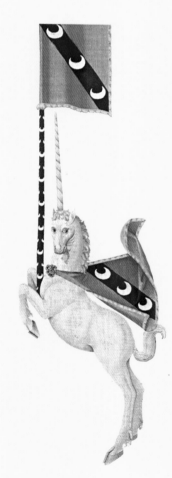

The Cluny tapestries are somewhat inaccurately named. In each of them the Unicorn is contrasted not so much with the Lady but with a lion, and the primary function of both animals is to hold upright the decorated flagpoles from which fly the banners and pennants bearing the crescent devices of the Le Viste family. Nonetheless, in two of them the unicorn is singled out for special treatment. In the tapestry known as *Touch* (fig. 28) the Lady holds the Unicorn's horn in one hand and a flagstaff in the other; in the one generally called *Sight* the lion alone wields a banner while the unicorn rests its forelegs on the Lady's lap and she reflects the noble beast's face towards the viewer in a small hand-mirror (Fig. 26).

Every other tapestry in the series shows the

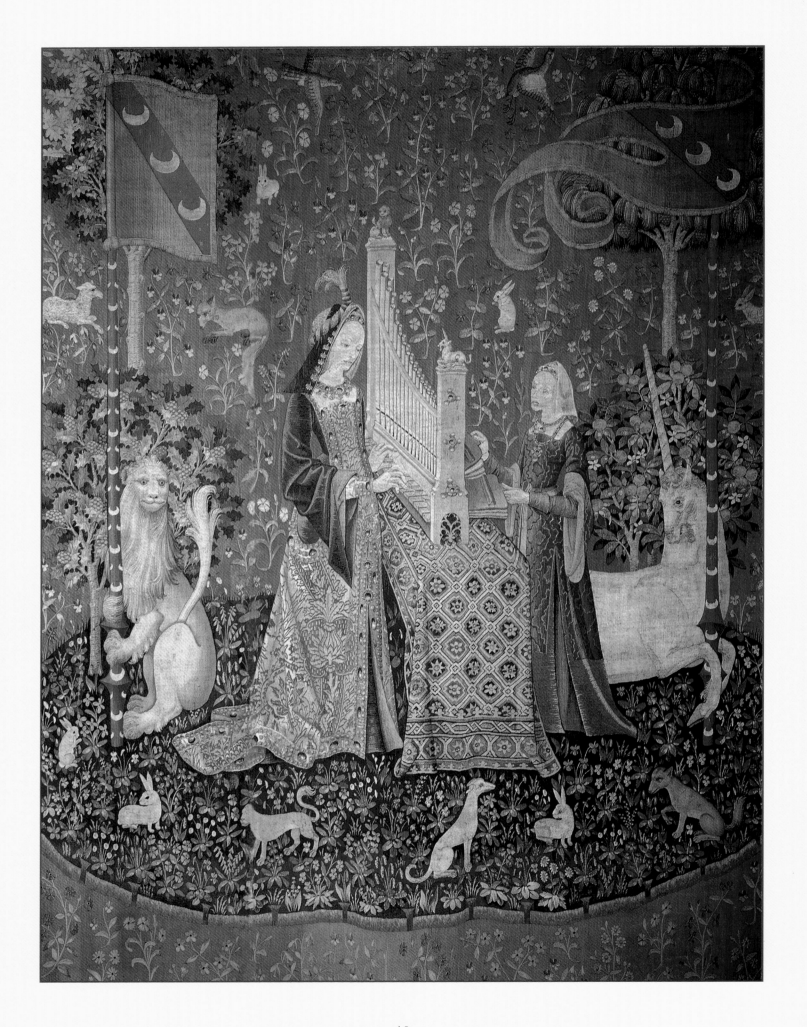

Lady accompanied by a maid. A more accurate title for the series might therefore be *The Lady, the Lion, the Unicorn and a Serving-Maid* – but it is a measure of the power and persistence of the traditional association of the Lady and the Unicorn that even today the tapestries remain known simply by it.

26 detail

History

Nobody knows who designed or wove these six tapestries for Jean Le Viste, President of the French Court of Assistance, sometime in the 20 years before 1500. But it is undoubtedly the Le Viste coat of arms – gules, a bend azure charged with three crescents argent – that is emblazoned on the pennants and banners supported by the lion and the

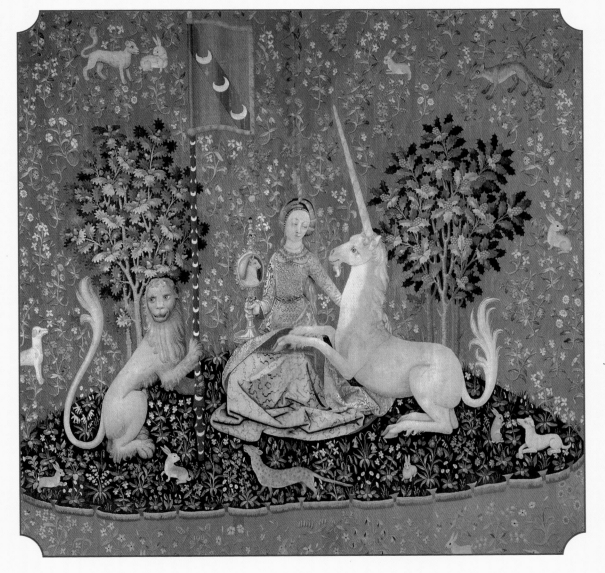

25 (far left) Hearing, 1484 - 1500, tapestry from the series The Lady and the Unicorn, Wool and silk thread, 312 x 330 cm, Musée de Cluny, Paris

26 Sight, 1484 - 1500, tapestry from the series The Lady and the Unicorn, Wool and silk thread, 312 x 330 cm, Musée de Cluny, Paris

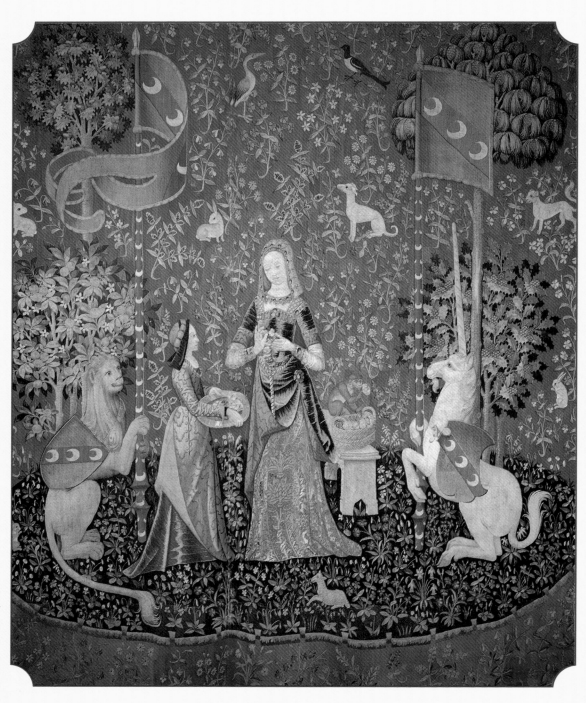

27 Smell;
1484 - 1500. tapestry
from the series The
Lady and the Unicorn,
Wool and Silk thread,
368 x 322 cm
Musée de Cluny, Paris

unicorn. The lion and the unicorn that are the heraldic
supporters of the British sovereign's coat of arms constitute an
emblem that is not only much later but that was deliberately
contrived to combine one of the (three) heraldic lions of the
monarchs of England with one of the (two) heraldic unicorns of
the Scottish crown – the two royal traditions becoming one in
the person of the Stewart king James I of England, VI of
Scotland.

Beyond that, the best information we have about the

tapestries is that they were probably made in northern France, perhaps somewhere in modern Belgium, to the design of an unknown artist. Unlike the equally famous *Hunting of the Unicorn* tapestries, there is no question but that they were intended for viewing as a single group, presumably in one enormous room. Yet it is not certain that there were originally six of them, for as late as in 1847 George Sand described eight tapestries hanging in the chateau of Boussac in an article in *L'Illustration*. It is even possible that the correct total was actually seven, because that number

25 detail

26 detail

27 detail

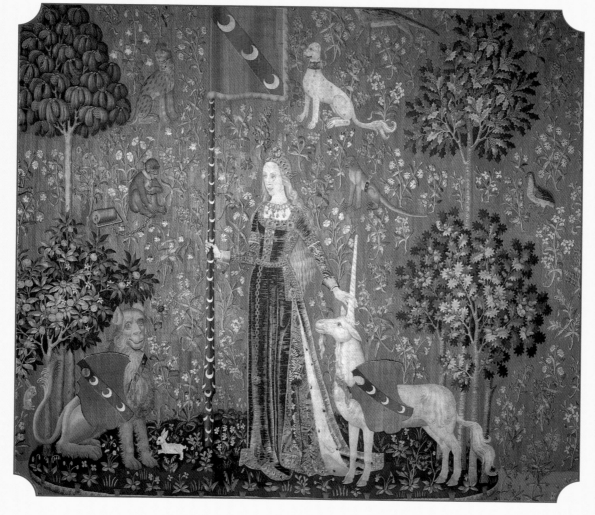

28 Touch, 1484 - 1500, tapestry from the series The Lady with the Unicorn, Wool and silk thread, 369 x 358 cm, Musée de Cluny; Paris

of tapestries bearing the Le Viste arms and featuring Wise Women and unicorns and other beasts is mentioned in a late sixteenth-century inventory of the château de Montaigu-le-Blin. These may not have been the same tapestries but they do appear to have been similarly woven for the Le Viste family.

However many there were originally, it was six

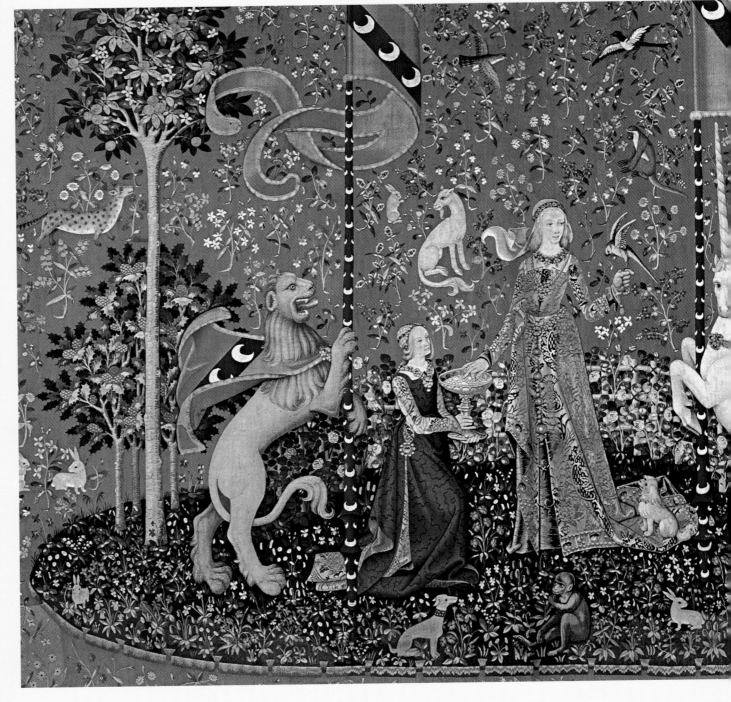

29 Taste, 1484 - 1500, tapestry from the series The Lady and the Unicorn, Wool and silk thread, 369 x 358 cm Musée de Cluny, Paris

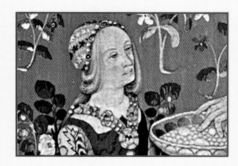

tapestries that the then Inspector of Historic Monuments, Prosper Merimée, in 1842 endeavoured to persuade the French national authorities to buy from the local parish council that had bought up the Boussac château and its contents from its previous aristocratic owners in 1835. Merimée commissioned an architectural survey of the property, from which we know that six tapestries were at that time formally on display, although there were certainly other tapestries hanging at Boussac. Agonizingly, local stories tell of old tapestries being used as tarpaulins on the château farm. Forty years later, in 1882, following protracted negotiations with the parish council owners, the nation bought the six tapestries and moved them to the museum at Cluny where, after the Second World War, the present circular room was specially built to house them.

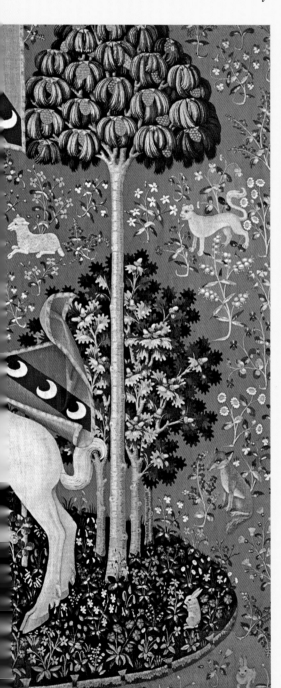

An allegory of the senses

The present-day understanding is that five of the six tapestries represent the five senses — hearing, sight, smell, taste and touch (fig. 25-29) — and that the sixth (fig. 30), dominated by the legend A MON SEUL DESIR, perhaps represents the renunciation of the passions engendered by the preceding (or following) five senses. It is well within the bounds of possibility that a better interpretation will in time emerge. Indeed, a recent proposal by Kristina E. Gourlay is that the tapestry series does not represent an allegory of the five senses at all, but rather

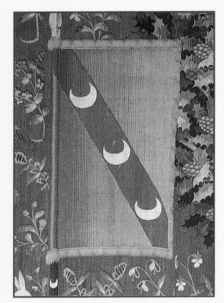

features the exaggeratedly elaborate story of a romance between the maiden and the unicorn as a commemoration of a marriage in the Le Viste family. (In itself this is an extension of an earlier suggestion that the tapestries were a wedding gift.) The standard argument against such a notion is that contemporary heraldry would have insisted on the arms of the groom and those of the bride's father being displayed side by side. It is additionally difficult to take such a theory seriously when, as we have seen, the lion is given almost as much symbolic weight in the tapestries as the unicorn, and when both — unlike the usual animals of contemporary narrative tapestries — are essentially heraldic devices.

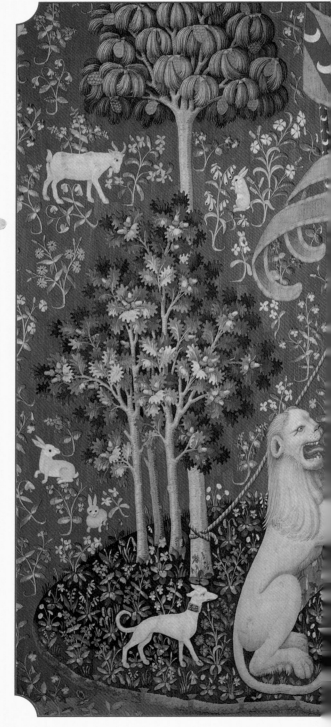

The fact that we simply don't know who the original designer was, where the tapestries were manufactured, exactly how many tapestries there were in the first place, and in which order they were meant to be viewed, has over the centuries led to increasing — rather than diminishing — speculation. At one stage, before the heraldic details of the Le Viste family coat of arms were rediscovered and associated with the tapestries, the presence of Islamic-style crescents

depicted on the banners evoked the theory that the tapestries had been woven at the behest of one of the sons of the fifteenth-century Ottoman sultan Mohammed II imprisoned at Bourganeuf, that the lady of the tapestries was his beloved far from him, and that in *A Mon Seul Désir* ('To My Only Desire') she was depicted choosing

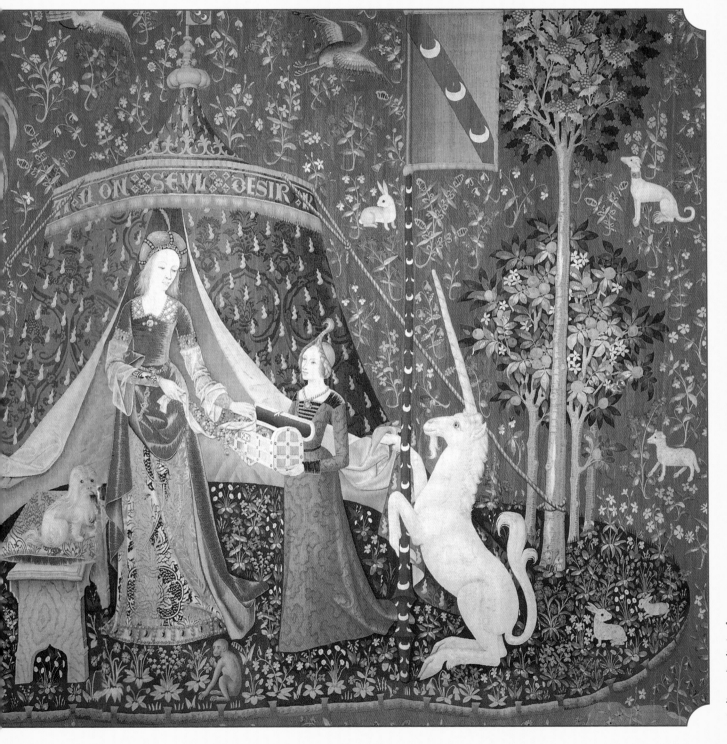

30 A Mon Seul Désir, 1484 - 1500, from the series of tapestries The Lady and the Unicorn, Wool and silk thread, 376 x 473 cm, Musée de Cluny, Paris

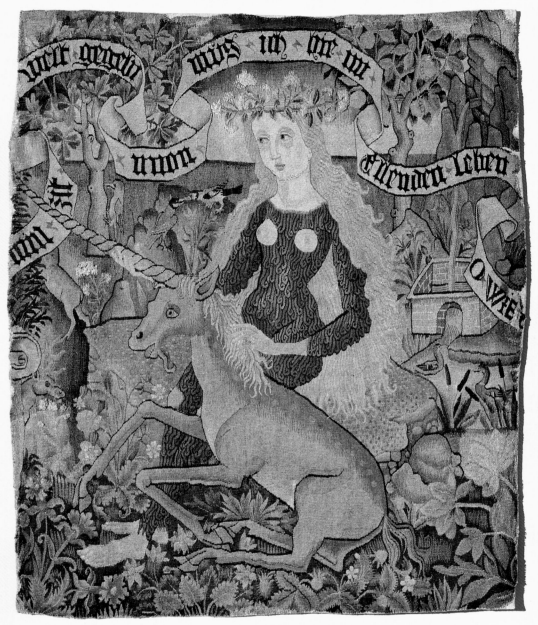

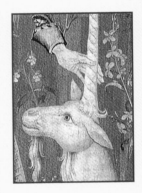

31 Wild Woman
With Unicorn.
Tapestry.
About 1500.
Historisches
Museum, Basle.

jewels that were no more and no less her due. However, a cursory glance proves that she is actually returning jewels to a case, rather than the reverse — and of course we now know that the crescents are those of the Le Viste family and not representative of some exotic Eastern potentate's captive son.

At various times the Lady of these six tapestries has been identified with any of a number of genuine historical personages — but pictorially there are actually as many ladies as there are

tapestries: each one
has clearly
different features
from the others. So
although some may
bear passing
similarity to various
contemporary
women of
note, none
of these

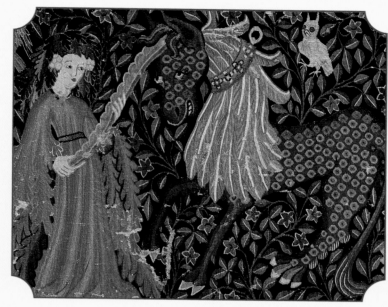

32 Tapestry
(detail). Swiss,
1420-40
Historisches
Museum, Basle.

identifications has stood up to scrutiny. (In fact, one
prominently suggested real-life model was born after the

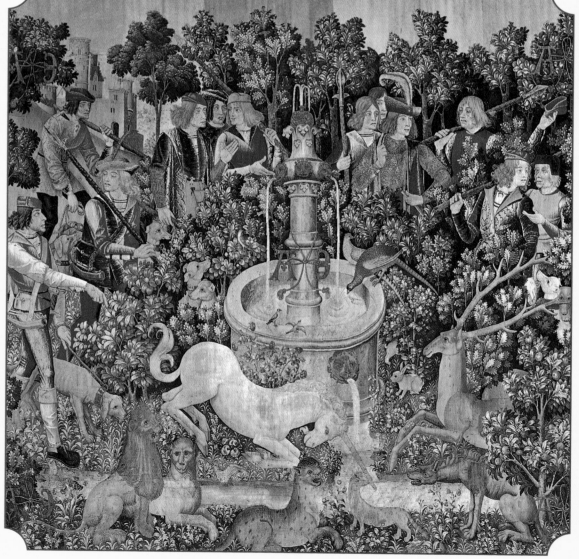

33 The Unicorn dips his
horn into the Stream to
rid it of poison,
Second tapestry from the
series The Hunting of
the Unicorn, ca. 1500,
Wool, silk and metallic
thread, 368 x 379 cm
The Cloisters,
Metropolitan Museum,
New York.

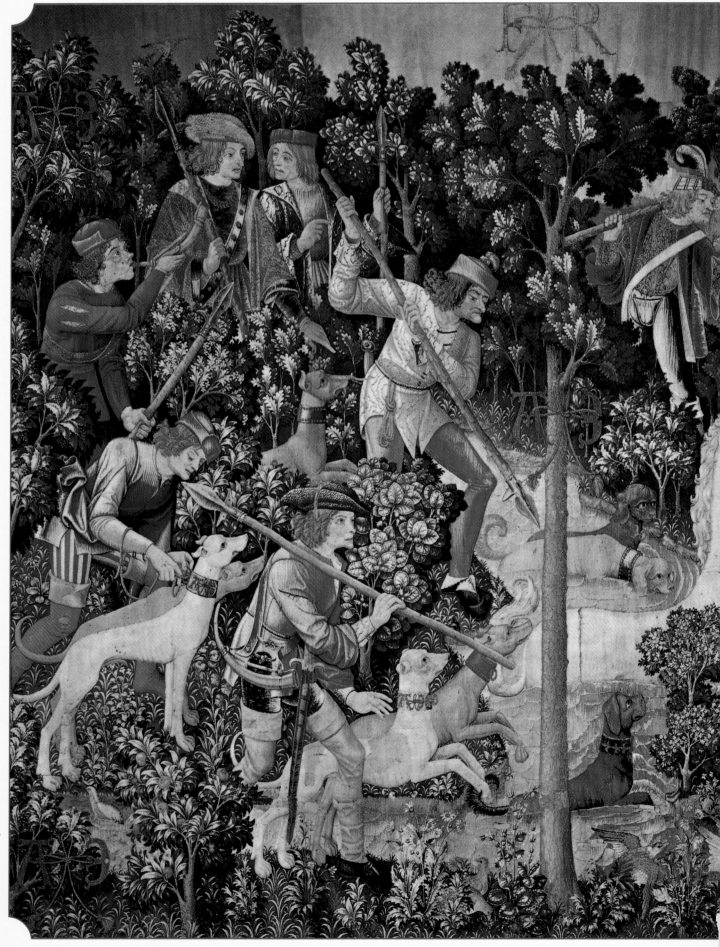

34 The Unicorn leaps
the Stream,
Third tapestry from the
series The Hunting of
the Unicorn, ca. 1500.
Wool, silk and metallic
thread, 368 x 427 cm
The Cloisters,
Metropolitan Museum,
New York.

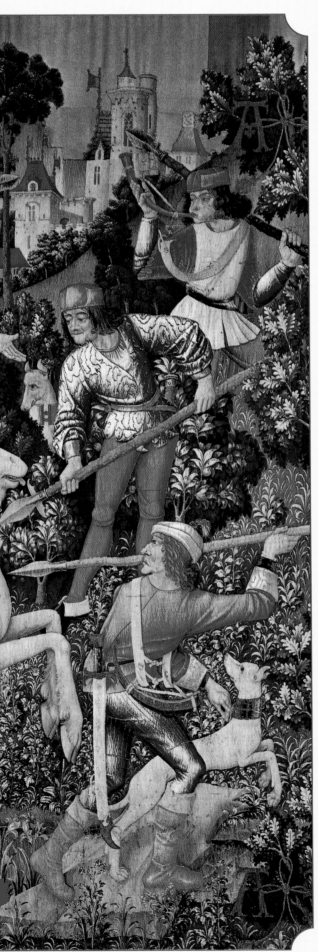

tapestries were woven.) Alternative theories have linked the images on the tapestries with the old Cathar heresies and with other religious themes, but such tenuous connections have won little support among mediaevalists.

The scene depicted in the tapestries seems to follow an established artistic convention in locating the main action on a predominantly blue mille-fleurs island which appears to lie within a mostly red background of foliage and branches representing trees in which small birds perch, and beneath and around which such animals as rabbits, lambs, foxes, cats, stoats, goats and dogs disport themselves. In the tapestry known as *Sight* the island boasts two rather shrubby trees: an oak and a holly-bush. In all the other tapestries there are two taller trees on the island – oak, pine, holly-bush or flowering orange-tree – one on each side accompanied by a smaller but different shrubby bush of the species listed. Oak (Quercus spp) has long signified strong faith, determined virtue, and the steadfast endurance of the Christian against adversity. Holly (Ilex sp) often corresponds to Christ's crown of

34 detail

thorns. The orange (Citrus aurantium) is a more complex symbol that can represent purity and chastity or generosity and freedom of nature, and that sometimes therefore appears in paintings of the Virgin Mary and also of the *Fall of Adam and Eve*.

35 detail

The maid who in four of the six tapestries accompanies the Lady would seem to be there primarily to emphasize the Lady's aristocratic status – or perhaps to liven up the rather flat compositions.

The location of an island was a fairly common artistic device at the time: the Metropolitan Museum in New York has several tapestries designed in this way. According to some interpretations, its form here is reminiscent of the fenced garden, the hortus conclusus, in which the unicorn is often seen in contemporary paintings and tapestries (compare also *The Unicorn in Captivity* (fig. 38), the seventh tapestry of *The Hunting of the Unicorn* – see below).

The Cluny tapestries as a sequence

The tapestry known as *Sight* (fig. 26) has the least formal composition. It is thought to allude to sight because the Lady holds a mirror reflecting the face of the unicorn. Turned full-on to the viewer, the lion holds up the only Le Viste

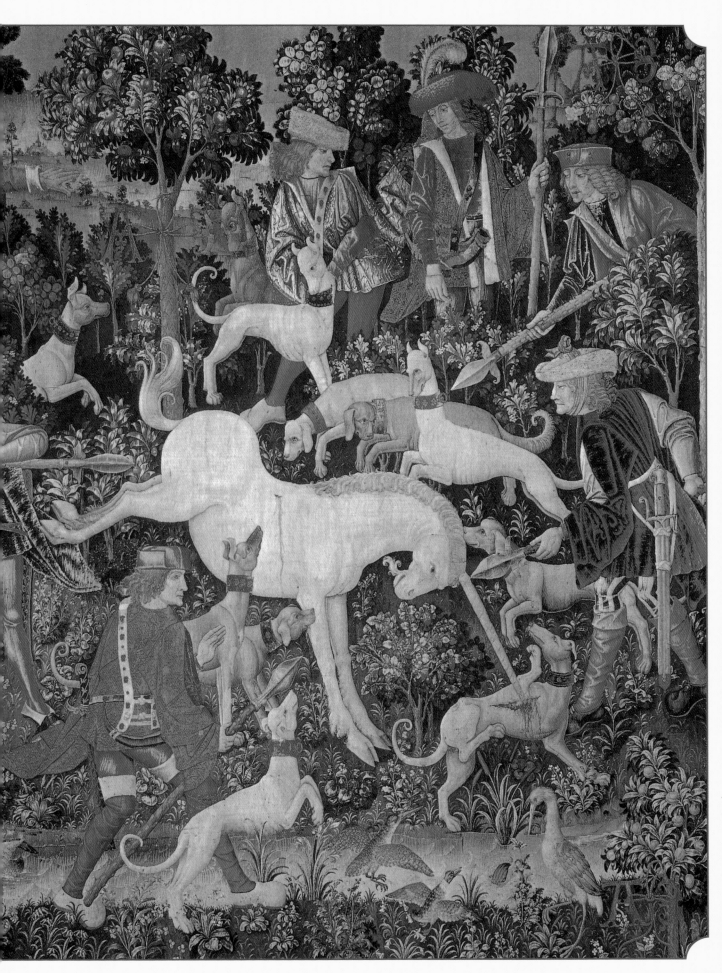

*35 The Unicorn
Defends Himself,
Fourth tapestry from
the series The Hunting
of the Unicorn.
ca. 1500.
Wool, silk and metallic
thread, 368 x 427 cm
The Cloisters,
Metropolitan Museum,
New York.*

standard in the tapestry, while the unicorn – its forelegs and their cloven hoofs resting on the Lady's lap – returns her sad smile. It has been suggested that this could actually represent a metaphor for the *Pietà:* the unicorn, representing Christ, lies in the lap of the Virgin, who holds up a mirror -perhaps the speculum sine macula, the flawless mirror of the book of Wisdom, a symbol of her purity. On the other hand, the goddess embodying Luxury in art often holds a mirror which symbolizes vanity and the seductive powers of women. In yet another way, the tapestry could represent fidelity, for although none of the other tapestries could justify the allegory, this one may also

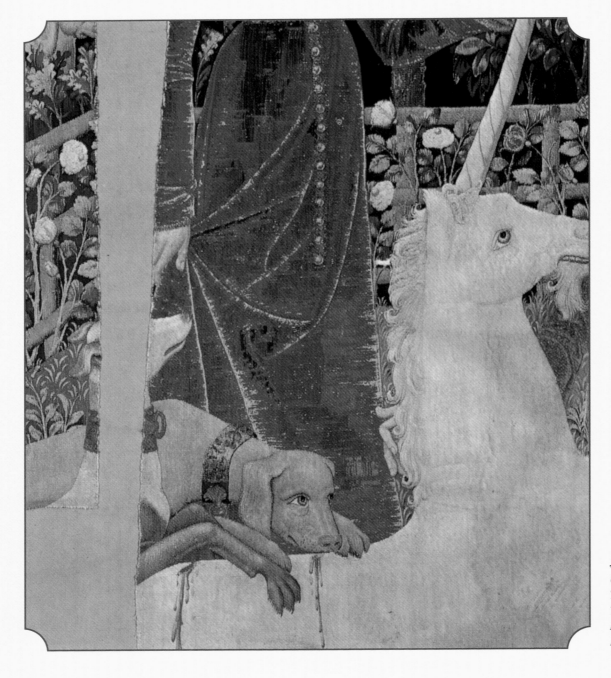

36 The Capture of the Unicorn, detail of fig. 4, Tapestry. ca. 1500. The Cloisters, Metropolitan Museum, New York.

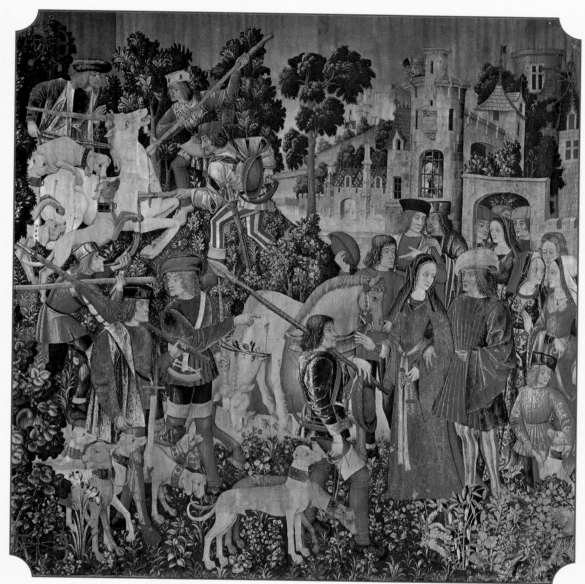

*37 The Unicorn is killed and brought to the Castle.
Sixth tapestry from the series The Hunting of the Unicorn, ca. 1500.
Wool, silk, and metallic thread, 368 x 389 cm
The Cloisters, Metropolitan Museum, New York.*

represent the lover – that is, the Unicorn – in the embrace of his Lady, in which case the mirror she holds stands for love requited as if reflected.

In the tapestry known as *Hearing* (fig. 25), the Lady plays upon a portable organ or harmonium (much like the box-organs of India today) which is set on top of a table that is covered in what looks like an ornate altar-cloth. On the other side of the table her maid pumps the bellows to supply air to the organ-pipes. To the left the lion sits up on its hindquarters holding its flagstaff vertical, while to the right the unicorn appears to be lying with its flagstaff cradled between its forelegs.

In the tapestry generally called *Taste*, (fig. 29) the Lady chooses a sweetmeat from a dish and a monkey raises a

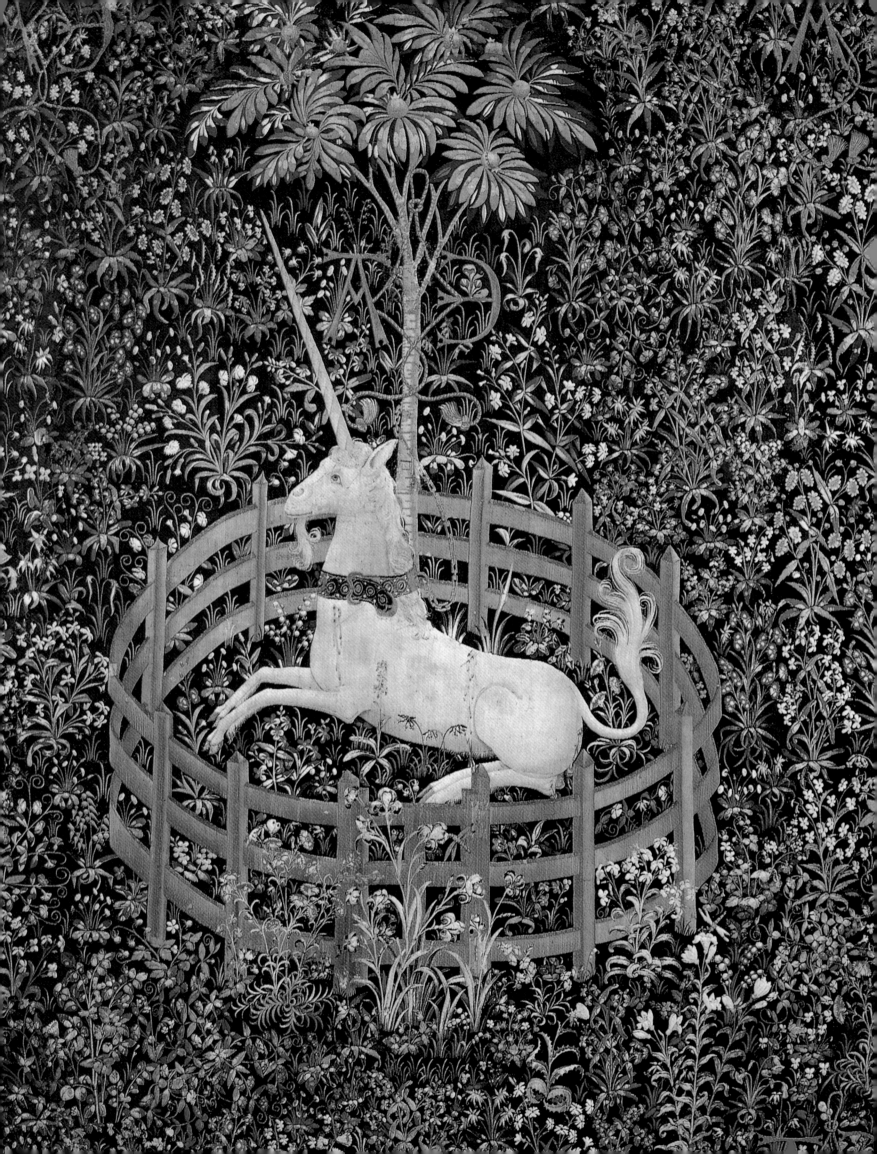

sweetmeat to its mouth. The unicorn here is the size of a small pony, up on its hind legs wearing – like its lion counterpart – a kind of mantle decorated with the Le Viste arms, its forelegs high up the length of a flagpole. Full face on to the viewer, its horn is vertical and confident.

In *Smell* (fig. 27), the Lady – attended by the maid, who holds a trug of flowers – weaves a garland while a monkey on a bench behind sniffs appreciatively at a flower it has taken from a double-handled basket. Both the unicorn and the lion face towards this scene and are set on their hind legs, their capes exchanged for emblazoned shields, and both are in the heraldic position described as rampant.

In *Touch* (fig. 28), the unicorn, now standing on all four legs, is comparatively smaller. This is presumably a compositional device that allows the Lady's left hand naturally to clasp the unicorn's horn near its base; her other hand holds up the only flag of the tapestry. Dog-like, the lion sits to the left offering a quizzical half-face to the observer. The whole effect is strangely comparable with that evoked by another tapestry featuring a Lady and a Unicorn woven at roughly the

39 English Manuscript, OXI 3B6, Bodleian Library, Oxford

38 The Unicorn in Captivity. Seventh tapestry from the series The Hunting of the Unicorn, ca. 1500. Wool, silk, and metallic thread 368 x 252 cm The Cloisters, Metropolitan Museum, New York.

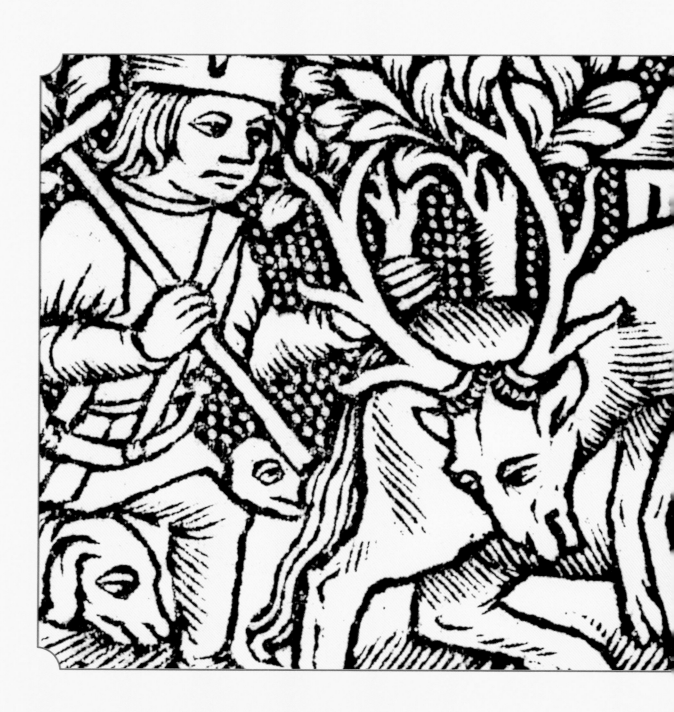

40 Detail of Woodcut showing scenes from a staghunt, from a Book of Hours published by Thielmann Kerver, French (Paris), 1504, The Metropolitan Museum of Art, Rogers Fund.

*41 - 45 Jean Duvet,
engravings from the series
The Hunting of the
Unicorn, ca. 1562, British
Museum, London*

*41 A hunter brings
fewmets to Henry II and
Diane de Poitiers for
judging the size of the
quarry, 22,4 x 39,6 cm*

same time (ca. 1500), now in the Historisches Museum at
Basle, Switzerland. In this tapestry, however, the Lady is
intended to be a 'wild woman', and her breasts are exposed
accordingly. But she too caresses the unicorn's horn as she
looks wistfully off to the viewer's left (fig. 31).

In *A Mon Seul Désir*, (fig. 30) the poses of the lion and the
unicorn in *Smell* are resumed. The right forelimb of each beast
holds back the entrance-flap of a pavilion or tent over which a
frieze bears the inscription A MON SEUL DESIR. Emerging
from the pavilion the Lady replaces in a casket of jewels held
by the maid the necklace she has (or her counterparts have)
worn in the other tapestries. To the left a lapdog sits on an
embroidered cushion, possibly signifying constancy.

In late mediaeval times symbols stood for what individual artists
meant them to stand for: there was no universally understood code or
vocabulary of symbols. The unicorn, accordingly, has been
associated with death as well as with Christ (eternal Life), with
untamed savagery as well as with meekness. And today, however
confidently we may theorise about the inner meaning of the images
in *The Lady and the Unicorn* series at Cluny, we are still speculating
– we don't know if these tapestries really are about the five senses.
On the other hand, to the uneducated mediaeval mind – which just
might therefore be more alert to the meaning of images – the

meaning of the tapestries may possibly have been immediately clear. Alternatively, perhaps Squire Le Viste asked his designer to do no more than create decorative tapestries which incorporated his coat of arms and some pleasant images to beguile and impress his visitors. Despite a wealth of mediaeval scholarship over the last century, we simply don't know for sure.

The Lion

More prosaically and, as we are much more aware today, somewhat truer-to-life than the unicorn, the lion stands for

42 The unicorn dips his horn into a river to rid it of poison, 22,7 x 40,1 cm

majesty, strength, bravery and courage. He is the king of beasts, and like the unicorn can represent Christ. It is said to have been believed in mediaeval times that lion cubs are born dead but come to life three days later when their father

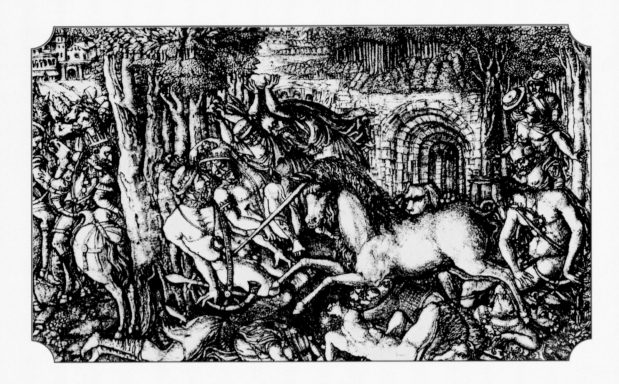

breathes on them. If this ever was a genuine piece of folk lore, it would have resulted from a combination of travellers' tales and a metaphor for the Resurrection such that the lion came to be associated with the notion of the Holy Spirit's breathing life into Christ on the third day, the day of his Resurrection. In Catholic hagiography the lion is an attribute of St Mary of Egypt (fifth century), St Euphemia (very early fourth century) and St Paul the Hermit (fourth century, two lions).

43 The unicorn gores one of the hunters, 23,5 x 39 cm.

The Hunting of the Unicorn at The Cloisters

The equally famous *Hunting of the Unicorn* series at the New York Metropolitan Museum's The Cloisters gallery is a sequence of masterly tapestries that depict the hunting and killing of the unicorn. It is not entirely certain that it is all of a piece as a series, but that hardly matters in reality. The first of the seven tapestries is a conventional scene that portrays men about to set out on a hunt. The following scenes depict a sequence of the discovery of the unicorn, his initial flight, a renewed attack, and the sudden presence of a virgin who brings the unicorn up short in his tracks. The unicorn is then attacked and killed by the hunters. Finally, the unicorn is restored to life, but only (as we have seen) to sit tethered with a golden

chain within a fenced garden.

The Hunting tapestries are of the same period as those at Cluny although, apart from the first and the last tapestries which utilize mille-fleurs backgrounds, some of the artistic conventions are different. In general, the foliage that represents the majority of the background is more realistic and more naturally arranged, and there is no resorting to the device of the mille-fleurs island to locate the Lady and the Unicorn.

The first tapestry is a fairly conventional hunting scene. The hunters and their attendants and the dogs are about to sight the quarry.

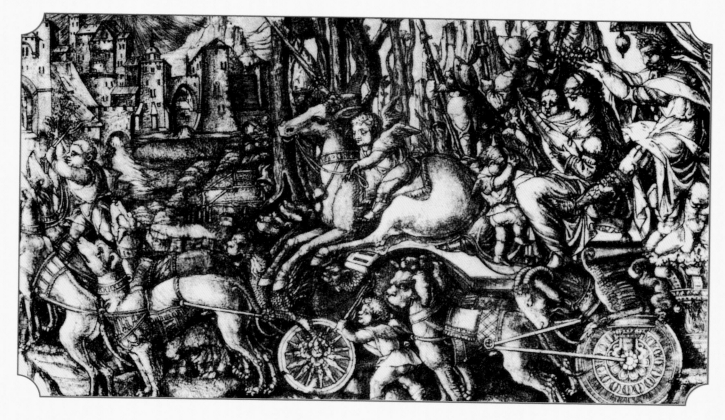

44 The unicorn, ridden by an amorino, is born on a chariot, 23,6 x 38,1 cm.

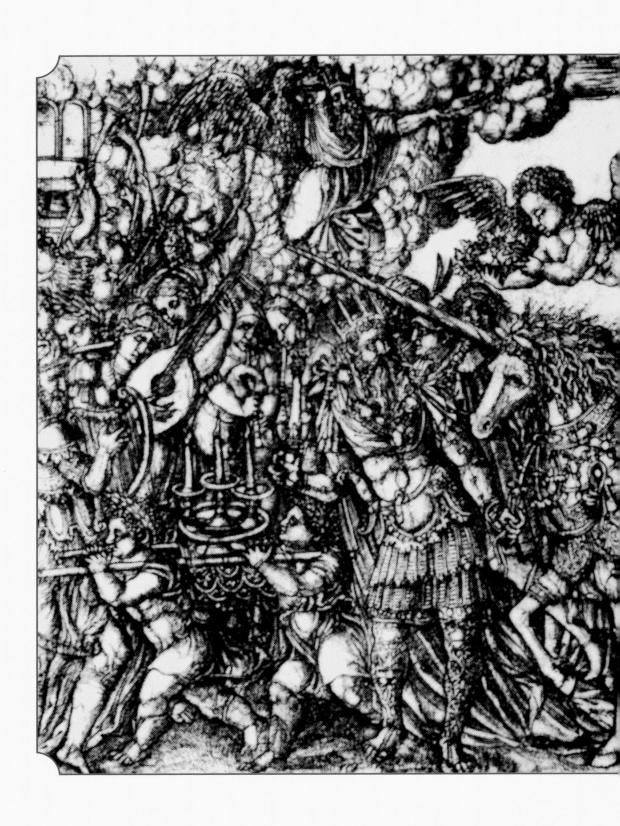

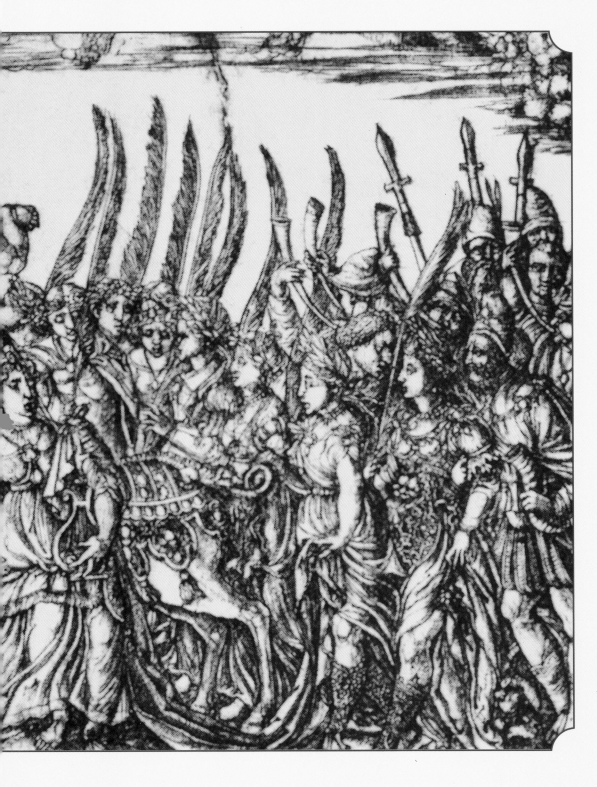

45 The Unicorn in a triumphal procession with an amorino about to crown him with a wreath of leaves, 23,5 x 39,2 cm.

At the centre of the second tapestry (fig. 33) is a fountain. In the foreground the unicorn dips its horn in the water of a stream that runs from the fountain, in order to purify it for a group of animals apparently waiting to drink, including lions, a leopard and a heavily-antlered stag. The stream that then

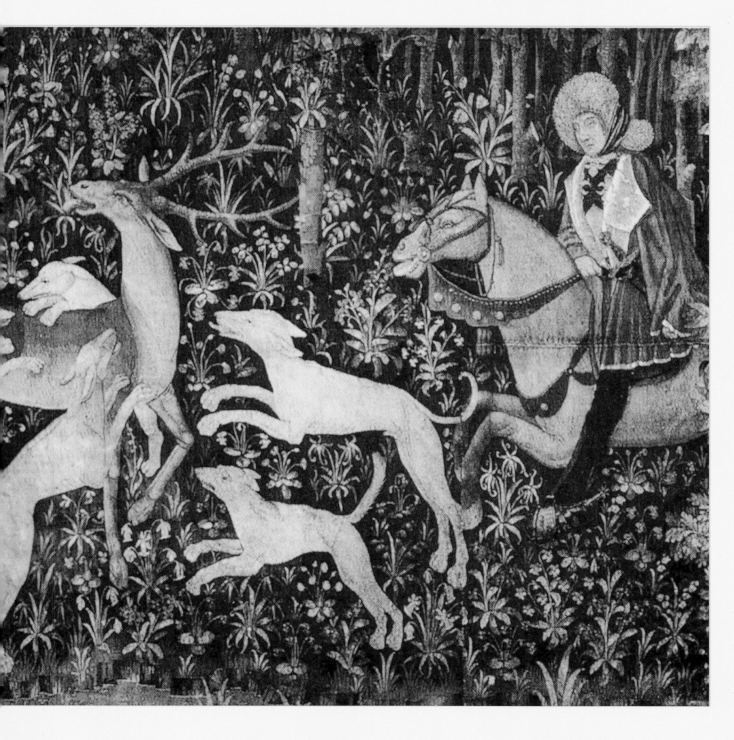

46 The Stag at Bay, Tapestry, Southern Netherlands, 1495-1515, Wool, 231 x 366 cm Metropolitan Museum of Art, New York

runs parallel with the bottom of the tapestry appears in subsequent scenes as a motif that lends visual continuity. In the background on the far side of the fountain the hunters gather among the bushes and trees, while to the left a patrolling gamekeeper with a dog silently points out the unsuspecting unicorn.

In the third, (fig. 34) the hunters surround the unicorn and attack it with their spears. But the unicorn – true to its reputation for agility- leaps the stream and makes a run for it.

In the fourth (fig. 35), the hunters have closed in with their dogs, but the unicorn fights back, kicking out wildly at the nearest hunter and seriously goring one of the dogs with its horn.

In the two separate fragments of the fifth tapestry (fig. 4, fig. 36 detail), the unicorn has almost escaped – but finds himself in a rose-garden and in the presence of one who is to be even more deadly to him, the virgin. Struck to the heart by her purity and her modesty, the unicorn stops motionless, allowing the pursuing dogs to catch up and to leap upon him, while the hunters appear coming out of the forest behind them. In dismay, the virgin closes her eyes and raises a distraught hand pityingly.

46 detail

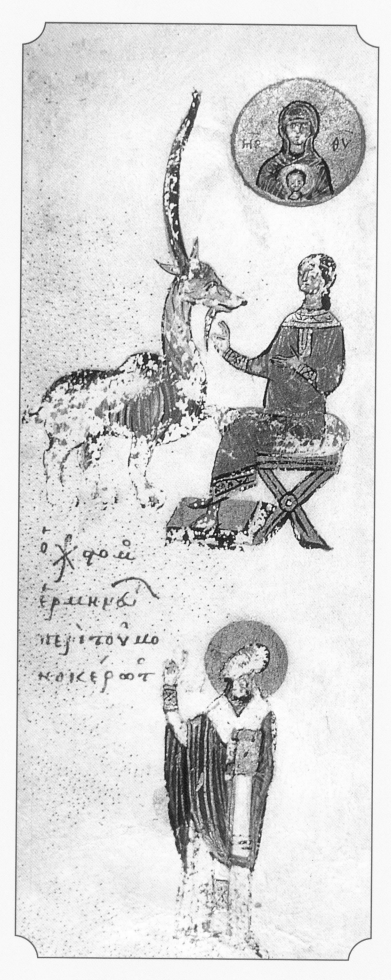

*47 Miniature in
Theodore Psalter.
Byzantine, 1066.
Ms 19352, fol. 124
British Museum,
London.*

In the sixth tapestry (fig. 37), the unicorn is finally done to death at the top left of the tapestry and in the centre his lifeless body is then shown draped over the back of a horse. The lord and lady have emerged from the castle in the background and evidently intend to accompany such a magnificent hunting trophy back home with the hunters and the court in triumph. That this was the standard way of ending a successful hunt at the time is proved by a wood-cut pictorial frame in a *Book of Hours* produced by Thielman Kerver in Paris in 1504 (fig. 40). The left and bottom parts of the frame contain images of a stag hunt that are very similar to those of the tapestries in *The Cloisters,* notably illustrating the way the dead stag is finally brought back to the local castle draped across the back of a horse.

In the seventh tapestry (fig. 38), the unicorn is shown alive and well again, but penned inside an enclosure and tethered with a golden chain to a pomegranate tree. It is very possible that this picture is intended to symbolise the risen *Christ in a Garden of Paradise,* for the pomegranate is associated with both Christ and immortality. Well before the beginning of the sixteenth century the mystic nature of the capture of the unicorn had become a metaphor for the lover overcome (to the point of self-sacrifice) by affection for his beloved. Several commentators have accordingly suggested an alternative meaning for the *Unicorn in Captivity* tapestry, to the effect that it shows the lover content to be held captive by his lady with the golden chain of matrimony. There is even a hint that their union will be fruitful, for fecundity is something else the pomegranate tree betokens in art.

Many of the events depicted in these tapestries are to be found repeated 50 years later in a set of six engravings by Jean Duvet (fig. 41 - 45) illustrating the hunting of the unicorn. In this series, the scene is first set for the hunters; the unicorn dips its horn in a river to purify it; the hunters attack; the unicorn is 'arrested' by the virgin and tied to two trees; the unicorn is borne home in a chariot of state; and in a

(presumably) happy ending the unicorn finally appears in a triumphal procession in which it is about to be crowned with a wreath of leaves.

Although there are few series such as these, unicorn-hunting images are virtually always based (as we have already seen) on stag-hunting, a sport that — like most modern sports — was governed by strict rules. To indulge in stag-hunting was not just to go out and chase down a stag. Whole books had been produced on the proper way to conduct a stag hunt. Our two unicorn-hunting series conform reasonably well with such depictions as *The Stag at Bay* (fig. 46), a tapestry of much the same date, which features a stag being savaged by blood-maddened dogs.

On the other hand, earlier examples in which the unicorn is portrayed as being 'arrested' by a Lady do not seem necessarily to involve the eventual slaughter of the noble beast. One such example is the drawing in the Psalter produced by the Byzantine cleric Theodore in the late eleventh century (fig. 47). Here a long-necked unicorn with a tall, forward-curving horn rests a foreleg on the lap of a woman sitting bolt upright on a stool.

This is no merely worldly encounter, for above the two is a medallion depicting the Virgin and Child, obviously intended to draw a parallel between a virgin's 'reception' of a unicorn and the Virgin's conception of Jesus following the Annunciation, so resulting in Christ's Incarnation. There is no suggestion as yet that the parallel might be extended and that both unicorn and Christ might be held to have died through self-sacrifice in the cause of Love.

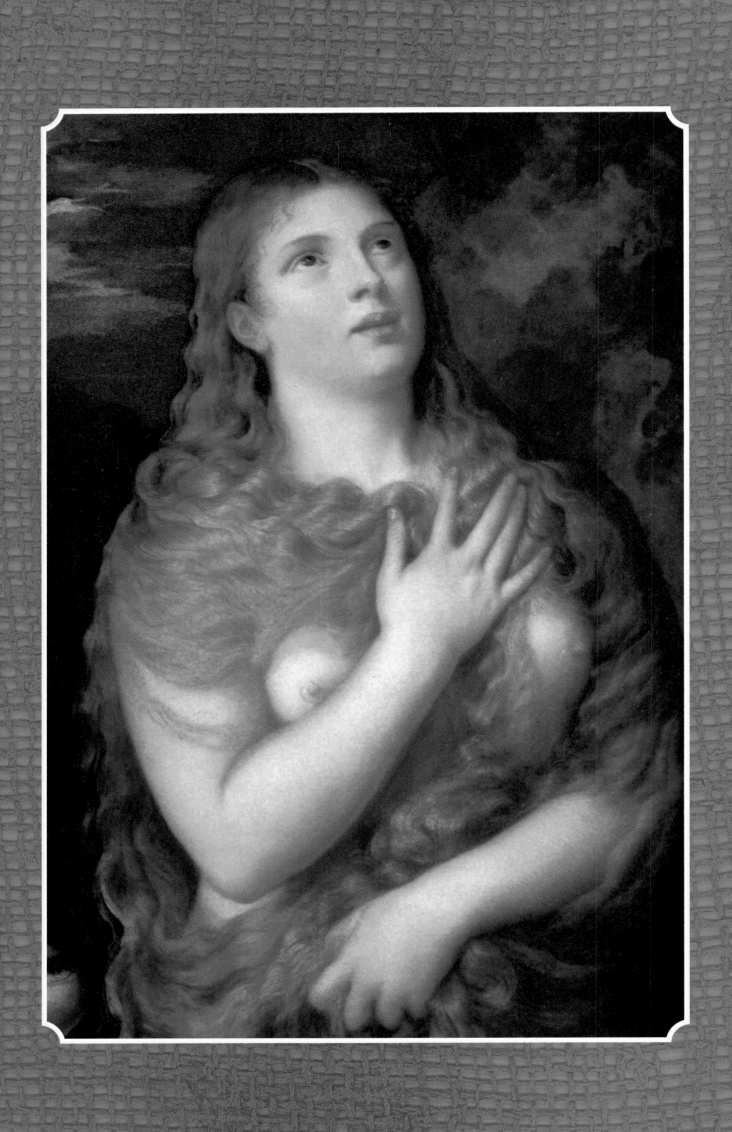

The Lady

The Lady of consequence

The Lady and the Unicorn series of tapestries currently on display at the Musée de Cluny, Paris, portrays a Lady who is a woman of some consequence. The presence of the handmaiden in most of the tapestries – and on a rather reduced scale – was intended by the designer to convey this. Moreover, this Lady is no shy, vapid creature but exhibits a clear personality and authority. It is arguable that her somewhat differing images in the tapestries have their parallels in those wonderful early Netherlandish portraits of notable women by such artists as Rogier van der Weyden (whose *Portrait of a Young Lady* of 1455 to 1466 now hangs in the National Gallery of Art, Washington), Robert Campin (whose *Portrait of a Woman*, painted in 1435, is in the National Gallery, London) and Jan van Eyck (whose portrait of his wife, completed in 1439, is now in the Stedelijk Museum of Fine Arts in Bruges). These works depict real women, women with serenity and authority, women of no less distinction than those in Lucas (the Elder) Cranach's later portraits of, say, Catherine of Mecklenburg, the wife of Henry, Duke of Saxony (fig. 48) or in François Clouet's portrait of Elizabeth of Austria, Queen of France (fig. 49).

Eve and the Fall

But these represent only part of the story. Mediaeval society was as ambivalent about the meaning of the Lady as it was about the overall status of women. Commentators have suggested that societies which on the whole actively oppress women tend to develop a series of exaggerated compensatory mechanisms as if unwittingly to ease their consciences.

Such mechanisms enable men to retain the far more comfortable belief that women like being revered or adored or respected or fought over, or being in some way singled out for special treatment, and would resent having some form of political power – even a say in their own future.

In consequence, mediaeval society was subject to a whole sheaf of sometimes opposing attitudes to women. On the one hand there were

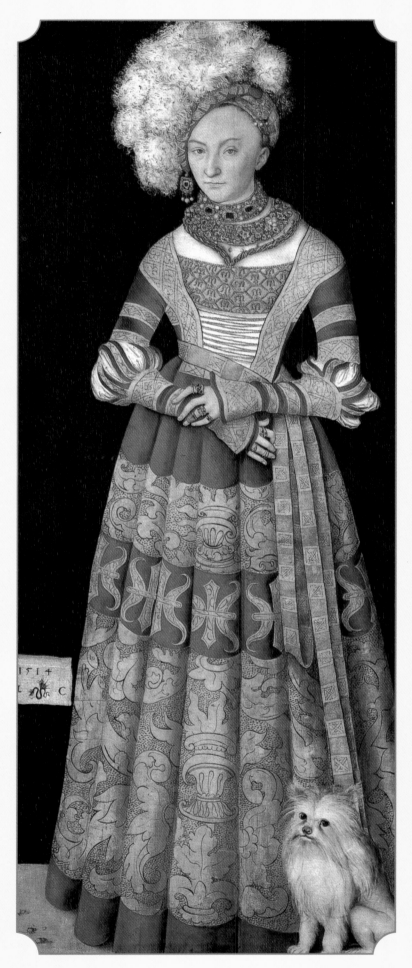

74

48 (left)Lucas
Cranach the Elder,
Portrait of the
duchess Catherine
of Mecklenburg.
1514,
Oil on canvas,
185 x 82,5
Staatliche
Kunstsammlungen,
Gemäldegalerie,
Dresden.

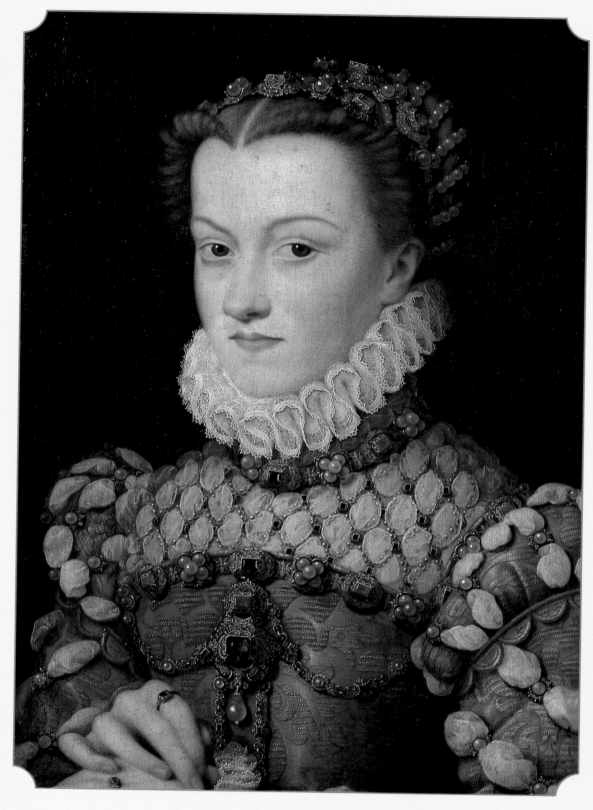

49 François
Clouet, Portrait of
Elizabeth of
Austria, Queen of
France. ca.1571.
Oil on wood,
36 x 26 cm
Musée du Louvre,
Paris.

the respected ladies of dignity, virtue and, occasionally, real authority, as reflected in the contemporary portraits. On the other, women in general were perceived as inferior by nature. They had been created second-hand, as it were, from Adam's rib rather than from the basic material which God had used to

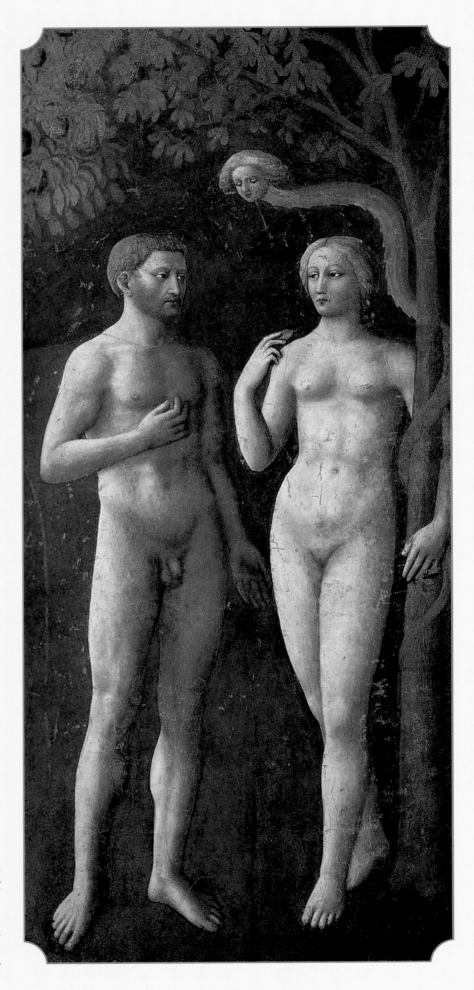

50 Masolino, The Tempting of Adam and Eve. ca. 1425. Fresco. 214 x 90 cm. Brancacci Chapel, Santa Maria del Carmine, Florence

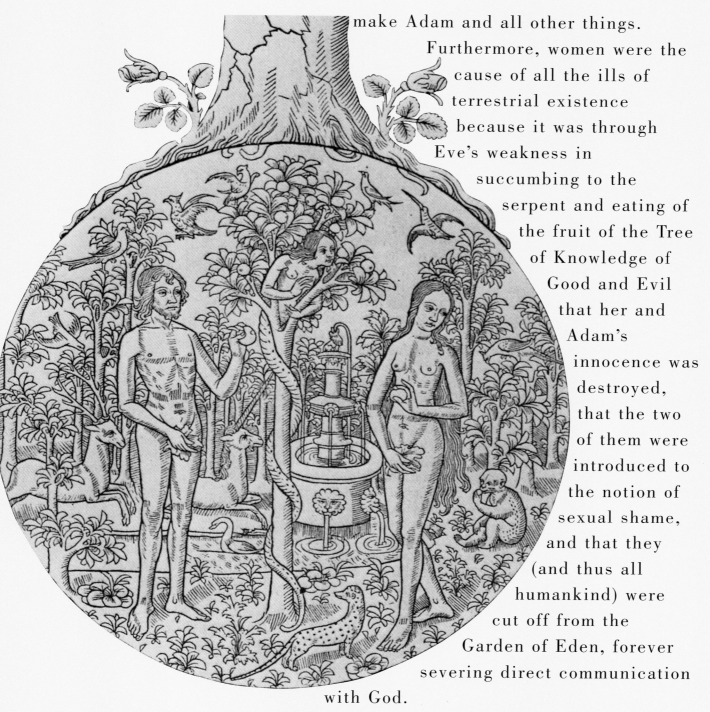

make Adam and all other things. Furthermore, women were the cause of all the ills of terrestrial existence because it was through Eve's weakness in succumbing to the serpent and eating of the fruit of the Tree of Knowledge of Good and Evil that her and Adam's innocence was destroyed, that the two of them were introduced to the notion of sexual shame, and that they (and thus all humankind) were cut off from the Garden of Eden, forever severing direct communication with God.

The tempting of Eve and the expulsion from the Garden of Eden (the Fall) are themes that are recurrent in religious painting of the fifteenth century, from Masolino da Panicale's two frescoes of 1425 in which the head of the serpent is that of a woman (fig. 50), through a woodcut in Antoine Vérard's Bible, produced in Paris in around 1500, in which a deer and a unicorn gambol around the familiar Fountain of Life while a female serpent coils around the Tree (fig. 51), to the extraordinary *Original Sin and the Fall* detail of the same date in Michelangelo's Sistine Chapel

51 The Tempting of Adam and Eve, Woodcut, published by Antoine Vérard, ca. 1500, Harris Brisbane Fund, Metropolitan Museum, New York

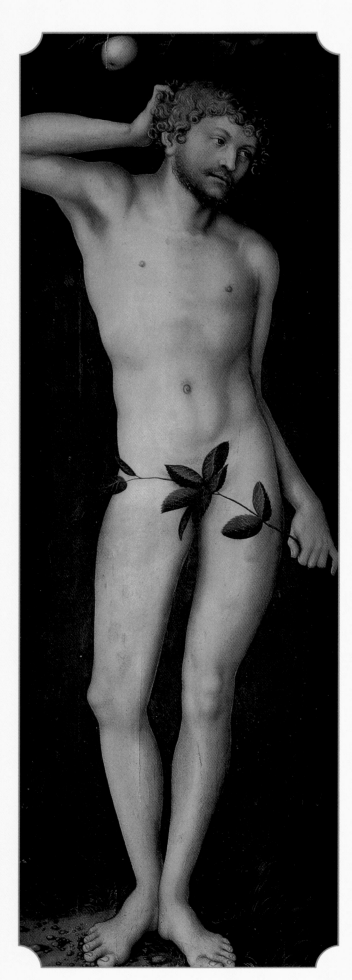

52 Lucas Cranach the
Elder, dyptich: Adam and
Eve, 1528
Oil on wood
Galleria degli Uffizi,
Florence.

52a detail : Adam,
172 x 63 cm

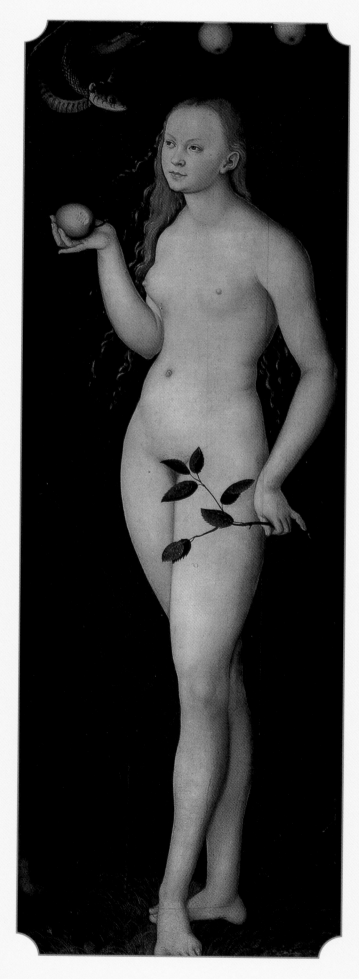

52b detail: Eve,
167 x 61 cm

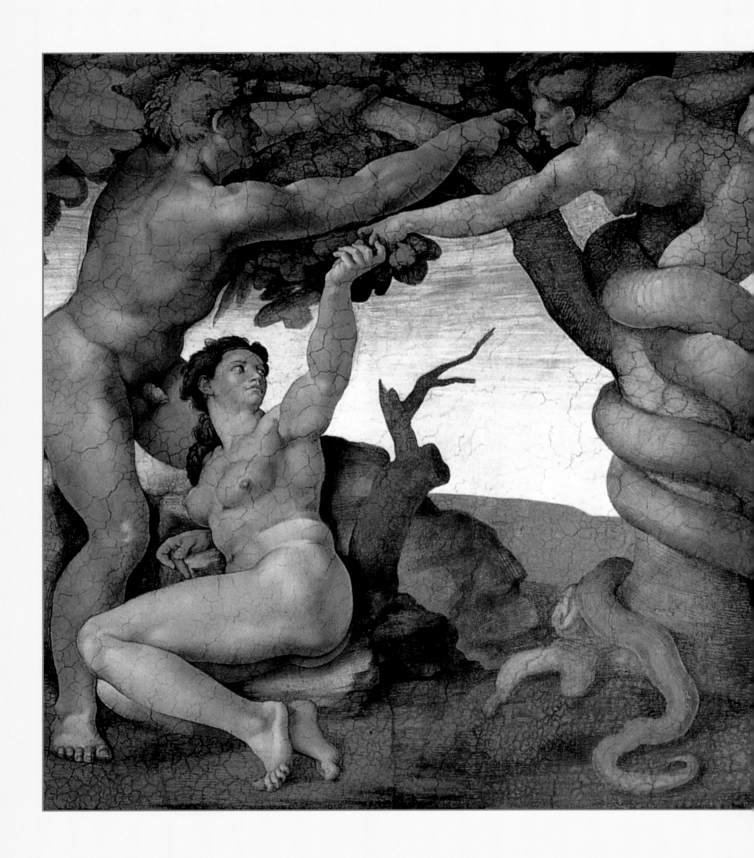

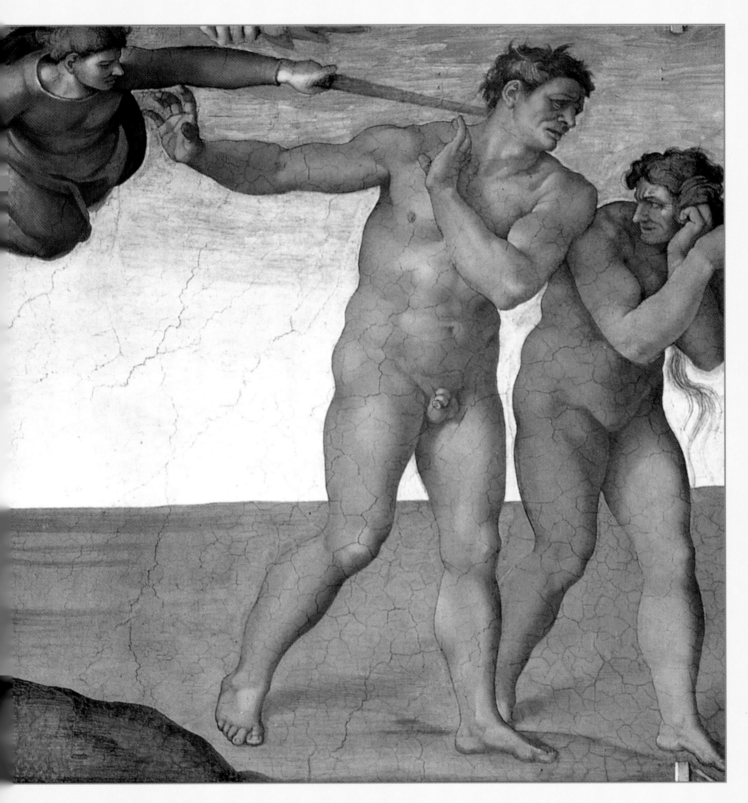

*53 Michelangelo, Original Sin and the Fall: detail
from the ceiling of the Sistine Chapel,
1508-12,
Fresco, 280 x 570 cm
Vatican Museums, Rome*

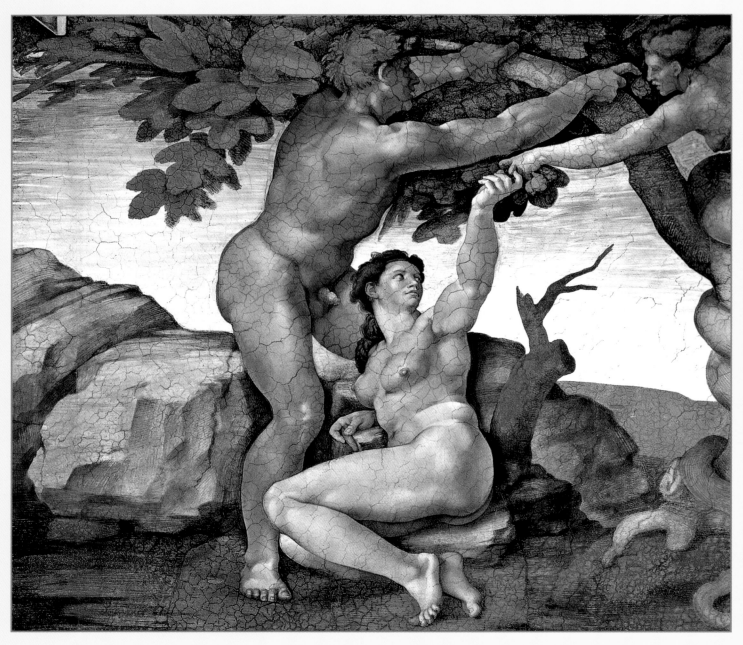

53a detail

53a detail

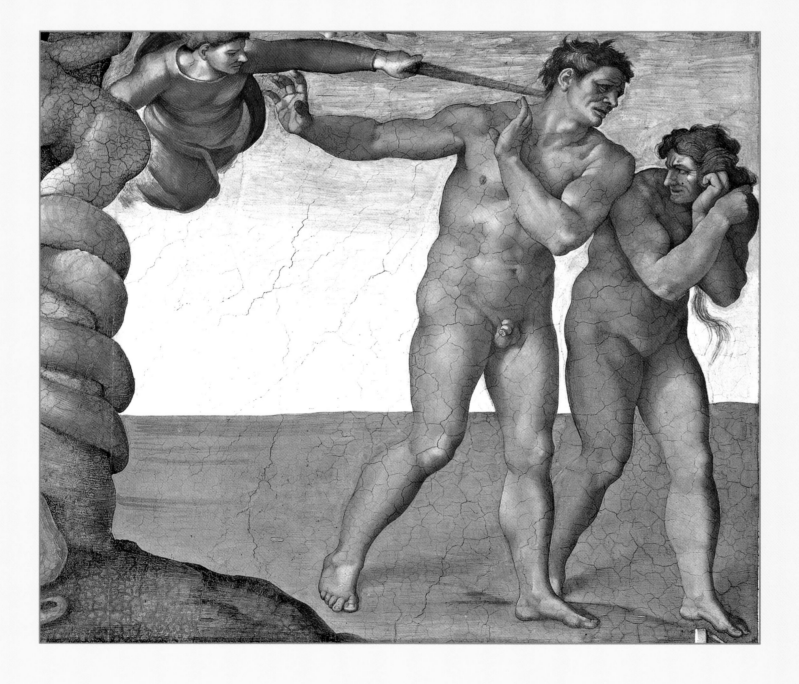

53b detail

ceiling in which the serpent, as in the wood-cut, is all too plainly a woman (fig. 53). In this way 'woman' is doubly responsible for the Fall: firstly for allowing herself to be seduced, and secondly for bringling the powers of seduction to bear on her partner.

The Lady and desire

The Church was run by male functionaries who, because they had ostensibly to be celibate, were in fact even more obsessed with sex than was the lay world. This affected their relations with women in two ways, neither of

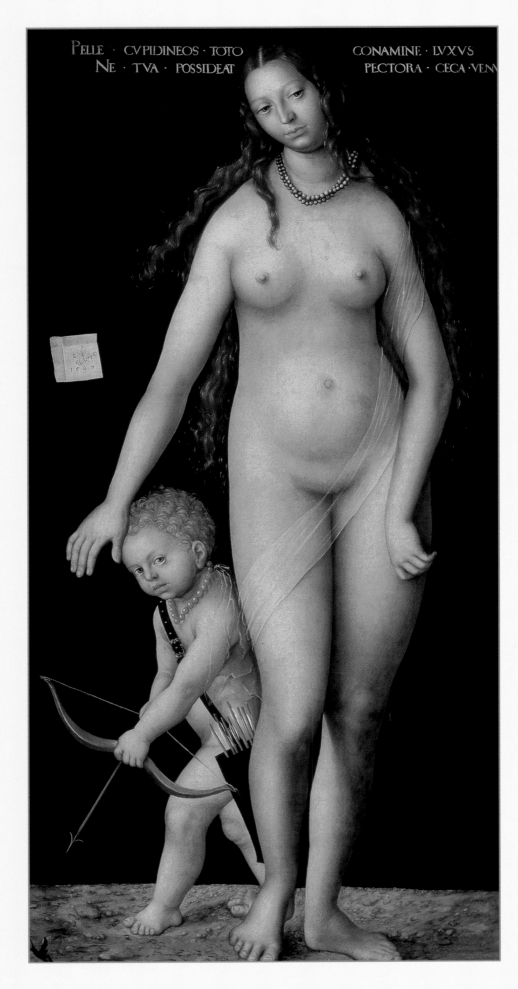

PELLE · CVPIDINEOS · TOTO CONAMINE · LVXVS
NE · TVA · POSSIDEAT PECTORA · CECA · VEN

54 Lucas Cranach the
Elder, Venus and
Cupid. 1509,
Oil on canvas (over
wood), 170 x 84 cm
The Hermitage,
St. Petersburg

them constructive. For them to see women at all reminded them that for them women were the forbidden fruit; and for others to be allowed to partake of the fruit forbidden them inspired them not only to set tight restrictions on what they termed then to be

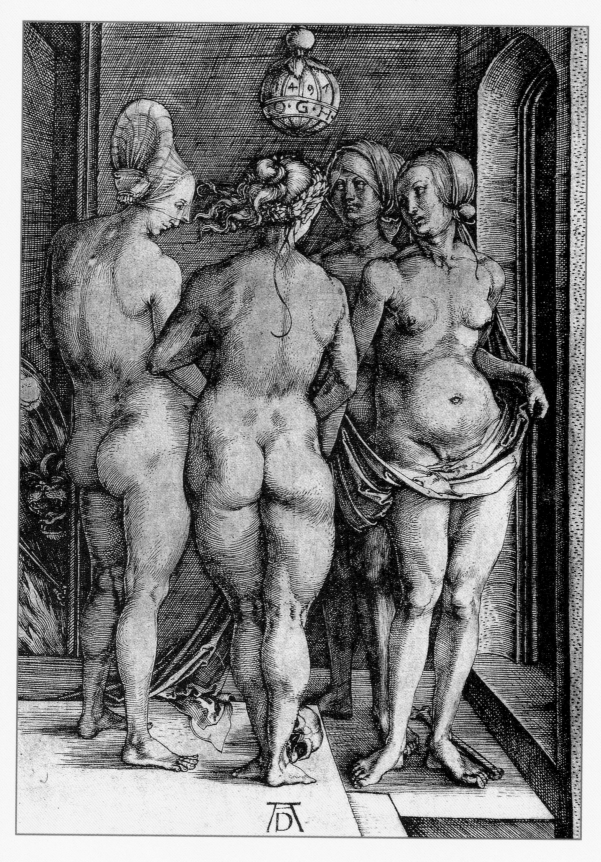

55 Albrecht Dürer,
Four Naked Women,
1497
Engraving
19 x 13.1 cm
Staatliche Museen
Preussischer
Kultturbesitz,Kupfer-
stichkabinett, Berlin

'morality', but to inflict penalties on those who did not conform and who therefore automatically committed sin. In this way, simply by existing, women could be held to be the cause of many of the sins committed in the world, and specifically those of lust but to a lesser extent also those of covetousness and avarice.

And although the burgeoning Renaissance gradually dispelled such notions of the 'evils' that women brought into the world – chiefly by

56-60
Martin Schongauer,
The Five Wise Virgins.
Late XVIth century
Engraving,
12.1 x 8.3 cm
Bibliothèque
Nationale, Paris.

representing the old Roman goddess Venus as Love in her more positive aspects, or at least as if she was restraining Desire in the form of the boy Cupid (fig. 54) – the fact remains that the more characteristic depictions of women of the time are those connected with sinful sexuality. It would seem, for example, that the diabolical nature of female nudity – nuditas criminalis, nudity with intent to arouse – is the subject of Albrecht Dürer's *Four Naked Women* (fig. 55) and other contemporary prints of his such as *Witch Riding Backwards on a*

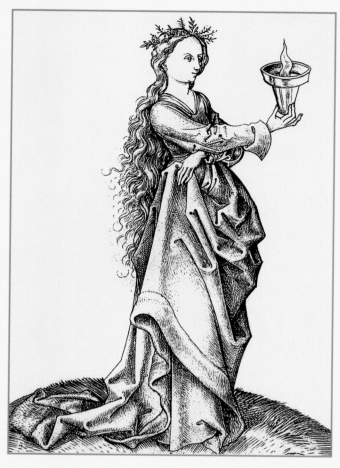

Goat. The works of Hans Baldung Grien – who may in fact have been taught by Dürer – tend similarly towards erotic allegories involving naked women. Likewise, a linked couple of paintings from the studio of Hans Memlinc (or Memling) show Vanity and Prudence. Prudence has her foot on the head of the serpent Lust; Vanity gazes at herself in a mirror, brushing back her hair to see herself better, only to be confronted by the reflections too of Middle-Age and Death who are standing close behind her. This was very much the continuation of a convention that was commonplace before the Renaissance – a convention that portrayed women as vain and weak, unreliable and lacking in moral fibre, occasionally even predatory in their appetites such as to lead innocent men hopelessly astray. Even the fully clothed and comparatively chaste looking ladies in the late fifteenth-century engravings by Martin Schongauer, intended to represent the five wise virgins as opposed to the five foolish virgins in the New Testament parable, actually support this convention by including somewhat frivolous details

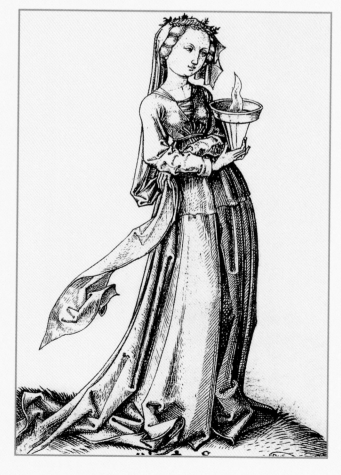

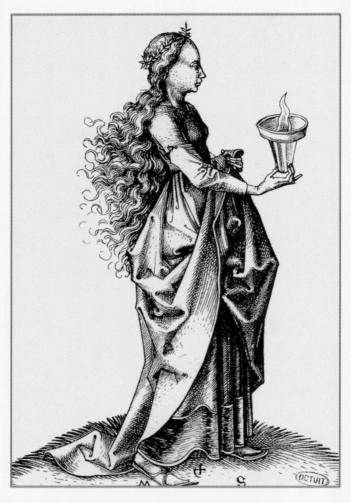

(fig. 56-60). But just as Venus was taking on a role of seemly propriety, the Catholic Church – not without some irony – was also promoting as its ideal of virtue the Virgin Mary herself. Of course she could hardly be said to be a real woman in that all kinds of divine qualities were being ascribed to her, and indeed she was in the process of becoming a Venus-figure corresponding to an impossibly perfect combination of all that might be the best in a woman, but in a sexless sort of way. To present an equally scriptural balance for this, religious authorities (and artists) could point to the scriptural equivalent of her obverse aspect, Mary Magdalene (fig. 61-62), by tradition an ex-harlot.

Lust, then, featured as one of the deadliest of sins to the mediaeval Church, a vice frequently portrayed as a naked woman lending her genitalia and breasts to the uses and abuses of her familiars in the form of snakes and toads – an image actually corresponding to the much earlier folklore surrounding the Earth Mother, especially as depicted in Roman times when Tellus Mater (the Earth mother, or Mother Earth) was ordinarily shown in company with such wild creatures. With the onset of the Renaissance, however, and with the consequent incorporation of rather more classical mythology into Christian iconography, lust was transformed into passion or desire, which could be both good and bad, righteous and evil. The good

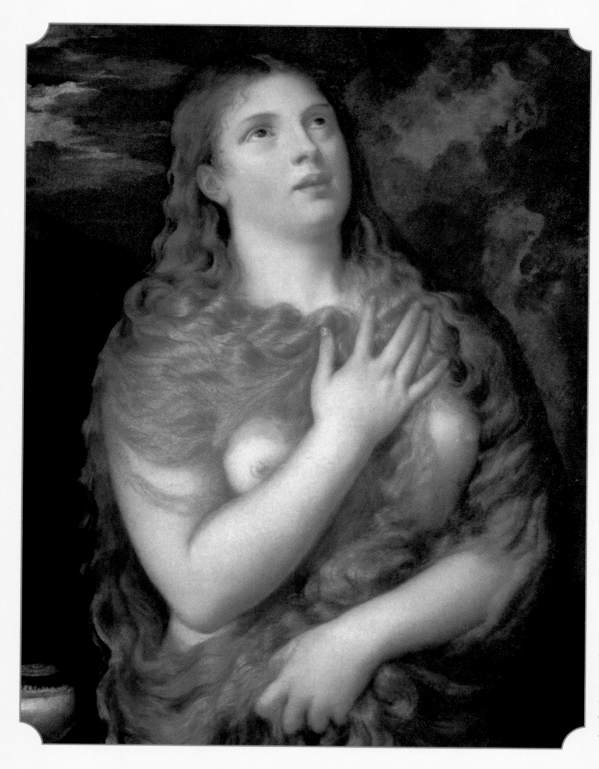

*61 Tiziano Vecello, said
Titian, Mary Magdalene,
1533-1535.
Oil on wood, 84 x 69 cm
Galleria di Palazzo Pitti,
Florence.*

aspect was intellectual love, the chaste yearning simply to be
with the adored one. And even the bad aspect, the heat of
desire, could be presented in classical guise as Voluptas,
sensuous pleasure, an aspect of Luxury and therefore not
entirely unacceptable under the new Renaissance moral
dispensation.

In this way Sandro Botticelli's famous *Birth of Venus*

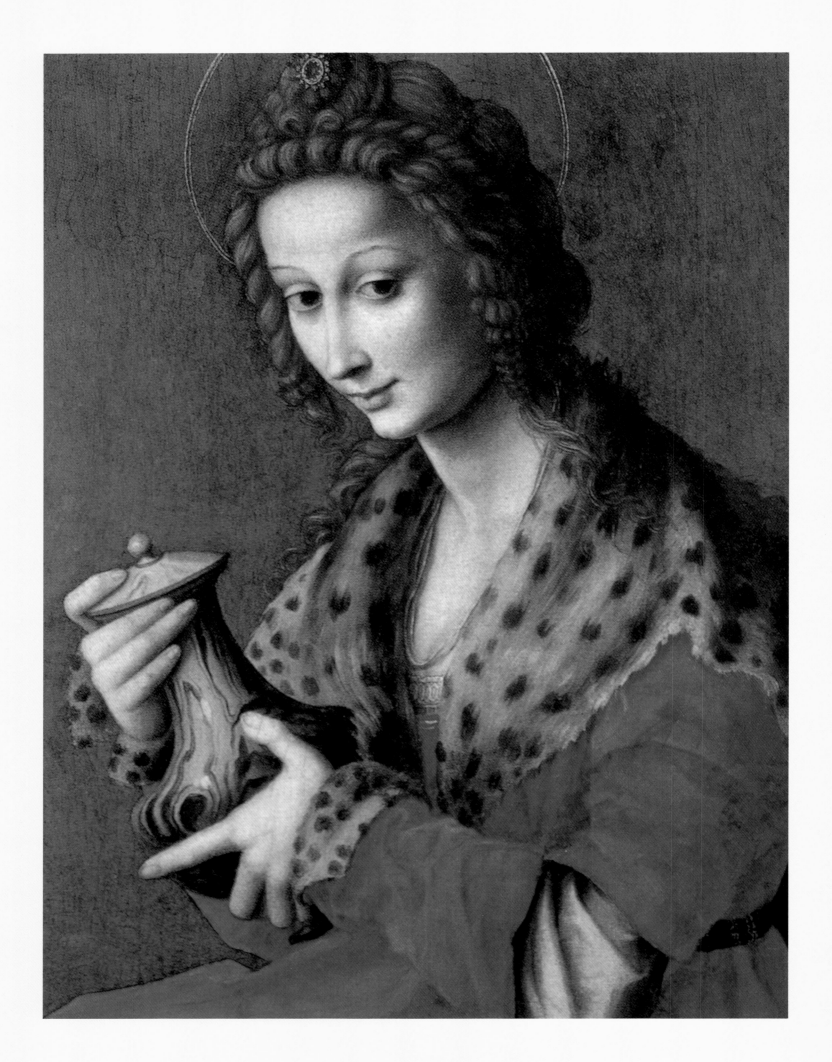

(fig. 63) is not only a representation of a plainly un-demonic
goddess born from the cleansing foam of the sea but an
idealised non-erotic being without shame. The Council of Trent
a century later was pretty well to prohibit the use of nudity in

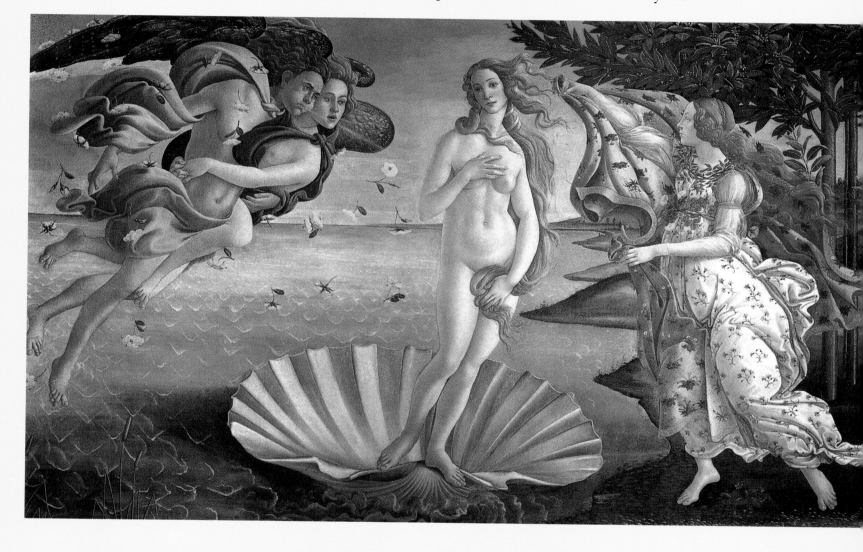

painting. But until that, during the fifteenth century Venus is
frequently represented nude – as in Lucas Cranach the Elder's
wonderfully human wood-cut *Venus and Cupid* of 1509
(fig. 64). These figures have almost the superbly self-confident
serenity of Giorgione's *Sleeping Venus* of the same date (now in
the Gemäldegalerie, Dresden). Here is the Universal Woman at
peace with herself and with her body: this is what the
mediaeval world knew as nuditas naturalis – nudity as a way of
expressing the purity of ideal Love.

But of course the more earthy side of love and desire
remained evident in life and in the art of the time. *The*

*62 Francesco
Verdi, known as
Bachiacca,
Mary Magdalene,
ca. 1530
Oil on wood,
51 x 42 cm
Galleria di
Palazzo Pitti,
Florence.*

*63 Sandro Botticelli,
The Birth of Venus
ca. 1484
Tempera on canvas,
172.5 x 278.5.
Galleria degli Uffizi,
Florence.*

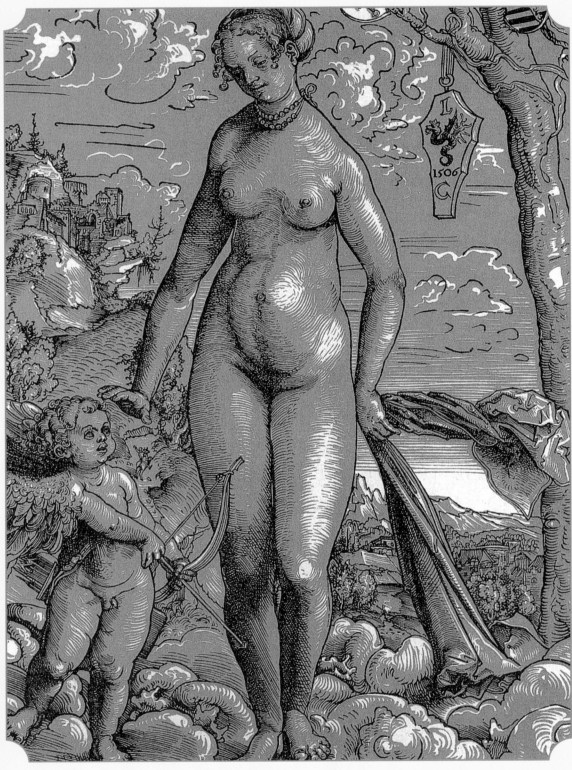

64 Lucas Cranach the Elder, Venus and Cupid, 1509. Two-colour Woodcut. 27.7 x 18.9 cm Staatliche Museen Preussischer Kulturbesitzitz, Kupferstichkabinett, Berlin

Housebook – a German manuscript of around 1475-85, which contains recipes for aphrodisiacs, among other novelties – features a coloured drawing of a castle-like building in an odd mixture of architectural styles (fig. 65). Women call to passers-by from two windows. In the distance a peasant is hanging upside down, one foot in a sort of rope-trap slung from

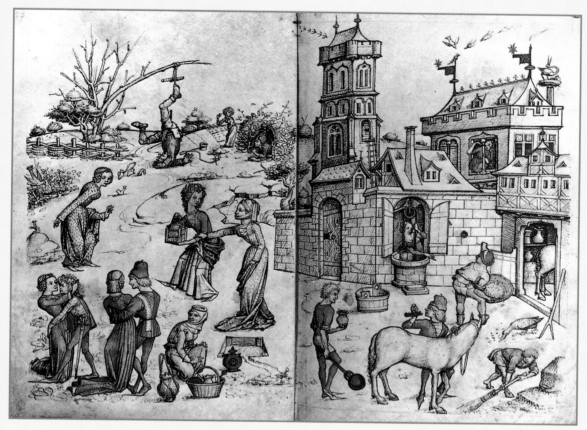

65 A Castle of
Unbridled Female
Desire, from The
Housebook,
ca. 1475-85.
fol 23v-24r
Fürstlich
Leinningensche
Sammlungen
Heimatsmuseum,
Wolfegg.

an overhead branch of a tree.
Couples engage in dalliance.
Elegantly dressed, though
peculiarly angular, ladies walk
and take the air, one with her
jewel-box. In the foreground
men who might be ostlers or
stable-lads groom a horse and
sweep the stableyard. One
commentator has suggested
that the scene represents the
overturning of those symbols
of social security of previous
centuries: we therefore see the
back of the palatial building,
not the front; the traditional
fountain, gushing water, has
become a well (from behind
which a harlot beckons to one

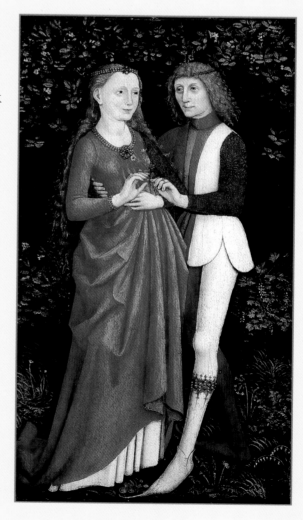

66 Unknown artist,
A Young Couple.
Germany, ca. 1470.
Oil on wood,
62.2 x 36.5 cm
Delia and L.E.
Holden Funds,
The Cleveland
Museum of Art,
Cleveland.

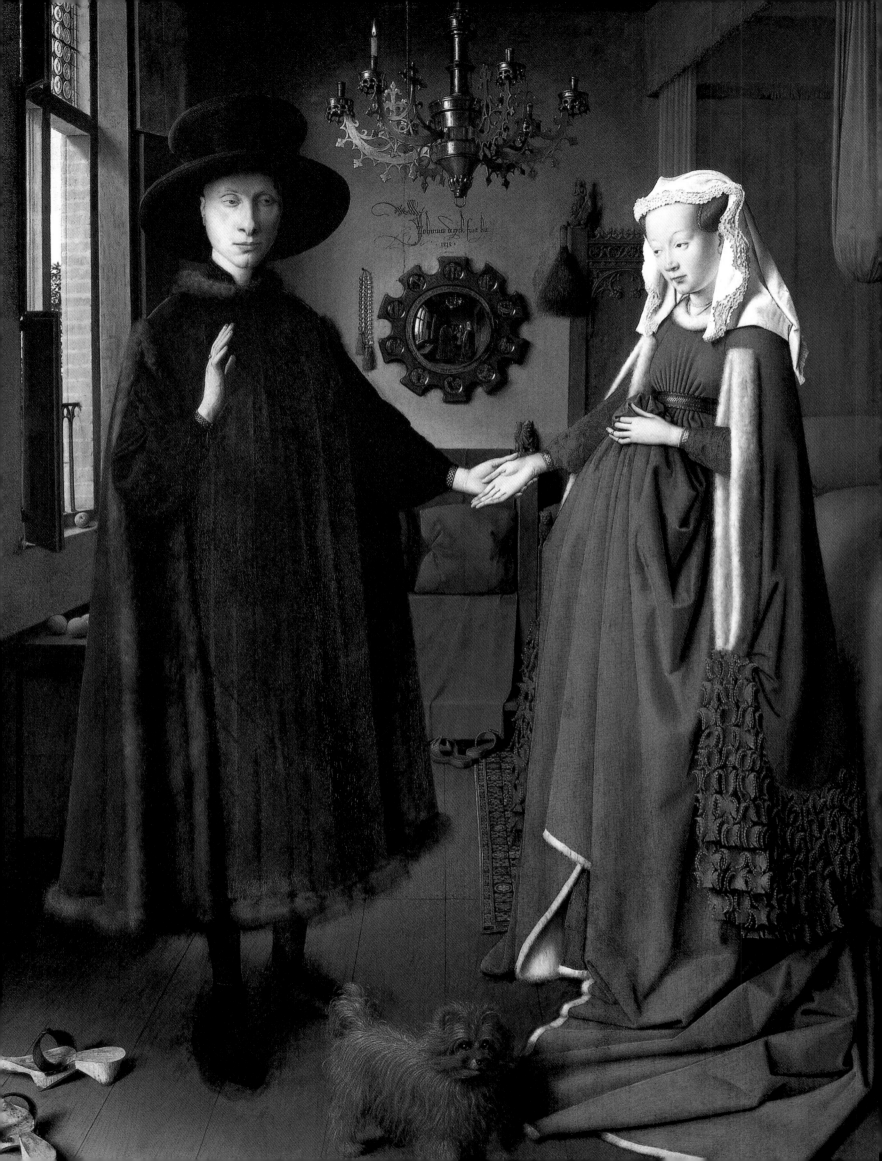

of the ostlers); the formal garden has turned into no more than a very simple setting for the tree from which the peasant now hangs upside down – it is a topsy-turvy world, in which women freed from the restraints of courtly life have as much licence as they wish and can associate with noble and servant alike on their own (potentially intimate) terms. Whether or not this interpretation of the picture is correct – and whether the title given it actually corresponds to what the artist had in mind – the artist is generally assumed to have been a man, and to have intended to indicate the sort of things women might get up to if they were allowed full emancipation. Yet the picture might in fact be no more than a slightly exaggerated commentary on contemporary life and customs. Whatever is the truth of the matter, the whole thing fits neatly with the aphrodisiac recipes it accompanies in the text.

67 detail

𝕿𝖍𝖊 𝕷𝖆𝖉𝖞 𝖔𝖋 𝕷𝖔𝖛𝖊

In those somewhat grim mediaeval times, marriage – which the Church was still in the process of formalizing as one of its own institutions – was controlled mostly by parents. At least in the upper two thirds of social levels, parents decided on a girl's wedding partner and arranged the whole business. Even once the ceremony had been solemnized, the bride (together with her belongings) was no more than a possession of her husband, subject to his word.

Yet people still fell in love. There are some charming illustrations of this. In one drypoint of around 1485, a pair of lovers sit together within a bower, holding hands, a flask of wine being kept cool in a tub beneath their feet. The girl clasps a small dog (as ever representing fidelity) on her lap.

67 Jan Van Eyck,
Arnolfini Wedding,
1434.
Oil on oak,
81.8 x 59.7 cm.
National Gallery,
London.

Similarly, in the German painting known as *A Young Couple*
(fig. 66) of perhaps fifteen years earlier, the two stand tenderly
together, evidently much attached – and she is shown in
virtually the same stance and the same costume as Giovanni
Arnolfini's bride in what has come to be called *The Arnolfini
Wedding* (fig. 67), by Jan van Eyck a generation earlier still.
Dating from somewhere in between the last two, the engraving
of *The Lovers* (fig. 68) by 'Master E.S.' shows that love (and
desire, in that the two are depicted in what today might be
described as the throes of amorous foreplay) played a part in at
least some betrothals and marriages. And we should not forget,
either, that notwithstanding the Church's lowering frowns upon
such things, one of the great literary works of the previous
century was *The Decameron* by Boccacio – in which people fell

*68 Master E.S.,
Pair of Lovers on a
bench of grass,
ca. 1460
Engraving (L.211),
13.4 x 16.4 cm
Albertina, Vienna.*

in love with each other willy-nilly, husbands were cuckolded, wives were deceived, daughters exhausted their swains, and sons sowed wild, impassioned oats. Lovers and love found a way, just as they always have done.

Courtly love

One interesting and particularly mediaeval variation on the theme was the strange, possibly even unnatural, theme of courtly love. Courtly love was the idealistic, unconsummated devotion of a 'lover' for his 'mistress' – a devotion that was generally also unrequited and didn't really require requital. The course of such a love was ritualised; its 'rules' were celebrated by their observation through difficult circumstances and against hopeless odds. It was a love that involved profound emotions for the most part never expressed directly, and that was therefore idealised to the point of being almost entirely intellectual. These days we might even consider that there was something perverse about it. Nonetheless, the theme of courtly love has since rung a loud bell through the centuries: it provided a wealth of stories and ideas for the contemporary troubadours but it went on featuring in the narratives of many authors thereafter, in some aspects to the present day. And of course, from the very beginning there were variants on the same theme designed to bring the emotional elements even more to the fore. Early examples include the *Tale of Tristan and Yseult* (Isolde), a tragedy that has everything anybody could wish for in terms of inner torments, suspense, and things going horribly wrong, and of course the better-known fable of *Sir Knight of King Arthur's Round Table* (fig. 69), and Queen Guinevere. Both stories demonstrate the disastrous consequences of the ideal courtly love's being 'sullied' by physical consummation.

Mind you, in the context of mediaeval literature anything that is of clerical origin and that has to do with the subject of sex must be regarded with some particularity, not to say suspicion, over the very real possibility of an ulterior motive –

especially when the physical act of sex somehow gets written out of the plot. There are now doubts about whether courtly love ever genuinely existed outside the fantasies of the clergy and the romantic maunderings of poets and troubadours.

For all that, the 'rules' of courtly love were laid down quite definitively towards the end of the twelfth century by one Andreas Capellanus (André le Chapelain) in three volumes called *The Art of Love*. A priest in the service of the Countess Marie de Troyes (daughter of the great Eleanor of Aquitaine), Capellanus well understood the contemporary theory of love as a process, a sequence of events involving a progression of emotional inputs, each becoming the more heady and insistent as the sequence continued. In this way the process was said to comprise visus, alloquium, contactus, oscula and factum – mediaeval Latin meaning (with specific reference to love) catching sight of, talking to, touching, kissing, and making (i.e. having sexual relations with). Courtly love, however, had another agenda. In his lengthy treatise – the source of many similar works for centuries to come – Capellanus offered no fewer than 31 fundamental 'rules' of love, some of which were:

69 Bonifacio Bembo, The God of Love Shoots his Arrow into Lancelot's Tenderest Parts, from Historia di Lancilloto, Milan, 1446. Pen and ink drawing on parchment. Cod.pal.556, fol.58v. Biblioteca Nazionale, Florence.

...mt amer

...gedrugen / ...maden zangen

So ich mir me vol ge... / herz harm e mer

...meus fa... / ...ich ge... / hat dw

Gy bett / mem herz

Claffen ist mancher lay · Da von / brucht man herz en may

Ey sol inreblich liben / vst mmem herz gesol...

ich wil sy sa mit sich / lieste dy mein herz / hat mit demem / meffer versmten

...ich kan mach re mt verwegen · Die / mem herz role dwach segen ·

...rop mach lich re haben mangel die / ...mch hat / an anem angel

...olt ich smt...

...bil ach len...

hertz hat durch schossen mein hertz hat nider...

Er kan mich wol unter weisen
Dy mein hertz wiltn ainer trewsen

...mocht ich re...
hat mein hertz man... la fa...

Sigtyt mir freud und trost dy
mein hertz hat uff ainem rost

Der liefer munt hat mein
hertz ser verwunt

O findest du schloß in
auß und
mach ich
auß

sein Schloß
der pein und
in die arm dein

Ich wil ir stete trew loben dy
mein hertz hat in einem doben...

...SCHWER...

...em sein
...gut... der sein

♥ Love can deny nothing in the service of love.

♥ A lover should be worthy of love: love is attainable by everybody, but righteous behaviour and goodness of character make a man worthy of it.

♥ For the 'mistress' to be married to someone else is no bar to her being the object of one's love – but such love must be secret in order to protect her from scandal and to avoid giving pain to her husband.

♥ No one can truly love without being aware of how it influences oneself and others.

♥ A conquest achieved easily is of less value than one achieved by overcoming difficulties.

♥ Love constantly changes in intensity – but there is a minimum level below which love will die altogether.

♥ A true lover thinks only of his beloved, seeing the world simply in terms of how it might be made pleasing to her; in his perpetual concern for her he eats and sleeps little; his heart bounds at the sight of her; he turns pale in her presence. Yet there is a limit to such fervency: a man overwhelmed with care and concern inevitably neglects the true idealistic form of Love.

♥ A true lover is faithful to one love: a new love may be commenced only once the old love has been concluded.

♥ No one can have more than one object of his love – but the object of one man's love may also be the object of another man's, just as one man may in turn be the object of two women's love.

♥ A man should not love a woman to whom he would in normal circumstances be ashamed to propose marriage.

♥ Jealousy is all too easily aroused by the slightest of

70 (previous two pages) Master Caspar of Regensburg, Frau Minne's Power Over Men's Hearts, 1479. Woodcut Staatliche Museen Preussischer Kulturbesitz, Berlin.

this page: details of 70

suggestions and rumours – but although jealousy actually increases the sensation of being in love (by enhancing cares and concerns), the jealous man inevitably neglects the true idealistic form of Love.

❤ *Love declared publicly rarely lasts.*

❤ *Love is ever a stranger in the home of avarice.*

❤ *The lover delights in doing whatever he can for his beloved: he takes little or no pleasure in doing anything that is not specifically for his beloved.*

Like most sets of behavioural 'rules', those of Capellanus were based on a combination of his observation of the vagaries of human nature and his knowledge of the contemporary social proprieties. Lovers on the whole do indeed value faithfulness, for example. Jealousy that is allowed to become obsessive eventually turns love back on itself, so that love for another effectively becomes care and concern over the effect of that love on oneself – a self-deluding form of paranoia. And so on.

After all, the love-struck swain is a familiar figure in art and in literature from the time of the ancient Greeks to the present day, as indeed is the heart as a symbol of love (albeit in a highly stylized form in art). The wood-cut of Master Caspar of Regensburg entitled *Frau Minne's Power Over Men's Hearts*, which dates from 1479, accordingly depicts in somewhat unnecessarily gruesome detail the torturing of nearly a score of hearts (fig. 70). Hearts are impaled, shot through, sawn in half, set alight, put to the sword, subjected to thumbscrews, and worse. And all this to give expression to the 'exquisite agonies' we suffer when we fall under the spell of the Goddess of Love – who in this case is her peculiarly German manifestation, Frau Minne.

But from a modern viewpoint, Capellanus's 'rules' – which of course derive from an age in which adultery was both unlawful and sacrilegious – still contain some surprises. We might think it extraordinary that he suggests that being married is no bar to being loved by somebody other than one's spouse, that love which is declared publicly rarely stands the test of time, and that everybody (without exception) can achieve love. The first of these is not at all to be understood as a proposal by a wearily wordly cleric in favour of total promiscuity: it is in fact a statement that is less about a lover and his loving than about being the object of love, and the object possibly of undeclared love at that. In addition, it is a statement to the effect that within a society dominated by arranged marriages love might transcend the conventions. The second suggestion partly reflects the same situation. In an arranged marriage – and following a wedding ceremony at which love had publicly to be declared – love might grow and flourish . . . but in Capellanus's experience it generally didn't. At the same time, and on a far more subtle level, the statement cleverly points out that a love that remains undeclared publicly, undeclared perhaps even to its object, tends not to change or fade for as long as its goal remains elusive within an idealized fantasy. Finally, the suggestion that everybody can achieve love is not intended to imply that everybody should be in love with one other person at all times. Nor does it mean (as one commentator has proposed) that everyone 'has a right to love'. Instead, it makes quite clear that it is possible for everybody individually to be the object of love, and with the suitable application of effort to be worthy of that love. Again at a different level, it is the voice of the cleric Capellanus pronouncing the spiritual truth that God's love is available to all who deserve it and strive for it.

That love might be considered at two different levels in such a way is not far removed from the neo-Platonist views expressed by the fifteenth-century Florentine philosopher Marsilio Ficino. He suggested that the God of Love was the

71 The Unicorn's beloved, Marietta,
about to place a chained collar around
its neck,
Italian (Florence) about 1465 - 80
Engraving, British Museum, London.

eldest and the Supreme Deity, pervading the universe with his
power – and that this power had two aspects: the sacred and
the profane, the spiritual and the sensual, the idealistically
contemplative and the intuitively dynamic.

Such notions duly appeared in the art of the time. We have already noted that Lucas Cranach was able to produce a Venus that was both naked and unerotic (the 1509 oil on canvas currently in The Hermitage, St Petersburg): this is the

'spiritual' ideal. The other side of the coin may be said to be represented (for example) by Francesco del Cossa's *Triumph of Venus*. Here the three Graces disport themselves naked on a cliff-top above a coastline rich in the symbols of sex and reproduction, particularly featuring rocks and recesses of suggestive shapes, and pools around which rabbits run freely. In the foreground a group of boys and girls, some of them with musical instruments, partly ignore, partly watch a kneeling couple who are getting down to some serious petting (notwithstanding her ineffectual attempts to stay his wandering hands). The whole picture is vibrant with sexual tension.

There may have been a clear distinction between sacred and profane love, between spiritual and sensual love, but it was a distinction sometimes observed more in theory (and in literature and art – Lucas Cranach actually painted two opposing pictures, one of *The Chaste Venus*, the other of *The Sensual Venus*) than in practice. The result, as of course was also represented in the art of the time, was that images that really belonged to profane Love became blurred with images of sacred Love, and vice versa. In many of the representations of the Lady and the unicorn, for example – some of which attribute clearly phallic symbolism to the unicorn – it is remarkable how similar the pose of the unicorn in the lap of the Lady is to the position of Christ in either the traditional Virgin and Child or the traditional pietà. Such a comparison can surely be made in relation to the devotional intensity depicted between Lady and unicorn in the Florentine engraving of around the 1470s (fig. 71) – in which the Lady is furtively seeking to put a collar and chain on the ecstatically reclining unicorn – and that between Virgin and Child in the engraving by Andrea Mantegna (fig. 72) a decade and a half later.

The Lady of chastity

There was originally nothing particularly pure or chaste about the unicorn. On the contrary, symbolism associated it with fairly crude sexual meaning. But once the unicorn had

been linked definitively with the Lady, it took on many aspects of the Lady's purity and chastity – and so much so that the unicorn came not only to signify the presence of Chastity personified but to be shown as itself purifying streams and rivulets by placing its horn in the water.

Chastity, it must be remembered, was one of the Christian virtues. Indeed, in a male-dominated society chastity might well have been considered the most important virtue in a woman. It was certainly a virtue continually lauded by the mediaeval (male) priesthood, who of course were themselves under strict vows of celibacy. But celibacy, temporary or permanent, in the human experience is almost always a matter of faith or of faithfulness. And an excellent example of this takes us right back to the time of Homer. He described the steadfast Penelope, who waited patiently for 20 years for the return of her husband Odysseus, sure that he would turn up again eventually, and in the meanwhile putting off the many suitors to her hand by saying that she would consider remarriage only when she finished her weaving – and undoing what she'd woven every day during the succeeding hours of darkness. Penelope, with an unusual hairstyle resembling that of some of the Lady of the Cluny tapestries, is one of *The Women of Virtue* featured at her loom in a series of (probably) Flemish tapestries of the early 1480s (fig. 73).

Historically more recently, the first two sections of Petrarch's popular mid-fourteenth-century allegorical text Trionfi were about the Triumphs of love and chastity – matters of which Petrarch himself had some experience, for he was the 'lover' from afar of a 'mistress' named Laura who may or may not have known of his adoration (and indeed who may or may not actually have existed in real life, although the consensus of scholarly commentary is that she did). The Trionfi were widely published and frequently used by contemporary artists as inspiration for pictorial representation. Standard illustrations of Chastity depicted her driving her triumphal chariot drawn not by horses but by unicorns, in some cases also showing

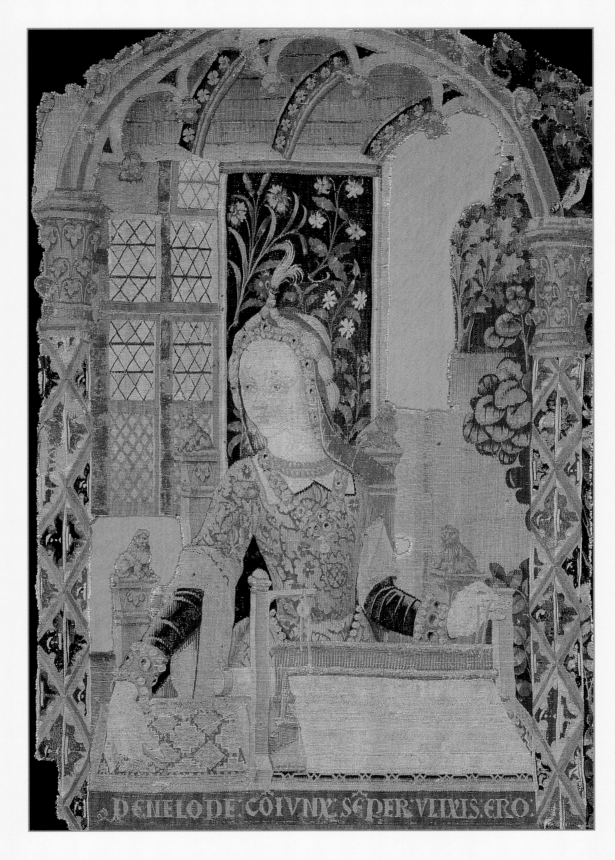

73 Penelope at her Loom: tapestry from The Virtuous Women series, 1480-83. Wool, 155 x 101 cm Museum of Fine Arts, Boston.

other unicorns dipping their horns in streams, so emphasizing still further the imagery symbolic of purity. Piero della Francesca made use of this same subject – a chariot drawn by unicorns – to suggest the chaste character of his sitter, the

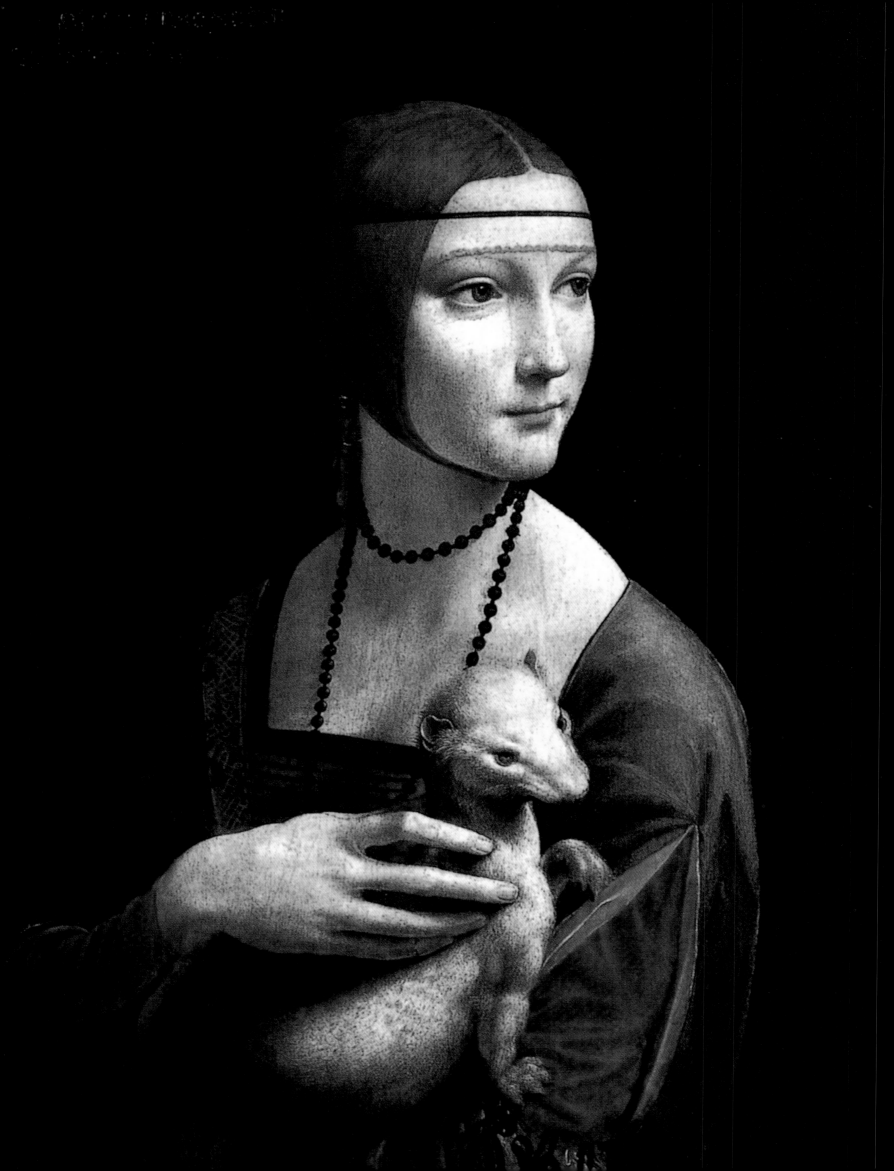

Duchess of Urbino, in 1465.

An equivalent of the unicorn in this respect is the north European stoat or ermine (as the animal can also be called, in addition to its white winter pelt decorated with its black tail-tip). Purity of motives is the symbolic reason that the robes of British judges are even today trimmed with ermine (or a synthetic replica). Leonardo da Vinci used this symbolism in the portrait he painted in around 1484 of *Cecilia Gallerani* (fig. 74), in which the lady holds the live animal on her lap. Like the unicorn, the colour of the ermine – white – was instrumental in its symbolizing chastity and purity, although it had the reputation too of preferring death to dishonour. As such a symbol, the ermine is to be seen in several of the Lady and the Unicorn tableaux, appearing more or less interchangeably with the dog that represents fidelity and loyalty.

74 Leonardo da Vinci,
Lady with an Ermine
(Cecilia Gallerani),
ca. 1484.
Oil on wood, 54 x 40 cm
Narodowe Museum, Cracow, Poland.

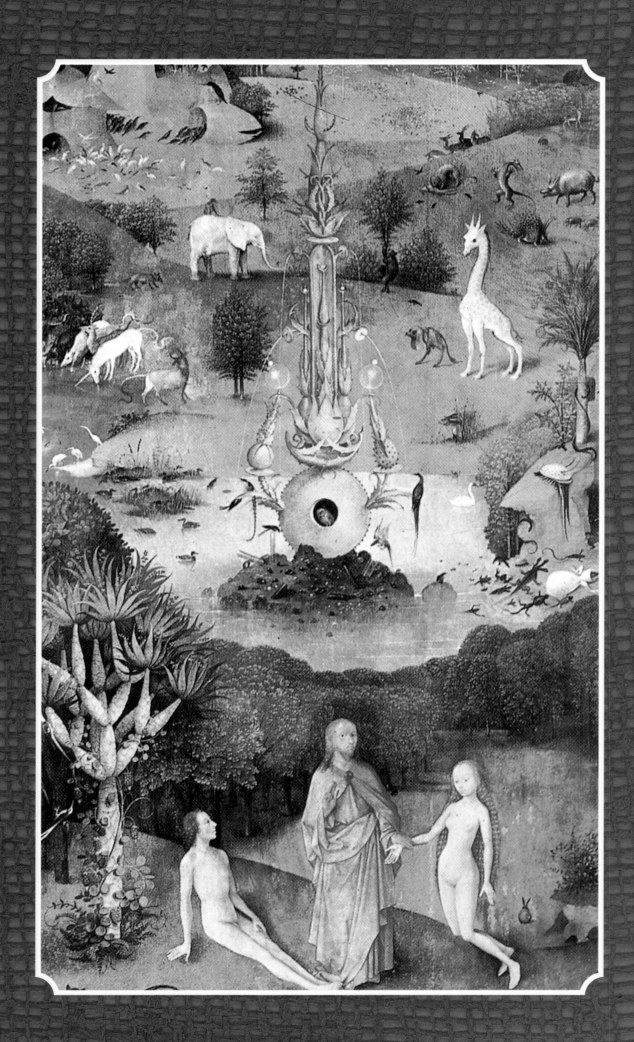

The Tradition of The Unicorn

Among all the fabulous beasts, the unicorn has just as long and persistent a history as the equally mythical dragon. That might well have something to do with the fact that, given the astonishing diversity in form of the animal world, unicorns are no more unlikely as creatures than many that do exist – and a great deal likelier than, say, the giraffe or the kangaroo. Notionally or otherwise, unicorns remain immensely popular today, as a quick search on the World-Wide Web testifies. The use of unicorns in a symbolic way was nonetheless effectively banned by the Council of Trent in the middle of the sixteenth century as part of the Catholic Church's general prohibition on 'immodest' and innovative subjects in art.

The unicorn's history transcends such more human restrictions. For example, a kind of bull unicorn is found in Assyrian art. The more horse-like animal appears first in early Greek texts. Ctesias of Cnidus, the Greek doctor at the ancient Persian court of Ataxerxes II in the fifth century BC, in his writings describes the wild ass of India as a beast the size of a horse, with a white body, red head, dark blue

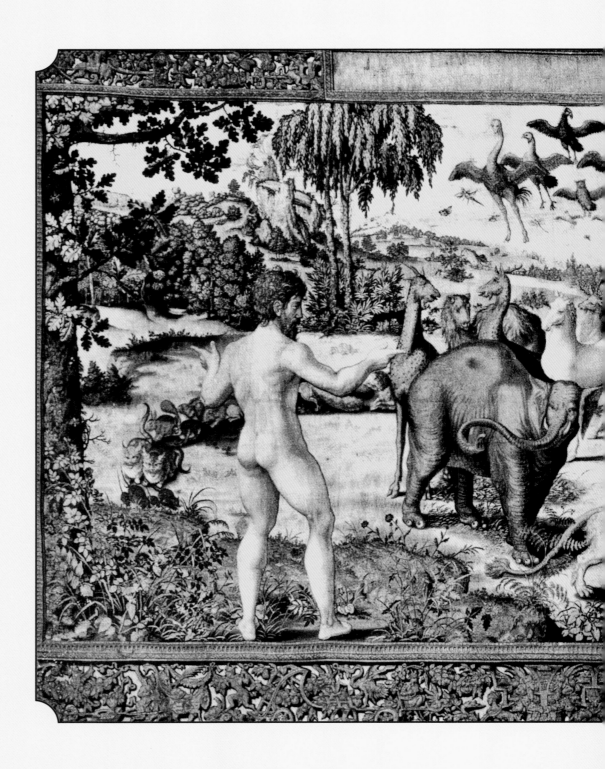

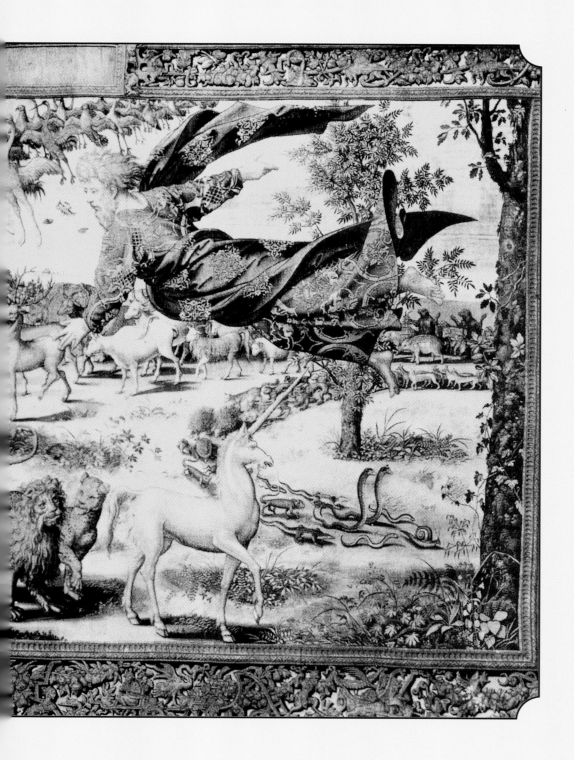

75 *The Creation: God Gives Adam Supremacy Over the Animals,*
Brussels, ca. 1540-50.
Tapestry, 465 x 790 cm
Galleria dell' Accademia, Florence.

76 Miniature painting in a
Xth century Manuscript of the Physiologus.
Bibliothèque Royale Albert I,
Brussels.

77 Hans Holbein the Younger,
Project for stained-glass with two unicorns
ca. 1522-23
Watercolours, 41.9 x 31.5 cm
Öffentliche Kunstsammlung, Kupferstichkabinett
Basle

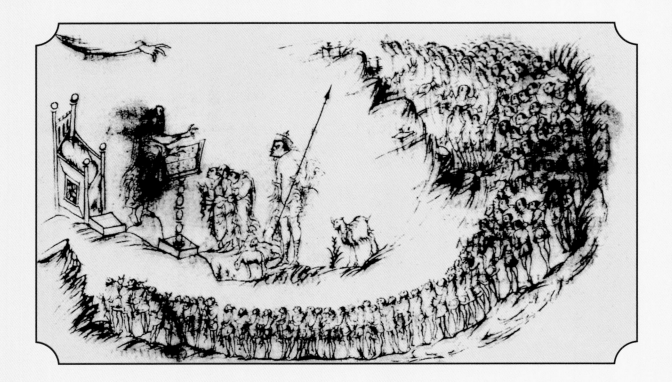

eyes and a half-metre-long (near 20-inch) horn on its forehead. The horn, said Ctesias, is white at its base, black half-way up, and red at the tip, and the animal itself is extremely fleet of foot, untameable, and very difficult to catch. Herodotus writing in the third century BC, mentions a 'horned ass of Africa', although this probably represents a second-hand report of a rhinoceros. Aristotle talks of several one-horned unicorn-like beasts. A bit later, no less an authority than Julius Caesar in The Gallic War writes about a beast with a single straight horn in its forehead that lives in the forests of Germany. His fellow-Roman, Pliny the Elder a generation or so afterwards similarly tells in his *Historia Naturalis of the Monoceros*, a ferocious beast with the body of a horse, the head of a deer, the tail of a wild boar, a single black horn two cubits long on its forehead – and, bizarrely, the feet of an elephant. Aelian, a Roman author of the third century AD, in a work entitled *On the Characteristics of Animals*, gives a description of a horse-like unicorn with reddish hair which combines both ferocity and gentleness in its nature. In other cultural contexts, one of the hymns ascribed to Siddharta Gautama, the Buddha, directs that followers should 'Like me, like a unicorn, in solitude roam'. And in the Judaeo-Christian Bible, references in the books of

78 Miniature in a Psalter from Utrecht, IXth century, Ms. 484, fol. 45r, Library of the Rijksuniversiteit, Utrecht

Psalms, Numbers and Job treat the unicorn as a real beast. Chinese classical literature alludes to a number of kinds of unicorn, and the Japanese likewise had at least two varieties. Islamic texts depict the unicorn in equine or bovine form and sometimes with wings.

In the West, belief in the existence of the unicorn was reflected in illustrations in the illuminated Bibles and *Books of Hours* of the late mediaeval period. A mid-fifteenth-century Dutch Bible shows Adam together with Eve blessing the unicorn in the task of naming the animals (fig. 93). And in an early fourteenth-century psalter, the unicorn is on one page among the beasts waiting for Noah and his family to climb into

79 Miniature in the Sant Pere de Roda Bible.
Xth century.
Ms. lat. 6, vol. 3, folio 66v
Bibliothèque Nationale, Paris.

Et des merueilles ..

la force des tartars. Mais se mistrent a desconfiture et tournarent a suie. Et qut
les tartars les virent desconfis si leur aloient derriere chassant et occiant et abatant
si malement que ce estoit vne pitie a voir. Et quant il les oient vne piece dureies
si ne les vouloient plus suire mais retournerent arriere es bois pour prendre des
oliphans qui estoient la tous. Et leur couuenoit tailler les grans arbres
et mettre leur an tenant pour auoir les. Et aucuc tiroit out ce ne les pouoi
ent anoir: se ne feussent les hommes mesmes du roy qui auoient este pris en
la bataille qui mieux les sauoient congnoistre que les tartars. Et ainsi les
prenoient. car les oliphans sont bestes qui ont trop plus grant entendemet
que nulle autre beste et en pristrent plus de deux cens. Et de celle bataille en a
uant commenca le grant haan a auoir moult doliphans. Et en celle ma
niere su desconfist ce roy par le sens et par la maistrie des tartars. si comme
vous poues auoir entendu cy dessus.

Comment len descent grant valee.

Quant len se peut de ceste valee que ie vous ay compte adonc
treuue len vne grant descendue. Car sachies que len cheuauche
ij. iournees et demie toutes sois a derlin. Et en toute ceste desce
due na chose qui a compter face. sois seullement que il y a
vne grant place ou il tiennent aucune sois grant marche
car toutes les gens de ceste contree y viennent aucunes iours nommez. et tien
nent la leur marche trois iours la sepmaine. il changent or pour argent &
car il lont de lor asses. il donnent trois pois de sin or pour.v. pois dargent sin.
et pour ce y viennent marchans de plusieurs paries qui portent leur argent

*80 French manuscript
Ms Fr.2810, fol.59r
Bibliothèque
Nationale, Paris.*

Et des merueilles s

Cy dist de la contree courmary.

Courmary est vne contree dinde meismes de la quelle len puet
veoir de la petite isle de sanna en ca. Et quant len la vault ve
oir si va len bien .xxx. milles dedens la mer. et la voit on bien vn cou
te hault. il est moult sauuaige bien. et si y a bestes de toutes sacons et
proprement singes qui sont si deuisez que vous dires que ce sont hom
me. Et si ya aussi lyons lupars et ours assez. et si ya moult grans pa
lus. et grans pantains a merueilles. Autre chose ny a q a roster face. Si no
en partirons et vous coptarons dun autre royaume qui a nom chj.

Cy deuise du royaume de chj.

Chy est vn royaume vers ponent loing de courmary entour
.CCC. milles s sõt idolatrs et ont roy et ne sont tieu a mil
lui et sy ont langaige par eulx. En ceste prouince na nul
port mais il ya moult desluns qui ont moult de bons
vis et sont grans et parsons. Il y croist poiure et gin
genbre et autres espices et grant soison. leur roy est moult riche de tresor.
mais il nest mie moult puissant de gent-mais son regne est si sort que
nul. ny puet ostoier sur luy. sy que pour ce il ne doubte nullui. Et sachie
que se ce aucunst que aucune nefz venist en leurs ports et combist la.
sy la prennent et robent se elle vouloit aler autre part. Et leur dient vo
voules aler autre part et noz dieux vous a cy amenez a nous. Sy que p
deuons auoir tout le vostre et ny cuient auoir nul peche. Mais celles
viennent en leurs pays il le reconnent a bonneur et sont bien garde et

81 French manuscript
Ms. Fr 2810, fol.85
Bibliothèque
Nationale, Paris.

122

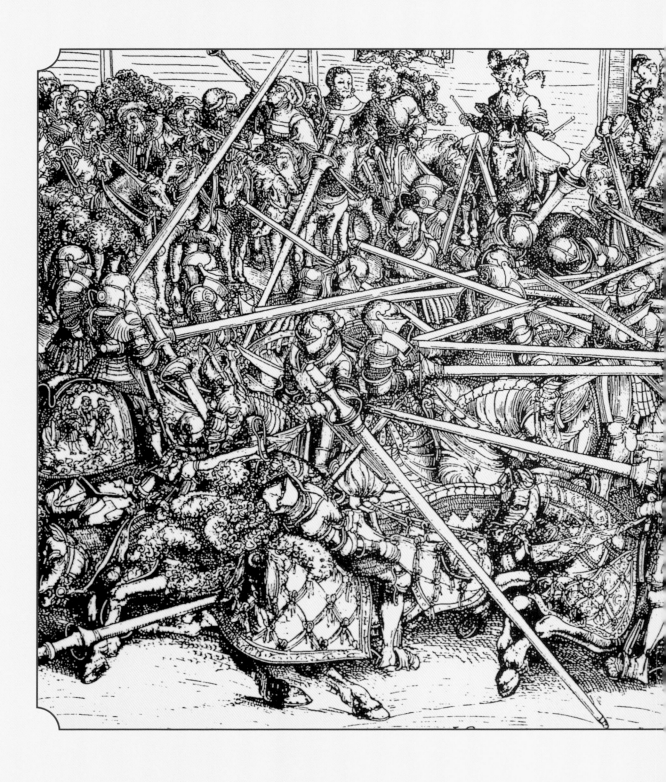

*82 Lucas Cranach
the Elder,
The Second Joust, Using the
Lance. 1509
Woodcut, 29.3 x 42.2 cm
Collection of the Veste
Coburg*

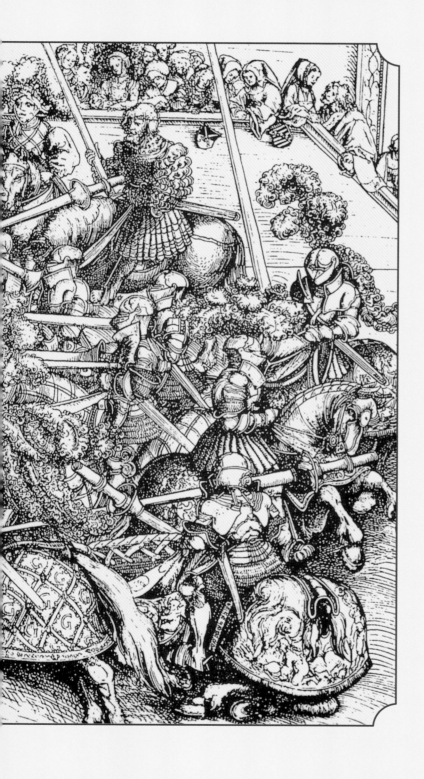

83 Master E.S.
Wild man on a
unicron with bird,
Vogel unter,
ca. 1450
Engraving,
13.1 x 8.7cm
Kupferstichkabinett,
Berlin-Dahlem.

the Ark (fig. 92), while on another page the unicorn is placed at the foot of the throne of God(fig. 91).

One particularly interesting point about such depictions is

84 Wild man on a unicorn, ca. 1475 Drypoint, unique impression, 9.2 x 8.4 cm Rijksprentenkabinet, Amsterdam.

that it proves people believed the unicorn to have existed right from the time of Creation. Designed 50 years after the Cluny wall-hangings, a large tapestry woven in Brussels and now at the Galleria dell'Accademia in Florence (fig. 75) depicts one

85. *Wild woman and
her children on a stag
Drypoint, unique
impression,
10.6 x 7.8 cm
Rijksprentenkabinet,
Amsterdam.*

tradition of the Eden legend. It shows Adam reviewing a parade
of pairs of animals over which God has just given him
supremacy and which are about to go forth and multiply.
Above, a long trail of pairs of birds stretches into the distance.
The first couple in the two-by-two procession on the ground is
the king of beasts, the lion, and his mate — but in front of them
and thus at the very head is a solitary, dainty unicorn. Here

*86 Lucas Cranach
the Elder,
Adam and Eve,
1509
Woodcut.
33.3 x 23 cm.*

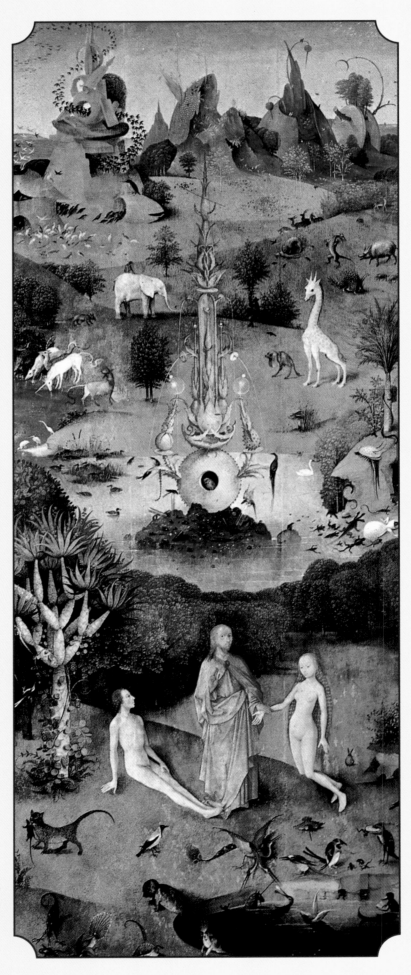

*87 Altarpiece by
Hieronymus Bosch
(detail, left panel).
Early XVIth century.
Museo del Prado, Madrid.*

the unicorn is goat-sized, much smaller than the horses several pairs of animals back. The naked Adam directs the animals on their journey as a mantled figure, presumably intended to represent an angel, flies straight over the unicorn's proud horn.

The unicorn was even more commonly to be found in mediaeval bestiaries. Now a bestiary was a sort of textbook of (Christian) moral principles in which each principle (and sometimes its

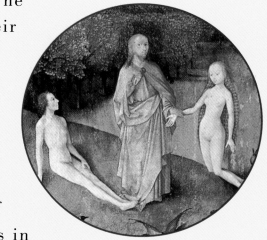

87 detail

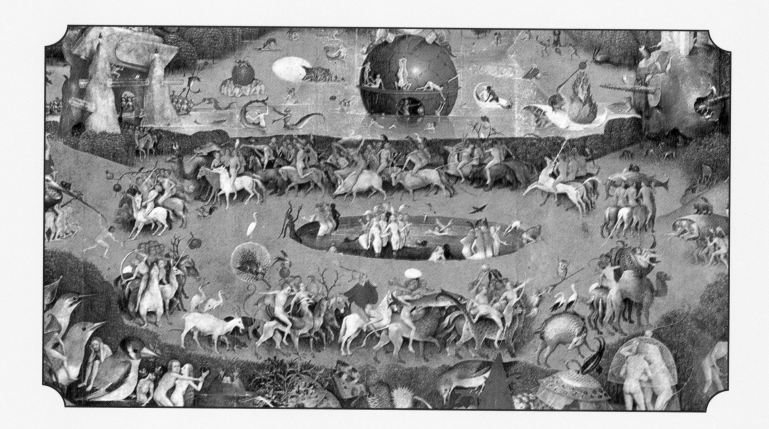

88 Hieronymus Bosch, The Garden of Earthly Delights (detail, central panel). Early XVIth century. Museo del Prado, Madrid.

opposite) was carefully related to a story about a particular animal; every bestiary contained as many improving tales as it could, and accordingly featured illustrations and descriptions of the animals referred to — some of which existed in folklore

89 detail

only. The first bestiary of this kind was produced as early as in the second century AD and is known as the *Physiologus* because the author ascribed much of the work's content to a 'naturalist' (Latin physiologus). It has been said that the Physiologus was probably as well known as the Bible by ordinary people of the Middle Ages. In a tenth-century version now in Brussels, the Virgin Mary draws the somewhat pug-like head of the unicorn towards where the king sits in his palace on his throne (fig. 76). A further scene below depicts the unicorn nuzzling Mary's hand on her lap while to the left, Christ urges his followers to 'learn from me, for I am meek and humble of heart'. Bestiaries based on such traditions were still being printed in the sixteenth century. They were used among other things as inspirations for carvings in mediaeval cathedral and church architecture, especially that of the order of the Cluniac monks who were prodigious builders. For example, a

meulx aduises et si remerchie
de voftre deliurance monseigneur
de bourbon et monseigneur de
coucy car ilz ont moult fort en
tendu pour vous. Et aussi la
conteffe de samt pol car la bon

ne dame sen eft moult grau
ment acquitte de vous aydier
Le seigneur de clary re
pondy en telle maniere et dift
grans mercis a messeigneurs
mais ie cuidoie auoir bien fait

Comment les souftes de samt
Insleuench furent emprises et
des faiz darmes par messire Re
tnault de wie messire bouch
cault le ieune et le seigneur de
samt py.

fut tresbel et bien estoffe legit.
Il auoit donne aux dames et a
damoiselles de ladicte ville de
montpellier furent recordees
et mises auant toutes ces piu
lees lesquelles ie vous ay recordee
et la cause pourquoy elles fur
la de nouueau recitees Ie le vo
duray. Tente eft que ie vo
ay commencie a purler de troi
vaillans cheualiers de france

E roy de france se
iournant en la bo
ne ville de mont
pellier en eflatement et reuua
ainsi comme il eft cy defue
contenu a pluet bancquet qui

*89 Froissart, Les chroniques de France
(The chronicles of France), XVth century
Biliothèque Nationale, Paris*

90 Miniature Bible
from Floreffe,
XIIth century
MS Add. 17738,
fol. 168
British Museum,
London

unicorn is among the beasts that illustrate the fifth day of Creation in the great architrave over the west door of the twelfth-century San Michele, Lucca, and there are two more in the early sixteenth-century coat of arms over a doorway from Montferrand.

For hundreds of years, then, bestiaries were very popular in the way animal books are today, regarded not so much as devotional works but as encyclopaedias of the strange and wonderful animals of the earth. Many of the animals illustrated were real. A considerable proportion, however, were utterly imaginary. These included the half-lizard half-bird basilisk whose look could kill; the centaur, half-man half-horse; and the water-dwelling hippocampus which had the front part of a horse but the tail of a dolphin. There were the mermaid and merman, the half-woman half-bird siren, and the manticora – a horse-sized beast which sported a human head on a lion's fore-body complete with mane, the wings of a dragon, the tail of a giant scorpion, three rows of metallic teeth, and which despite its flute-like voice had a ravenous appetite for human flesh. And on top of these there were those fabulous beasts which featured in heraldic symbolism, notably the phoenix, the griffin and the wyvern.

90 detail

90 detail

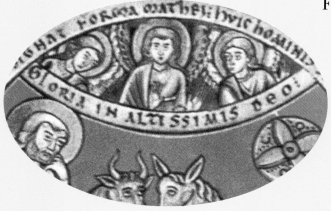

For unlettered peasants who probably never moved outside the clearing of their little village, these fabulous beasts because they were illustrated so clearly were entirely real. Many were equally taken for granted by educated people as well. Despite that sceptical late-

sixteenth-century passage in Shakespeare's *The Tempest,* 'Now I will believe that there are unicorns...', it is not difficult to appreciate how a mediaeval scholar could find beasts as strange as the camel, giraffe, salamander and crocodile perfectly credible and so be confident too that the amphivia, the fish which walked on land, and the yala ,which had the body of a lion, and the trunk, head and tusks of an elephant, were freely roaming in some distant forest. And the reality of the unicorn seemed to be confirmed by the existence in mediaeval times of a number of 'unicorn horns' fashioned into long cups and poniard-scabbards.

91 detail

The beast

Today we think of the unicorn as a horse-like beast, white in colour, a straight spiral horn in the middle of its forehead, sometimes a goatish beard, and often with cloven hoofs (although it is now known that animals with cloven hoofs always have skulls with a seam down the centre, making it impossible to accommodate a horn there). A noble beast, this is the unicorn of the tapestries. But for people in the mediaeval world the details were variable. As we have seen in the Cluny tapestry now entitled *Touch* (in Chapter 1), the unicorn did not have always to be the size of a horse. In fact its size ranged from that of a small goat to that of a large deer depending on the requirementss of whatever literary or religious metaphor was expressed. For example the unicorn of the *Physiologus* is normally goat-sized. In the *Utrecht Psalter* (fig. 78) the unicorn has a shaggy coat like a goat's, and a curving horn not unlike that of the beast in

91 Miniature in Queen Mary's Psalter, Early XIVth century, Royal MS 28vii, fols 2 British Museum, London

*92 Miniature in
Queen Mary's Psalter,
Early XIVth century,
Royal MS 28vii, fol. r6
British Museum,
London*

93 Dutch Bible,
Adam naming the animals,
Royal MS 38122 fol12
British Museum,
London

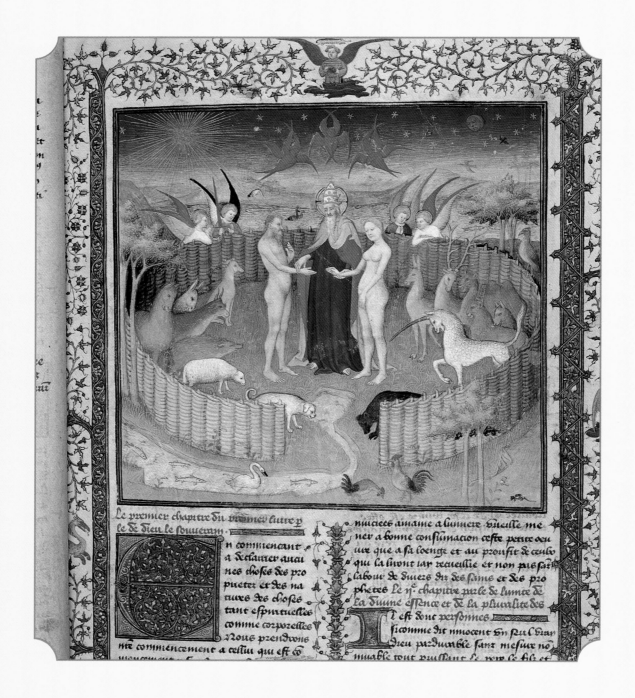

the tenth-century Sant Pere de Roda Bible (fig. 79). What we might think of as more conventional unicorns are to be found in early fifteenth-century books such as the Livre des Merveilles (fig. 80, 81), among illustrations of Marco Polo's travels. Yet a jewel-box (see fig. 3) of the same date bears a relief carving of a unicorn that is no greater or smaller than the dogs menacing it. In the early sixteenth-century *Book of Simples Medicines* by Matteus Platearius the unicorn is the size of a small sheep, small enough to rest on the Lady's lap – and at the same time purify the nearby stream with its horn.

94 Des Proprietez des Choses, detail : The marriage of Adam and Eve, ca. 1415 Vellum, MS 251., fol. 16r Fitzwilliam Museum, University of Cambridge, Cambridge

Molto sono grande quelle cose che tu me dici. e si sono Pietro
per douere gionare a la edificatione de molti. Ma io quanto
piu me dici de li miraculi de questo bono homo. tanto piu
ne desidero de oldire. e quanto piu ne beuo. tanto piu ne ho
sete. Come florentio prete emulo de sancto benedecto
mori. Gregorio Cap⁰. IX.

Rescendo la fama de la sanctita del uenerabile benede
cto e di suoy monaci. e multiplicando el feruore loro in
lo amore del signore nostro iesu christo. e molti lassiasseno la
uita seculare è domasseno la superbia del suo cuore soto el
suaue giogo del nostro redemptore. come e usanca di mali
homeni che hano inuidia al bene de la uirtu de gsialtri. el gle
bene loro non desiderano de hauere. uno chi hauena nome
florentio prete de una chiesia li apresso ano di questo nostro
sotodracono florentio. percosso de la malitia de lo antiquo
minico. comincioe ad hauere inuidia a le uirtu del sancto ho
mo. e a infamare la sua conuersatione. e si sforgaua etiam
dio de constrengere quelli che poteua da la sua uisitatione.
Euedendo che non poteua nuocere ne diminuire la sua bona
fama. e uedesse crescere la opinione da de la sua conuersatio
ne. e che molti se conuertiueno al stato de meliore uita. e
luy etiamdio per la laude de la sua opinione continuamente
essere chiamato. molto infochato da li ardori de la inuidia
diuentaua molto pegiore. pero che desideraua de hauere
la laude de la conuersatione del sancto homo. ma non
uoleua hauere la sua laudabile uita. el quale acechato de
le tenebre de questa inuidia. peruene a tanta malitia che
al seruo de lo omnipotente dio mandasse uno pane auene
nato soto specia de caritade. el quale lo homo de dio
receuite molto regratiandolo. ma non gli fue pero nascosta
la pestilentia del ueneno. chi era nascosto in lo pane.

95 A unicorn at a
well surrounded by
other animals, detail
from the life of
St. Benedict,
XVth century.
Italian manuscript,
M 184, Fol.14
The Pierpont Morgan
Library, New York

The horn

The unicorn's horn had magical healing properties: it was principally supposed to be able to detect and neutralise poisons. In the late fourteenth century, Johannes van Hesse of Utrecht claimed to have seen a unicorn come splashing out of the sea every morning to dip its horn in the water of a stream that was deliberately befouled every evening by malicious animals. A hundred years later, one Friar Faber claimed to have seen a unicorn on a mountain peak, after which one or two

96 Italien Master, allegoric theme, Triumph of Petrarch's Chastity, XVIth century Inv. Nr. 230-231 Landesmuseum, Mainz

other travellers made the same claim – and of course mountain streams are renowned for their purity. In this way, the image of the unicorn with its horn immersed in a stream remained consistently potent for centuries. We have already seen (in Chapter 1) the early tapestry presently displayed at *The Cloisters* in which the unicorn is depicted purifying a stream for other beasts with his horn. Another example is to be found in a fifteenth-century Life of St Benedict, in which an illustration (fig. 95) shows the unicorn drinking at a stream, its horn in the water purifying it while other animals, including a camel, lions, tigers, deer and a monkey, wait expectantly. Only a white-headed bird is temerarious enough to test the

water. A contemporary tapestry now lost but known by its description apparently depicted a virgin embracing a unicorn, which had around its horn, and sweeping around the virgin too, a series of banners proclaiming 'it eliminates toxins'.

The mediaeval world accordingly believed that ground

unicorn horn protected against poison – and was also effective in staving off disease and could sometimes even bring the dead back to life. Wealthier members of society owned drinking

97 Detail tapestry Legend of St Stephen, ca. 1500, Musée de Cluny, Paris

horns formed supposedly of unicorn horn which were thought to detect and neutralize poisons. Actually, most derived as tusks of the small Arctic whale called the narwhal. Decorated 'unicorn' horns are exhibited in a number of major collections, including London's Victoria and Albert Museum.

It is possible that the unicorn achieved some of its popularity through other associations. The Middle Ages were a time when tournaments were common: jousting was both sport for the powerful and entertainment for the peasantry. Such events were certainly not always the light-hearted contests enlivened by the presence of ladies with their handkerchiefs and the noble display of knightly self-restraint portrayed in the romances. Lucas Cranach the Elder's series of jousting engravings (fig. 82) pose the provocative suggestion that the long horn of the unicorn might have taken on the quality of a mounted knight in the lists.

One association that anyone educated in the post-Freudian era is quite unable to avoid is the evident connection between the unicorn's horn and male sexuality – especially when, as in many an Italian painting of the fifteenth century (fig. 96), and in almost all the Lady and Unicorn images of the period, the horn is being held by a woman. This particular painting is nonetheless entitled *Chastity*, and chastity was (as we have seen) one of the virtues the unicorn symbolised. The standard explanation for this apparent dichotomy is

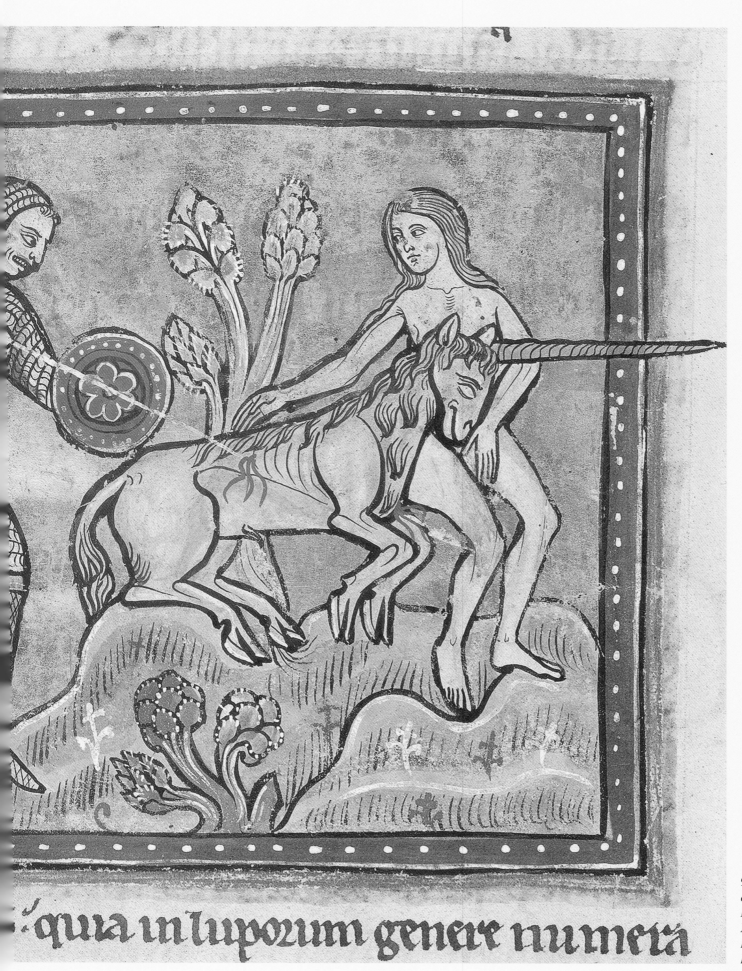

quia in luporum genere numera

98 Knight, Lady and Unicorn Man Roy 12 F XIII, Fol. 10v British Museum, London

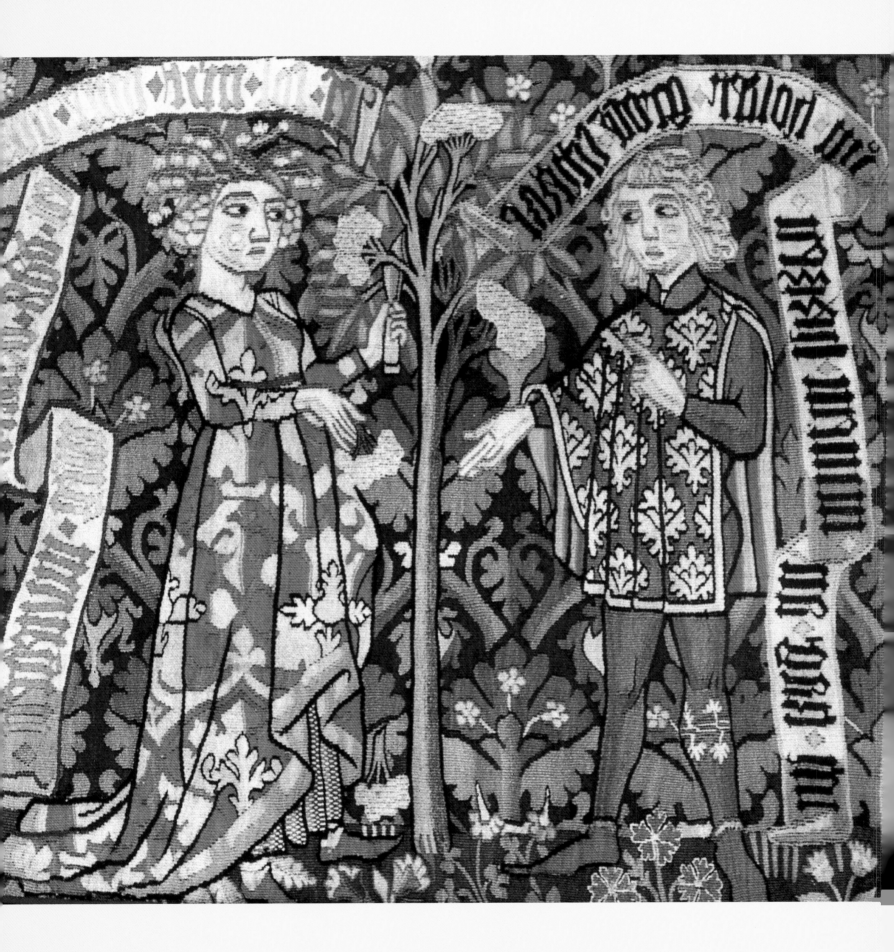

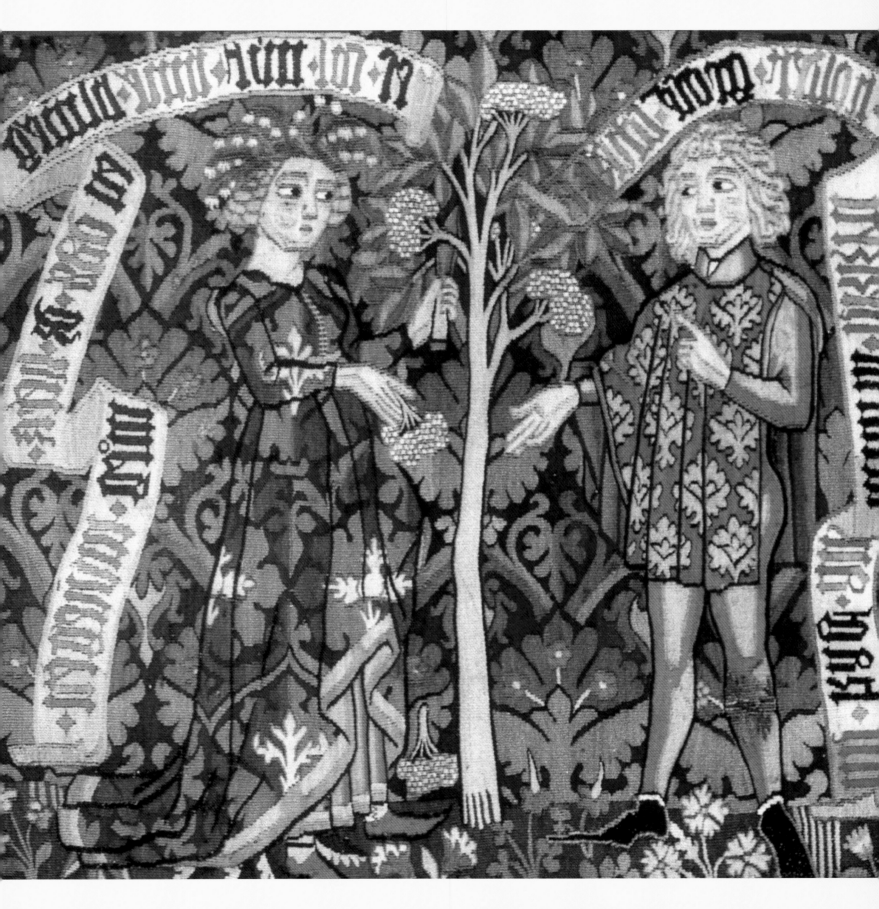

99 Couple of Beloved, Swiss tapestry
XVth century
Wool and white flax, 60 x 135 cm
Musée de Cluny, Paris

100 Jan Van Eyck
Virgin painted for Chancellor Nicholas Rolin,
XVth century
Wood, 66 x 62 cm
Musée du Louvre, Paris

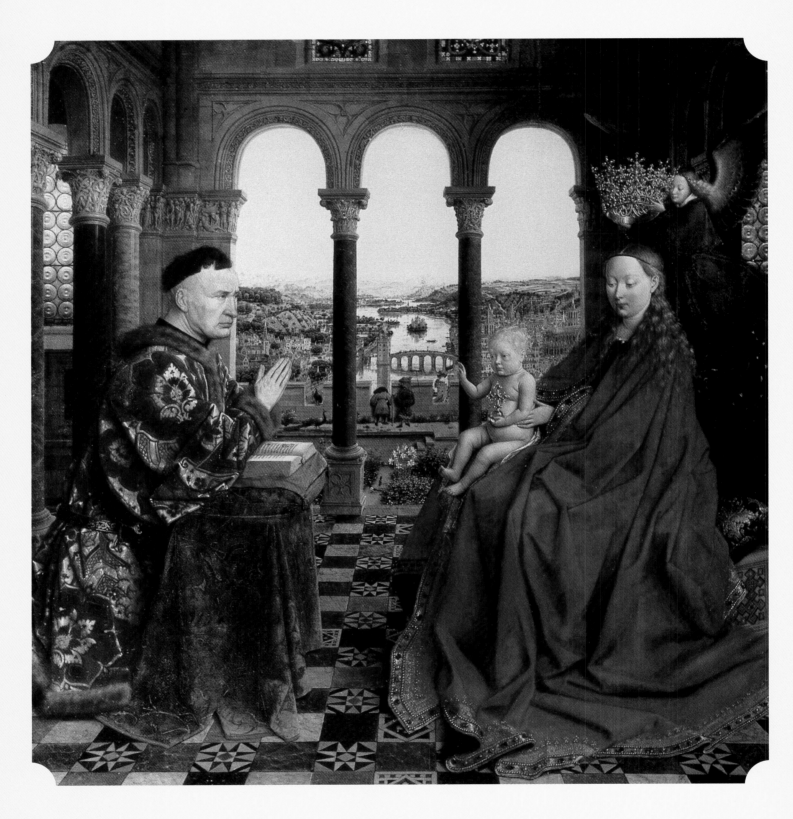

that the unicorn derives its symbolism for purity by direct association with the virgin whose own chastity could alone stop the animal in its tracks. Yet it is undoubtedly the case that the Lady and the Unicorn motif was simultaneously understood to represent the Lover under the spell of his Beloved, so the potentially phallic nature of the unicorn and its horn cannot be dismissed. After all, much of mediaeval symbolism had more than one concurrent and entirely opposite meaning.

Another aspect of the unicorn that is often forgotten because of its apparent 'domestication' by the Lady is that it represents a wild animal: it is both wild and free. Consequently – although, it has to be said, not very frequently – mediaeval art sometimes depicts the animal being ridden by wild men, their bodies covered in hair or leaves. These are men in a primal, happy state: men in direct communion with nature. Depictions of this kind occur particularly on packs of playing-cards engraved in Germany during the fifteenth century either by 'the Master of the Playing-Cards' or by 'Master E.S.'. As shown on the playing-cards, the wild men sit very naturally astride their wild, prancing (fig. 83, 84, 85). Interpretations vary between extremes. Some commentators suggest that because the unicorn is to be regarded as a symbol of chastity these engravings contend that the wild men's wild erotic urges will be tamed. Others declare that because one of these cards is paired with another that shows a wild woman and two infants riding a stag (fig. 85) – an animal that symbolizes loyalty and honour – a wild man riding a leaping one-horned beast therefore represents rampant lust.

100 detail

The general consensus is, however, that horned beasts are intended to have an obvious sexual symbolism. In Cranach's *Adam and Eve* (fig. 86), for example, Adam chews on his apple, his mouth nuzzling Eve's right nipple, the whole effect of sexual tension underlined by the fact that if they are not simply dangerous, the surrounding animals are all horned. And it is notable that in Hieronymus Bosch's *Garden of Earthly Delights* almost all the animals shown are horned – and include unicorns (fig. 87, 88).

101 Hans Memling, Virgin said to be painted for Jacques Floreins, XVth century Wood, 130 x 160 cm Musée du Louvre, Paris

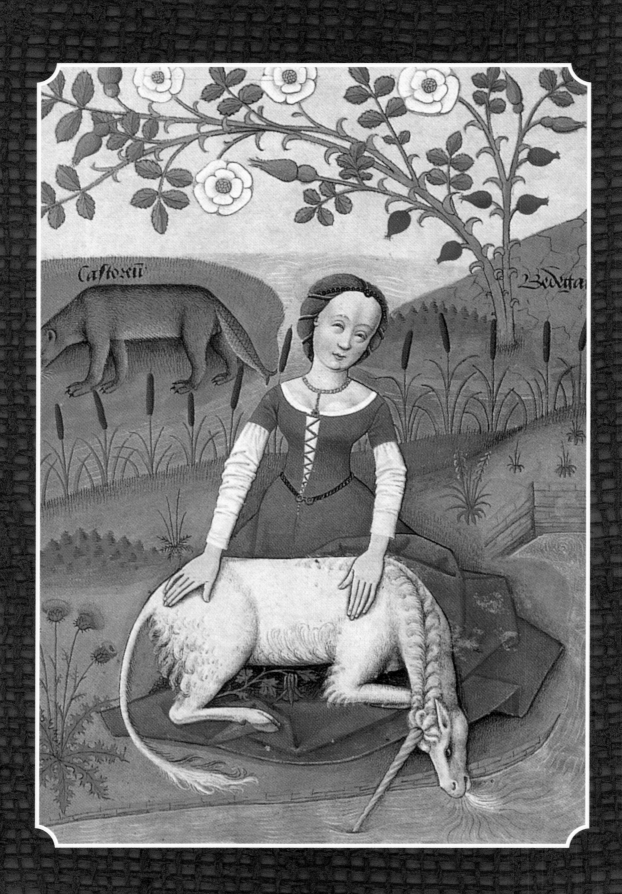

The Lady, the Unicorn and the Garden

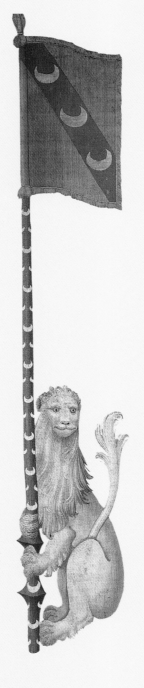

Ferocious and wild in its isolated natural habitat, the unicorn evaded capture by human hunters with its astonishing fleetness of foot, succumbing only when its young were in danger or on coming into the presence of a virgin in whose chaste lap it would (with due care, if somewhat improbably) lay its head and remain docile and tractable. The mediaeval accounts vary over exactly why the virgin has this unexpected effect on the animal. Some suggest that it might be because of her 'natural perfume'; many more declare that it is her virginal aura that transforms the fabulous beast into a gentle, even somnolent animal which can thereupon be done to death. There is also, say a few, the possibility that the unicorn is bemused by her bared breasts which, according to a pre-Christian tradition now difficult to credit, tamed the beast's erotic urges. In Chapter 2 we reviewed a tapestry dating from around 1500 and currently in the Historisches Museum in Basle, Switzerland, in which a barefoot Lady – specifically identified as a 'wild woman', and whose gown has openings that expose her breasts – holds a small unicorn's horn in her right hand and strokes the beast's mane with the other. According to a banner flowing above and

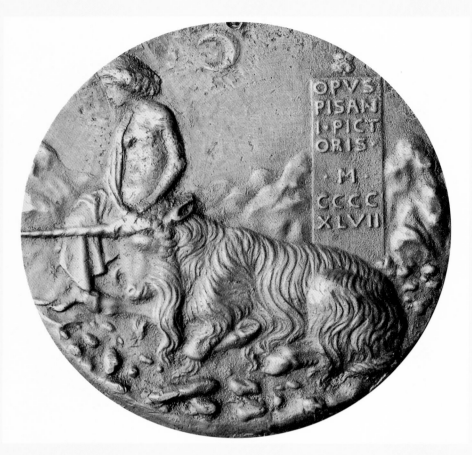

102 Pisanello, Medal for Cecilia Gonzaga of Mantua. Early XVth century. Victoria and Albert Museum, London.

around her she is saying that she has led a distinctly worldly life so far, and must now live in the misery that has accordingly come upon her. She is evidently very different from a Lady with a 'virginal aura'. In the background a horn-like obelisk stands within a walled enclosure. In other scenes of the same kind the walled garden setting further includes a phallic fountain that has a secondary basin lower down the shaft.

A similar wild woman is also to be seen in the medallion made for Cecilia Gonzaga of Mantua (fig. 102) in the early fifteenth century. Half-clothed, the Lady grasps the rather shaggy unicorn's horn near its base. Considered together with a number of comparable contemporary views of the Lady and the unicorn, a robust interpretation has to be that these are discreet images of women holding phallic objects.

But the sexual aspect is only one interpretation of some recurrent features in the traditional image. There are other aspects — and other recurrent features. For example, on a medallion made in fourteenth-century Paris a knight impales the unicorn with his lance from the safety of a tree while a Lady holds the unicorn's horn and bedazzles it with a mirror. This is reminiscent in many ways of the mirror held by the *Lady in the Sight* tapestry we looked at in Chapter 2. Perhaps the mirror is intended to link with

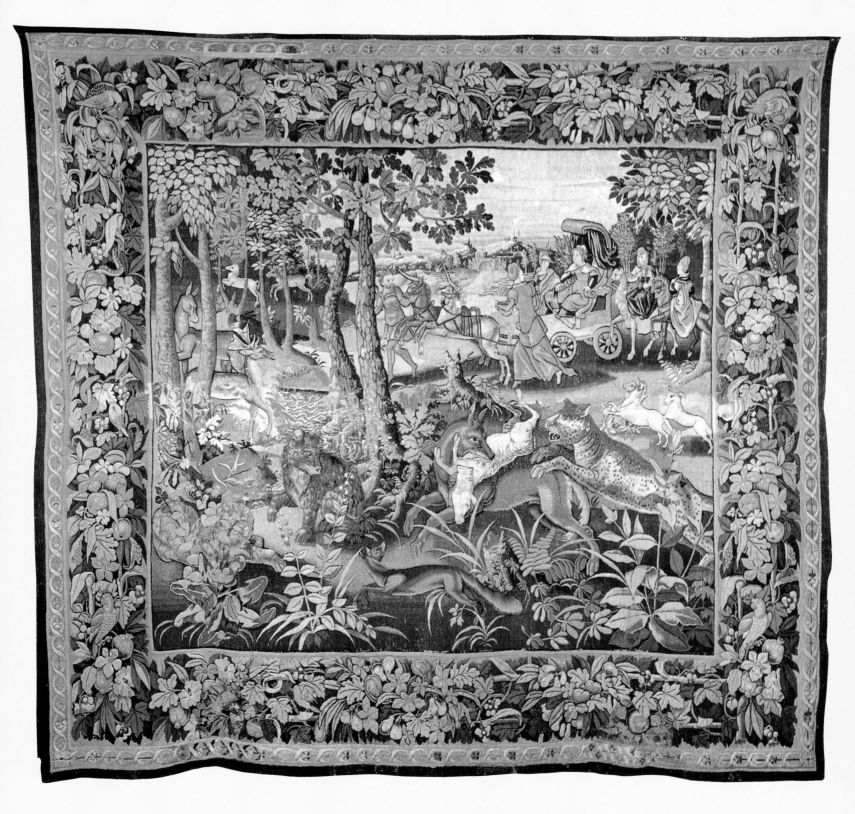

103 The animals in the forest. Audenarde,
Second half of XVIth century
300 cm x 320 cm
Collection Dario Boccara

104 The Virgin Traps the Unicorn,
end of an ivory casket made in Paris,
ca. 1320
British Museum, London

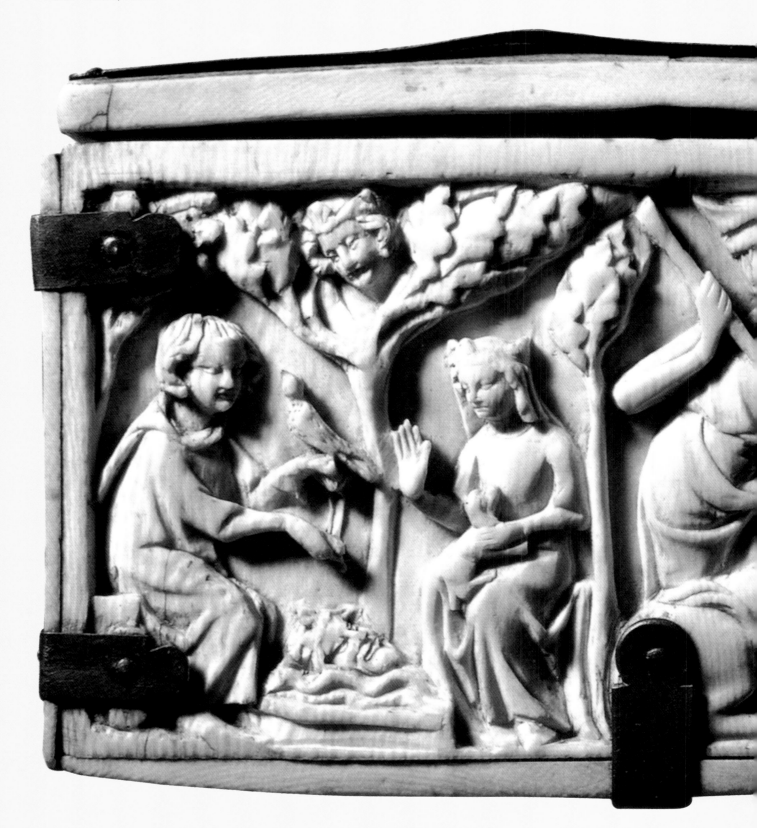

the Virgin Mary's *Mirror Without Blemish;* perhaps it owes something to the ancient Greek myth in which Perseus uses a

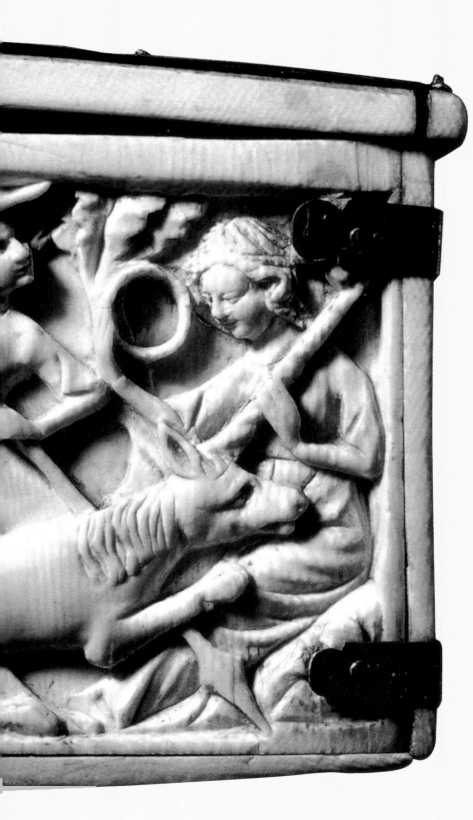

reflective shield to kill the Gorgon Medusa – but in any event the mirror is a device that appears in a number of scenes depicting the killing of the unicorn. An instance of this is a carving on the rear panel of an ivory casket again dating from the early fourteenth century (fig. 104), although it has to be admitted that the circular mirror is in this case alternatively held to be a wreath (yet another recurrent feature associated with the unicorn).

It may well be that to us as we enter the twenty-first century there is some difficulty in reconciling the quiet, almost Madonna-like calm of the Lady in the paintings and engravings with the apparent betrayal of her unique gift in the effecting of an innocent beast's death. For although the unicorn is essentially a wild animal, it fights only when attacked: unlike the lion or the

*105 Miniature in a
Psalter from Stuttgart.
ca. 820.
Cod. bib. 2°23, fol.27
Württembergische
Landesbibliothek,
Stuttgart.*

tiger it never attacks first – it relies mainly on agility and speed of flight. And in that very many of the unicorns depicted in Lady-and-unicorn tableaux are rather small goat- or lamb-like animals, the betrayal seems all the worse.

𝔥unting the unicorn

Many modern urban-dwelling people might wonder why anybody would want to hunt and kill a unicorn. The fact remains that the hunting of wild animals is still relatively common in continental Europe and America even today, and was part of daily life in the mediaeval world. At that time there was of course the additional incentive of gaining possession of the magical properties of the unicorn's horn. But few representations of the killing of a unicorn simply with this in mind seem to exist.

A small number of images featuring the slaughter of the unicorn have an undeniably Christian symbolic context. So there

106 Martin Schongauer,
The Great Carrying of
the Cross, ca. 1470
Engraving,
28.6 x 43 cm
Musée du Petit Palais,
Paris

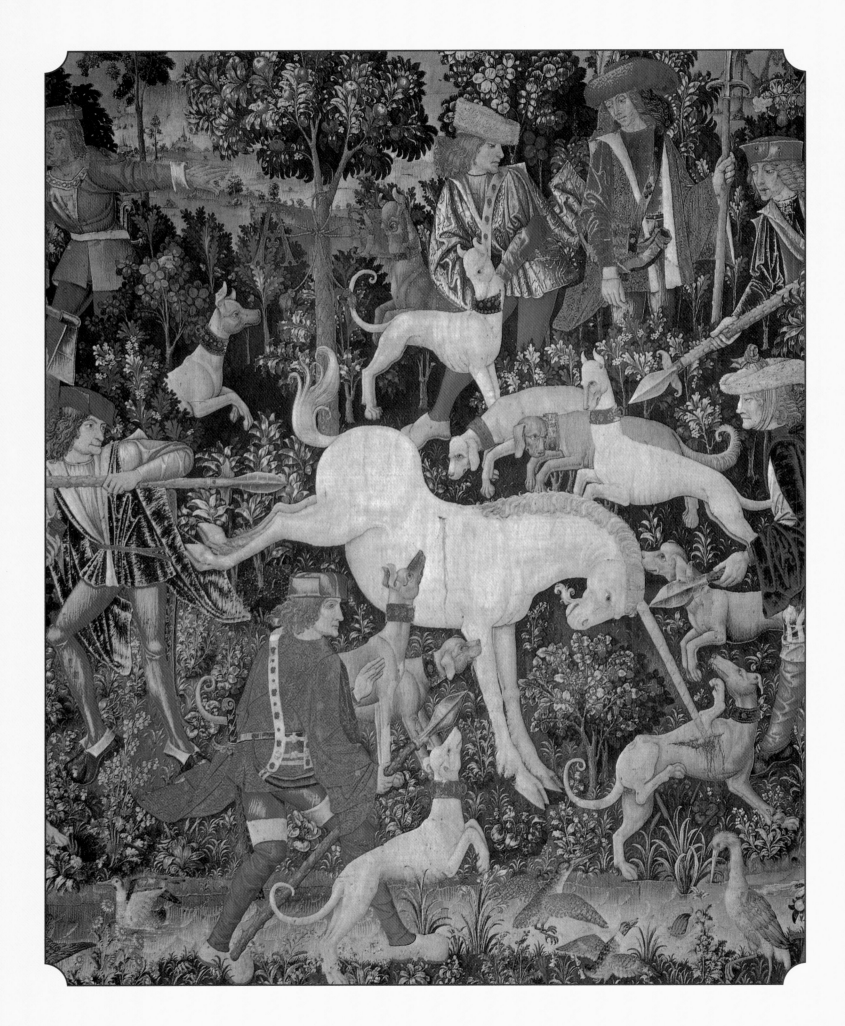

may be something in the idea that the unicorn transfixed by a spear while resting its head in the lap of the Lady represents Christ betrayed by Judas and subsequently killed. Such an interpretation equates the Lady with Judas — hardly acceptable as an interpretation today — but sympathy for Judas might have been greater during the Middle Ages. There is an image from a very early German psalter of the ninth century (fig. 105) which shows Christ on the Cross: the soldiers with their spears jeer at Jesus on

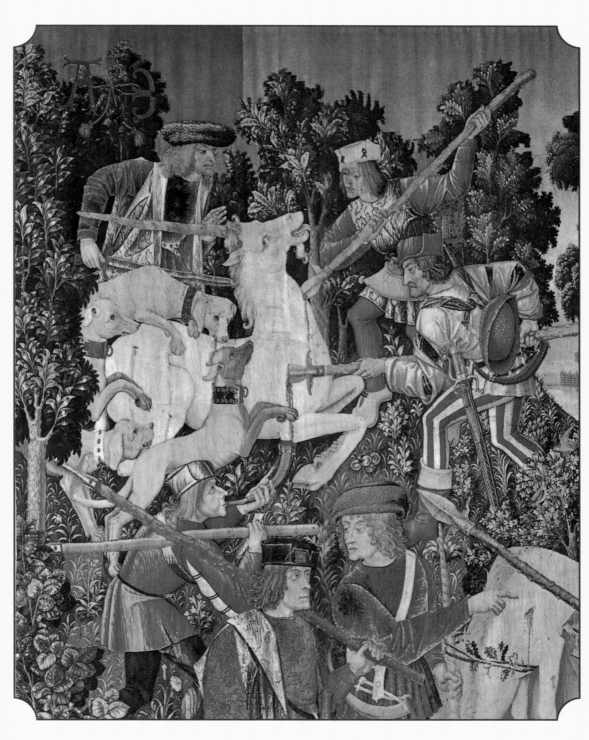

109 (left)
Luca Signorelli,
The flogging of
Christ,
ca. 1475-1480
Wood, 80 x 60 cm
Pinoteca di
Brera, Milan

the left and on the right a leaping unicorn appears above a similar lion. Accidentally or not (for this refers to Psalm 22 in which the psalmist laments that 'they glare at me, gloating; they divide my garments among them and cast lots for my clothes' while also pleading to be delivered from 'the lion's mouth (and) from the unicorns' horns'), the unicorn's horn is about to penetrate Christ's left side.

But with or without any particularly religious connotations, the death of the unicorn remains a paramount element of the tradition. A Physiologus bestiary of the twelfth century has an illustration of two hunters, one with an axe and the other with a spear, in the act of killing the unicorn, which this time has a curved horn, as it rests its head in the lap of an unappealingly grim-faced

110 Hunters killing the
Unicorn,
ca. 1170
Miniature from a
Physiologus,
Pierpont Morgan
Library,
New York

*111 Marginal decoration
in the Ormesby Psalter.
Early XIVth century.
Bodleian Library,
Oxford.*

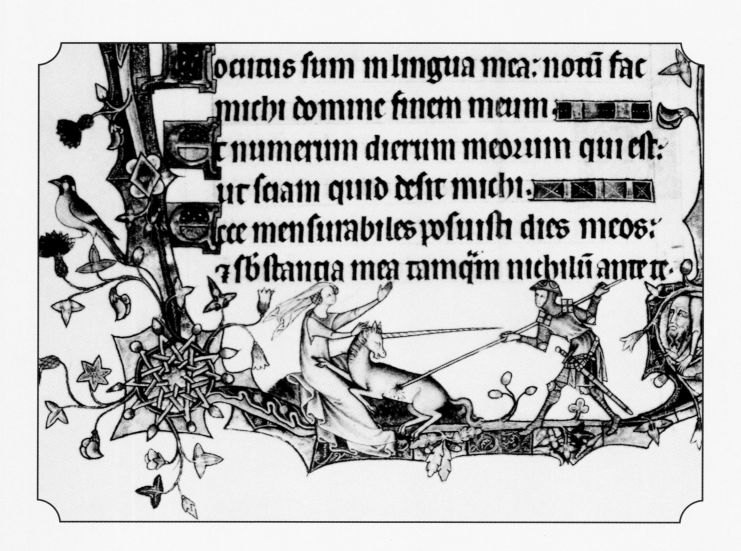

virgin (fig. 110). It is an image that in one format or another occurs over and over again. For example, one of the marginal decorations in the English *Ormesby Psalter* of the early fourteenth century shows the unicorn, here with a long straight horn, turning round in appalled dismay as an armoured knight – summoned by the richly-dressed virgin in whose lap the unicorn is lying – thrusts a spear into its side (fig. 111). Perhaps there is just a

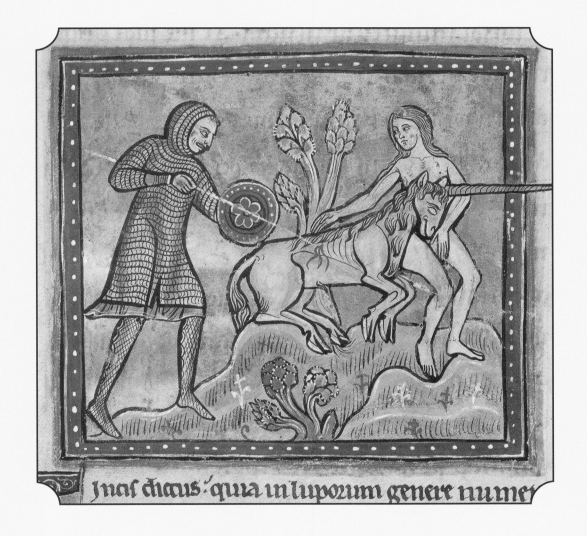

suggestion in the scene of the way the Roman soldier thrust a spear into the side of Christ on the Cross. So too in a thirteenth-century English bestiary in the British Museum, an illuminated capital shows a knight in chain-mail creeping up behind an unfortunate unicorn to spear it in the side while its attention is elsewhere (fig. 112). There would seem to be a powerful reason for the unicorn's distraction on this occasion, however, for the maiden

112 Miniature in an English bestiary, XIIIth century. British Museum, London.

113 Miniature in Richard de Fournival's Bestiaire d'Amour. Early XIVth century. Ms. Fs 25566, fol.88v Bibliothèque Nationale, Paris.

whose breast its head is lying contentedly against is without any visible form of clothing. On the other hand, such an implication of a sexual motif may once more be a cynical modern interpretation: the fresh-faced girl in this picture may be meant to look too young for such carnal considerations – and we have already seen that nakedness may represent an ideal state, a state of nature, as opposed to any attempt at being provocative.

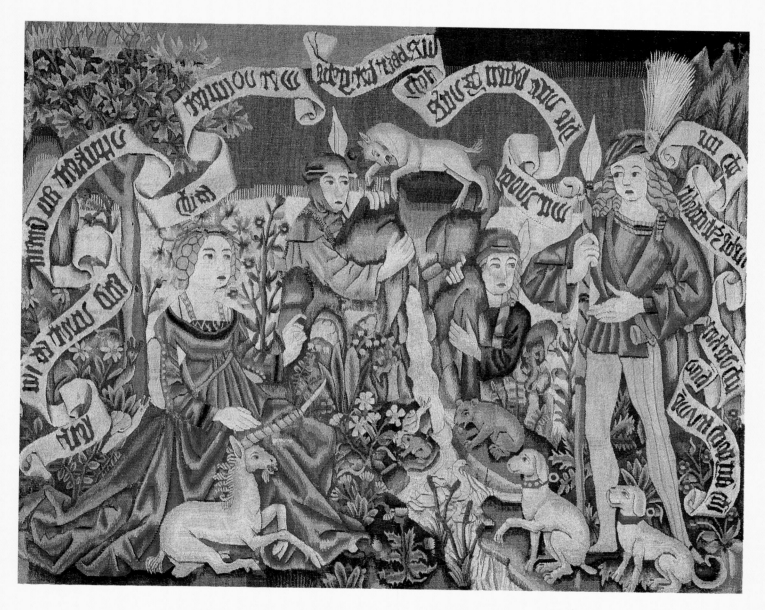

114 *Swiss tapestry, end of XVth century Landesmuseum, Zurich.*

Yet another unicorn being impaled with a spear is to be found in a miniature in an early fourteenth-century bestiary now in the *Bibliothèque Nationale* in Paris. But the title of this bestiary rather gives the game away: it is *Bestiaire d'Amour,* a Bestiary of Love, and the text that surrounds the miniature is careful to inform the

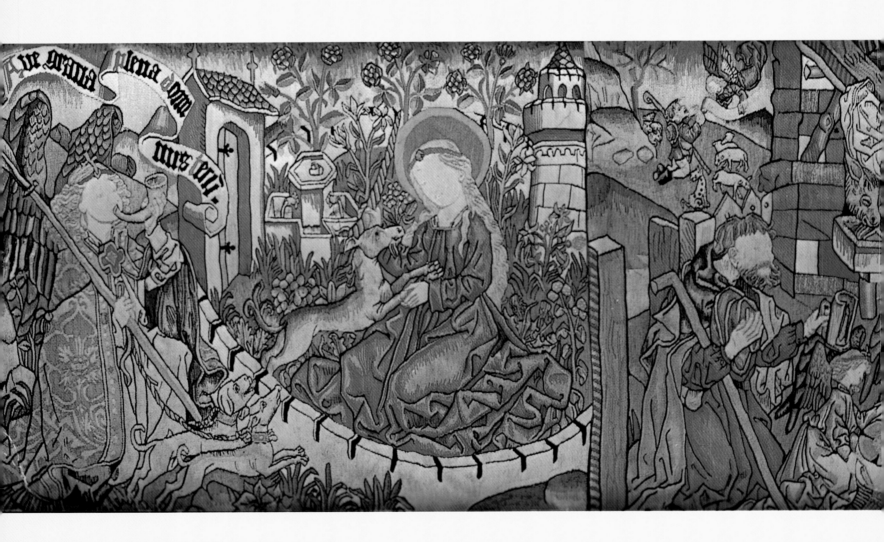

115 Middle Rhenish altar frontal.
Tapestry. ca. 1500.
(The faces have been retouched.)
Marienkirche, Gelnhausen.

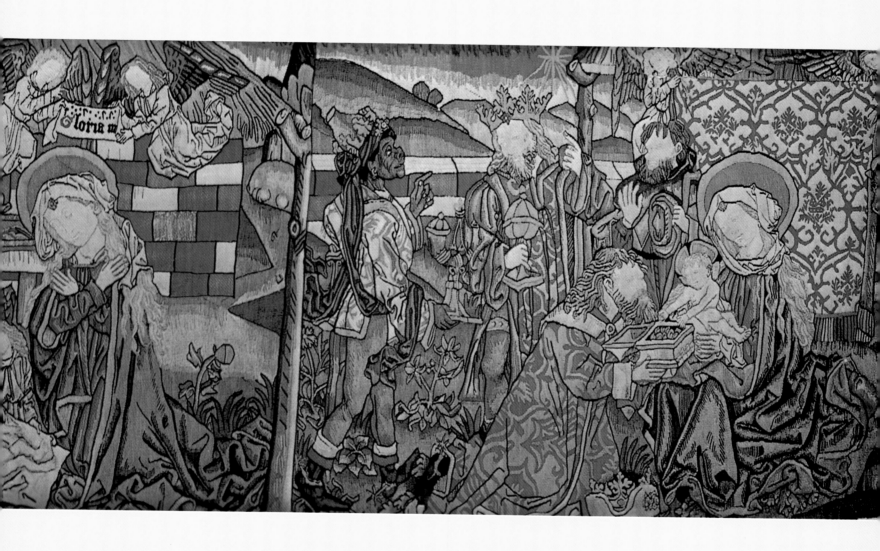

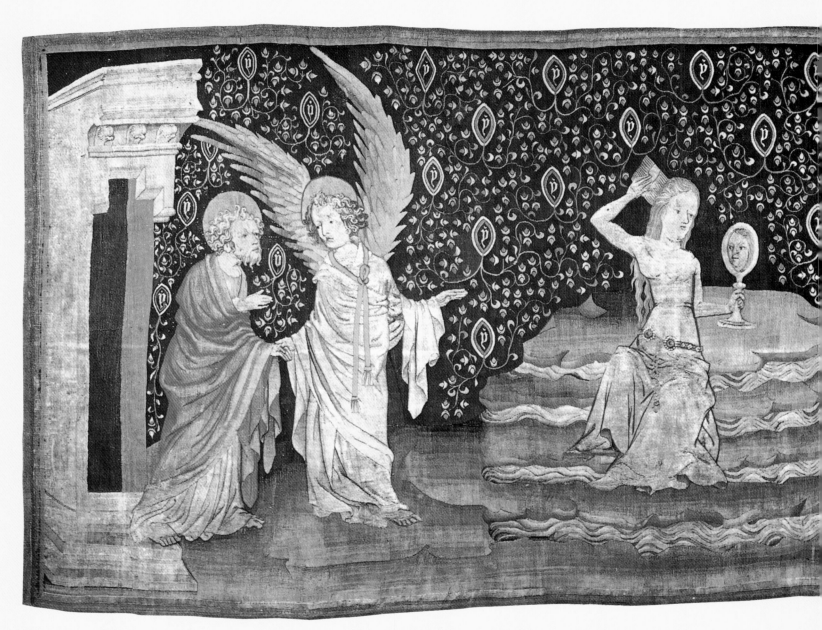

*116 The Apokalypse of
Angers: The Great Prostitute,
Sixth piece of the tapestry,
France, End of XIVth C.
Château d'Angers.*

reader that here the hunter represents Love, the woman the Lady, and the unicorn her besotted lover (fig. 113). This implies that the hunter is not after all putting to a violent death an innocent animal

117 French, *The Lady and the Unicorn, from Matteus Platearius, Book of Simple Medicines, fol 160 National Library, St. Petersburg*

– he cannot even be said to be increasing the rarity of an endangered species – he is no more than a variant on Cupid with his bow and arrow. In effect, the unicorn – the lover – may now be

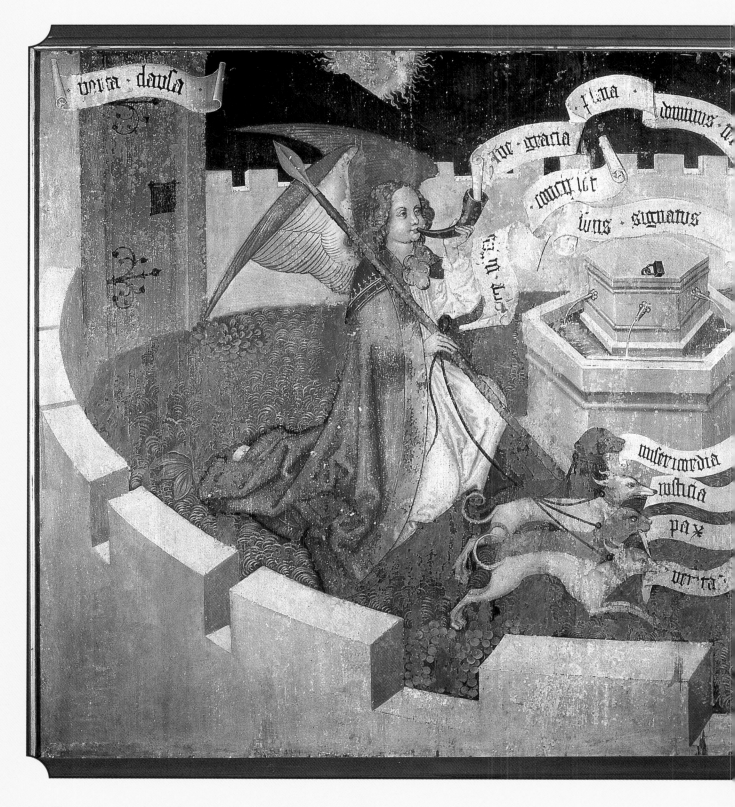

118 Martin Schongauer's workshop,
Altarpiece of the Dominican order: The
Mystical Hunt and The Lady and the Unicorn
(2 of 8 pannels), ca. 1475.
Painting on wood. Height 115 cm.
Musée d'Unterlinden, Colmar
(Photo: O. Zimmermann)

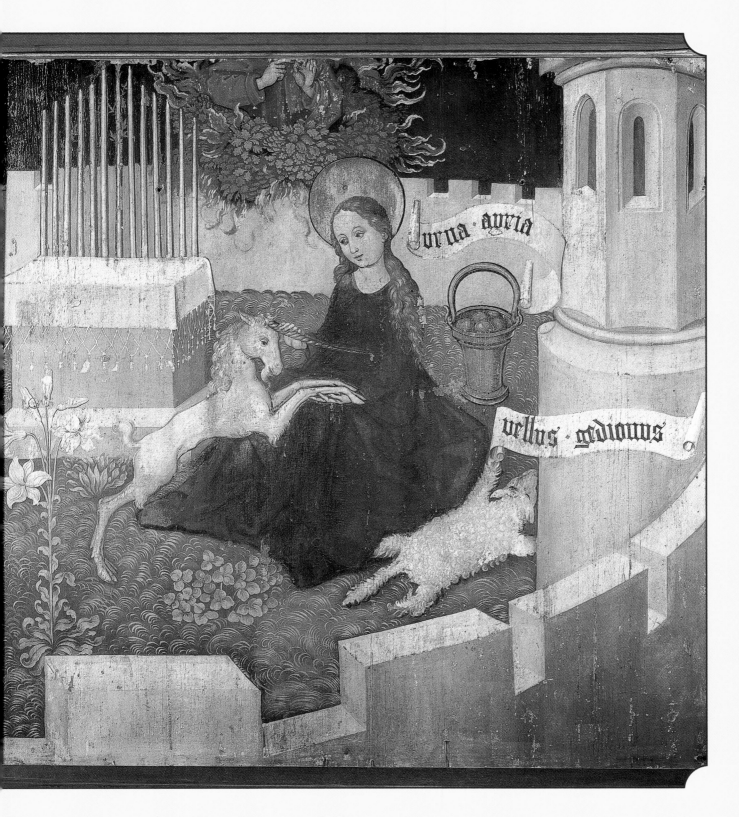

more alive than ever before.

Conversely, in a Swiss tapestry dating from the end of the fifteenth century it seems that it is not the unicorn but the hunter who represents the lover (fig. 114). Dressed in his finest outfit, the hunter is nonetheless being severely admonished by the Lady (who is accompanied by a particularly small unicorn) through the

medium of the banners above and around them both. The banners give the hunter to understand that 'Whoever hunts for the pleasures of the flesh will find grief' – to which the hunter replies that his search is solely for constancy, and that to find it would be his most

pleasurable trophy. Yet the captions over the hunter's two furtive companions lurking in the undergrowth near by imply that the hunter may be employing a certain glibness, for – apparently mindful of the Lady's warning – they complain that they are risking their lives. This is surely one scenario in which the unicorn appears simply in order to emphasize the chastity of the Lady.

119 Fra Angelico, The Annunciation, ca. 1432-33 Tempera on wood, 175 x 180 cm Museo Diocesano, Cortone

120 Cosimo Tura, Pietà,
1469-70
Oil on wood. 48 x 33cm
Museo Correr, Venice

THE LADY, THE UNICORN & THE GARDEN

*121 Lucas Cranach the
Elder, Pietà
Oil on canvas,
54 x 74 cm
Pinacoteca del
Vaticano, Rome*

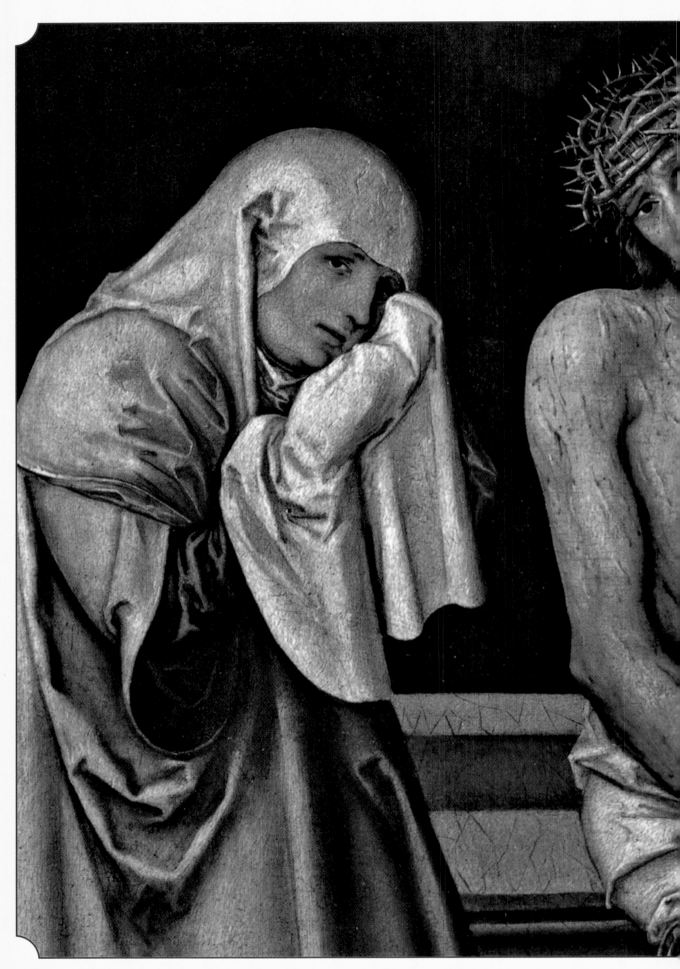

The Unicorn as a religious symbol

The penultimate part of the tradition of the Lady and the Unicorn features the unicorn within the Lady's garden, struck to the heart by her modest purity, as the hunters draw close. Often – as in the fragmented fifth tapestry of the series exhibited in The Cloisters, New York (see Chapter 2) – a hunter is depicted emerging from the forest and blowing a

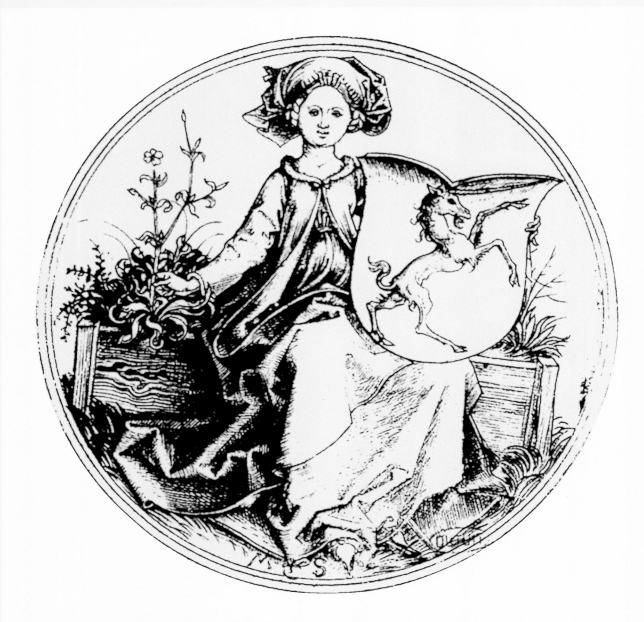

122 Martin Schongauer, Lady holding a shield with a unicorn, ca. 1485 - 1491, Armorial medallion, diam. 7.7 cm Bibliothèque Nationale, Cabinet des Estampes, Paris.

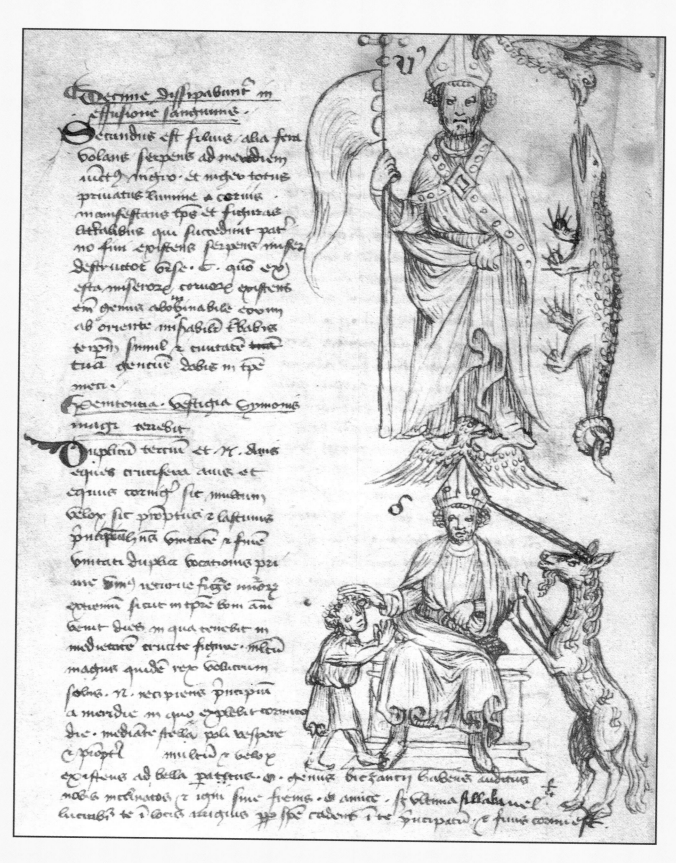

123 Vaticinia de summis pontificibus,
France(?), middle of XVth century
manuscript coming from abbey of Marmoutier.
Bibliothèque Municipale, ms. 520, f.222v., Tours

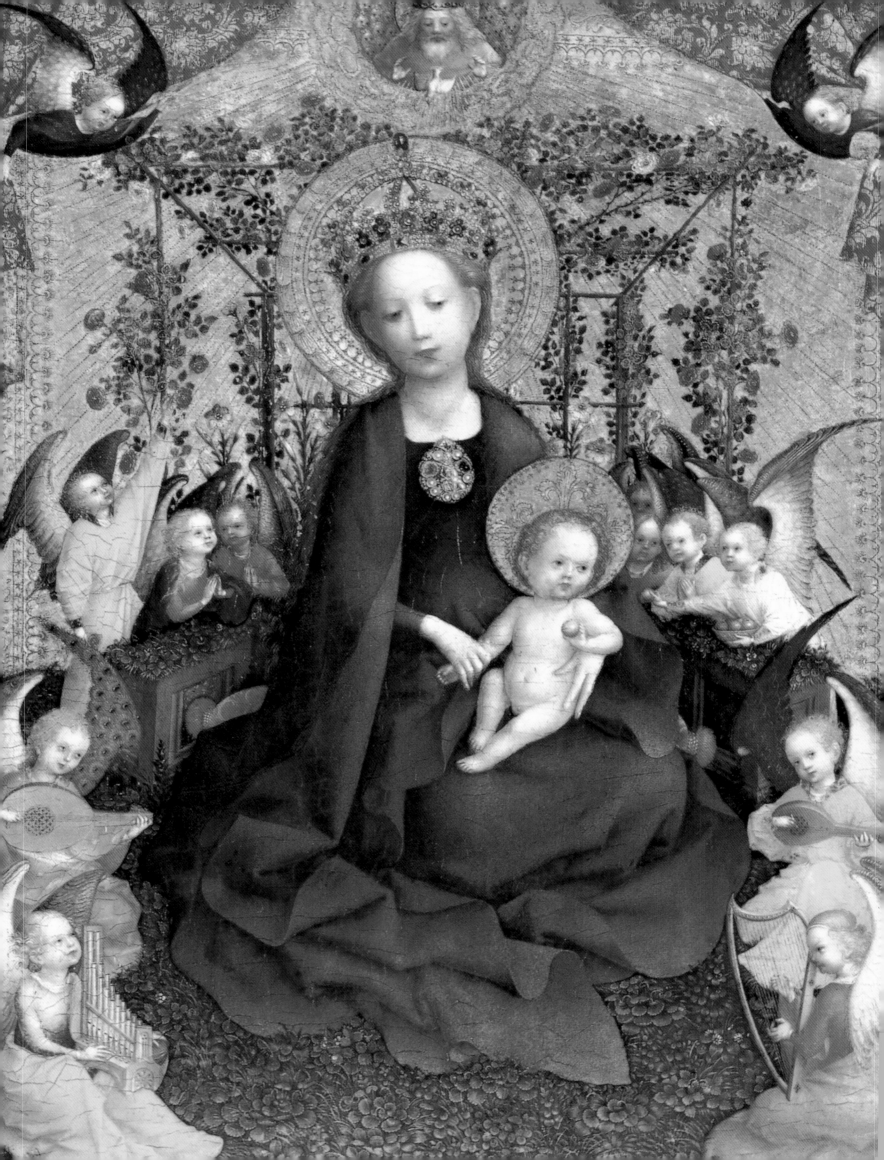

horn to urge on the dogs to bring down the quarry. Hard as it may be to believe, this scene too has its religious equivalents. The altar frontal from the Marienkirche at Gelnhausen, for example, in place of showing a courtly – or even a terrestrial – hunter actually depicts the angel Gabriel in the role of horn-blower, so demonstrating that the designer obviously

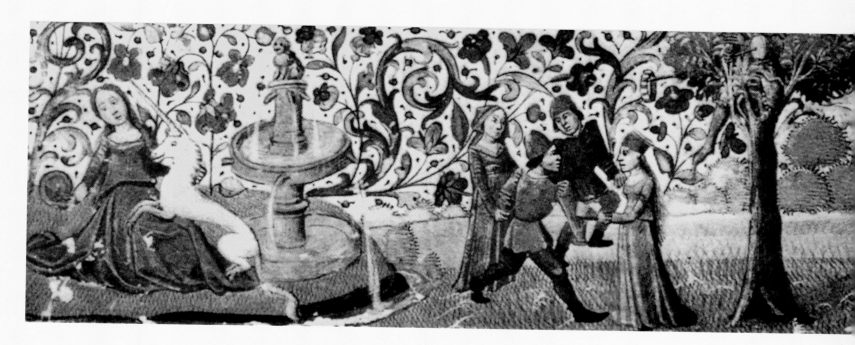

125 Border miniatures in the Wharncliffe Book of Hours by Maître François. ca. 1470. MS 1062, National Gallery of Victoria, Melbourne.

equated the story of the Lady and the unicorn with – at least in this case – that of the Annunciation to the Virgin Mary that she was to be the mother of Christ (fig. 115). The implication is that the same designer would have understood the entire tradition of the Lady and the Unicorn, and in particular the hunting of the unicorn (in which the virgin finds herself unexpectedly in the presence of the self-sacrificial unicorn), to equate with the mystical entering of Christ into the Virgin Mary's womb (by which the Virgin finds herself unexpectedly pregnant with her self-sacrificial Son). However far-

124 (left) Stephan Lochner The Virgin in the rose-tree, ca. 1448 Painting on wood, Height 50.5 cm Wallraf-Richartz Museum, Cologne.

124 detail

126 French Manuscript
Ms Pc 18, Fol.15
Bibliothèque Nationale,
Paris.

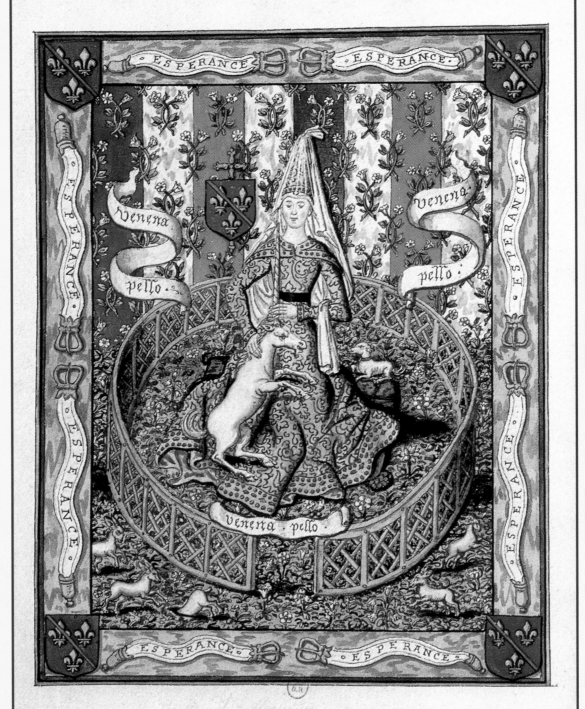

ESPERANCE · ESPERANCE

Venena

pello

Venena

pello

Venena · pello

ESPERANCE · ESPERANCE

Devise de la Branche de Bourbon et de Charles Cardinal Archeveque de Lion.

fetched this may seem, it is an interpretation that is reinforced by the existence of an Annunciation of around 1420 in Erfurt cathedral (fig. 132) which depicts a horn-blowing angel Gabriel and a collared unicorn on the lap of the Virgin in the characteristic semi-prancing pose. A similar altar frontal of the same time and in a similarly Germanic tradition (fig. 131) shows a

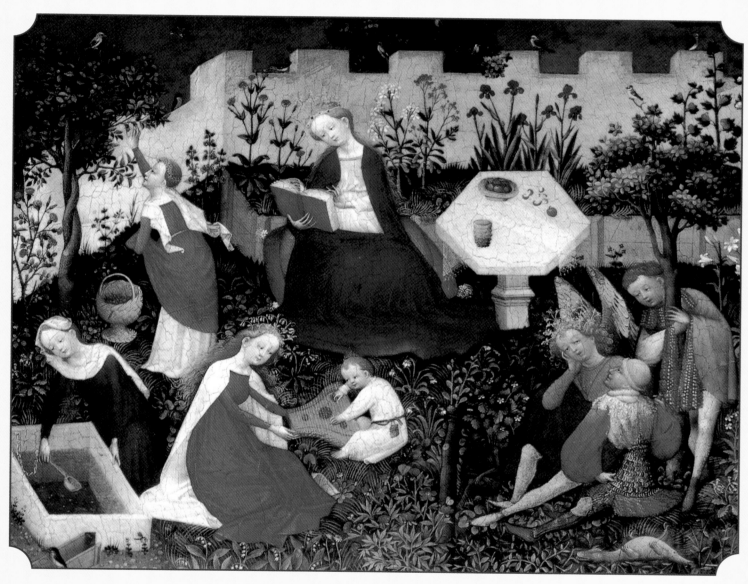

scenario of Adam and Eve in which Eve has taken on the role of the Lady and holds the unicorn's horn while Adam transfixes the unicorn with a spear.

As early as in the fourth century AD the unicorn was associated by Christian theologians with Christ himself. Their reasoning was varied but generally relied on rather tenuous

127 Master of the Little Garden of Eden (active ca. 1410 - 1420), Little Garden of Eden, ca. 1410 Painting on wood, Height, 26 cm Städelsches Kunstinstitut, Frankfurt.

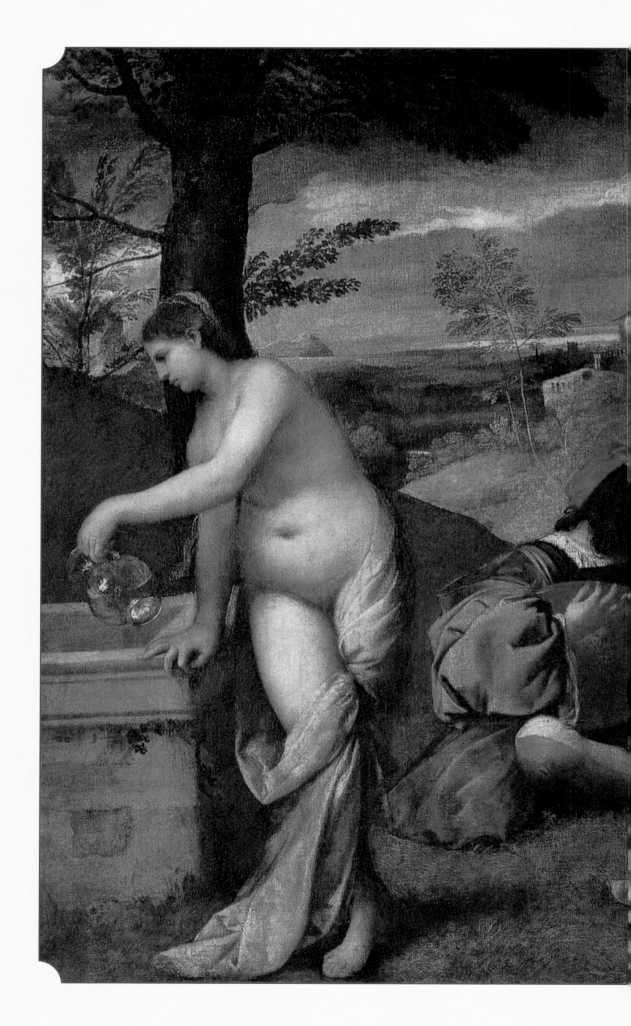

128 Giorgione (Titien),
Rural concert, 1508
Canvas, 105 x 136 cm
Musée du Louvre,
Paris.

129 French (?) tapestry,
Scenes from Lordly Life, detail:
The bath, Louis XIIth's times
260 x 280 cm
Musée de Cluny,
Paris

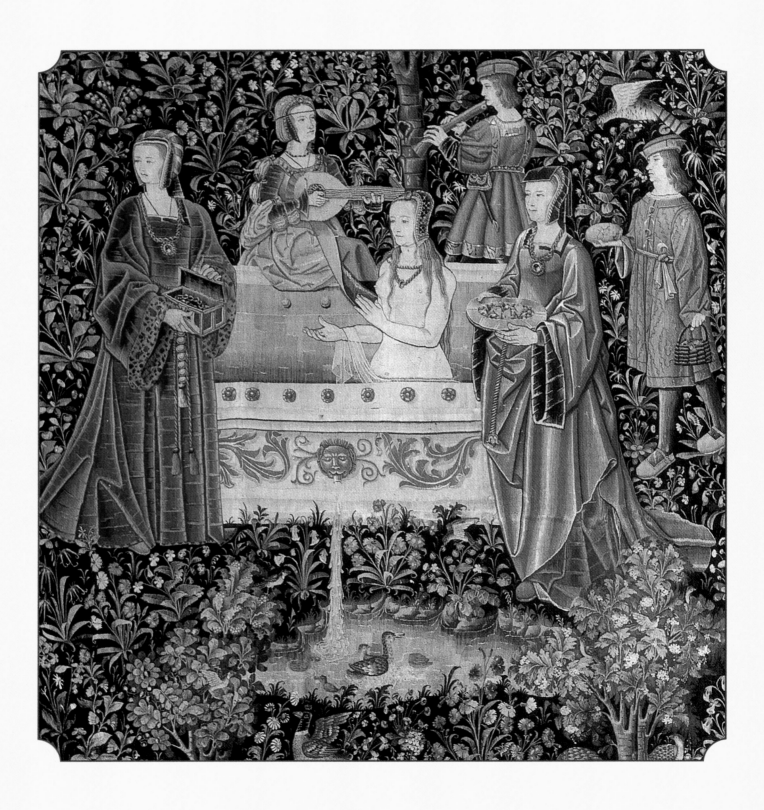

associations with the singularity of the unicorn's horn and the singularity of Christ – the fact that the unicorn was different from any other animal in respect of the two horns of other animals, and that Christ was likewise different from the two other Persons of the Christian God. It was also suggested that

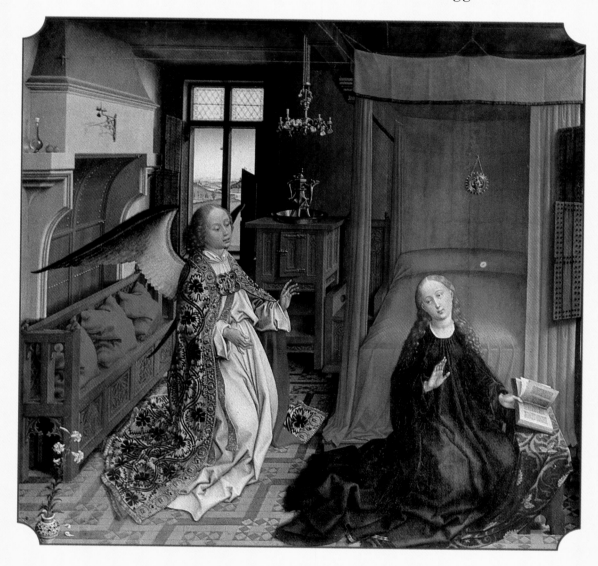

the horn might symbolise the Cross.

On the other hand, the bestiaries tended to adduce an analogy between the way the unicorn was captured and shown off at the palace of the king and Christ's capture and exhibition before Pilate – or with Christ's surrendering his divine nature via the medium of his mother Mary and providing salvation for the world. In fact the *Brussels Physiologus* illustration we saw in the previous chapter (the one featuring the snub-nosed unicorn) is one of the very few occasions when the unicorn is visibly placed side by side

130 Rogier Van der Weyden, The Annunciation, *XVth century Wood, 86 x 93 cm Mussée du Louvre, Paris*

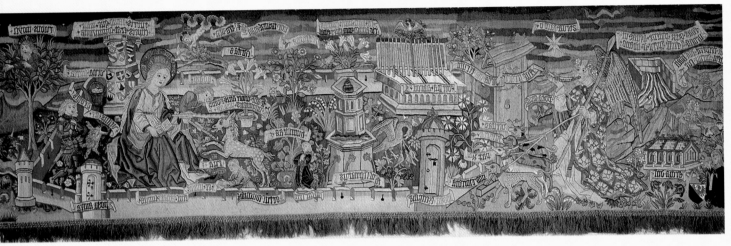

131 Annunciation
in the hortus
conclusus,
tapestry, altar
frontal, Swiss,
ca. 1480
Landesmuseum,
Zurich

with the figure of Christ, although the association had very wide
currency at the time. Compensating for this otherwise strange
omission is the fact that – as we have also seen previously – the
Cluny tapestry known as *Sight* and many other Lady and unicorn
images contain a good number of the painterly elements of a
conventional fifteenth-century Pietà, such as that by Cosimo Tura
(fig.120).

Without a doubt the theme of the Lady and the Unicorn during
the Middle Ages had religious connotations. Indeed, one modern
commentator on the tapestry series in The Cloisters believes that

132 Allegory of the
Annunciation, German,
ca. 1420
Altar frontal (middle
panel)
Tempera on wood,
133 x 154 cm
Dom zu Erfurt, St. Marien
(Cathedral Erfurt),
Courtesy of the Domkapitel
St. Marien, Erfurt

*The Hunting
of the Unicorn*
has three
equally valid
religious
aspects. In
the first, the
*Mystical Hunt
of the Unicorn*
corresponds to
the
Annunciation,
implying that
the sudden

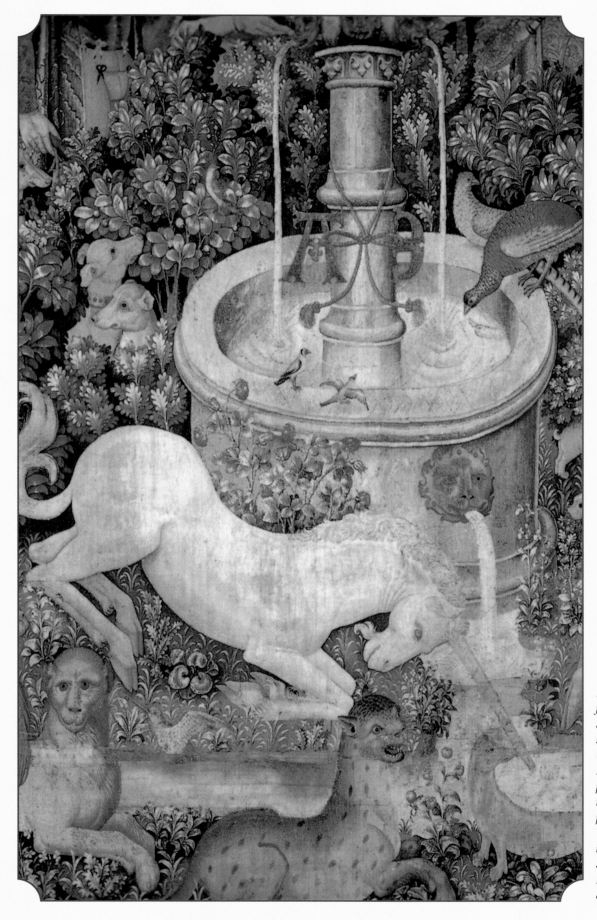

133 *The unicorn at the fountain, detail of fig. 33, Second tapestry of the series* The Hunting of the Unicorn, *ca. 1500 Designed in France, probably in Paris, woven in South Lowlands, probably Brussels Wool, silk, and metallic thread, 368 x 379 cm Metropolitan Museum of Art, New York*

134 - 139 Tapestry
The Lady and
the Unicorn
1480-1500,
Musée de Cluny,
Paris.

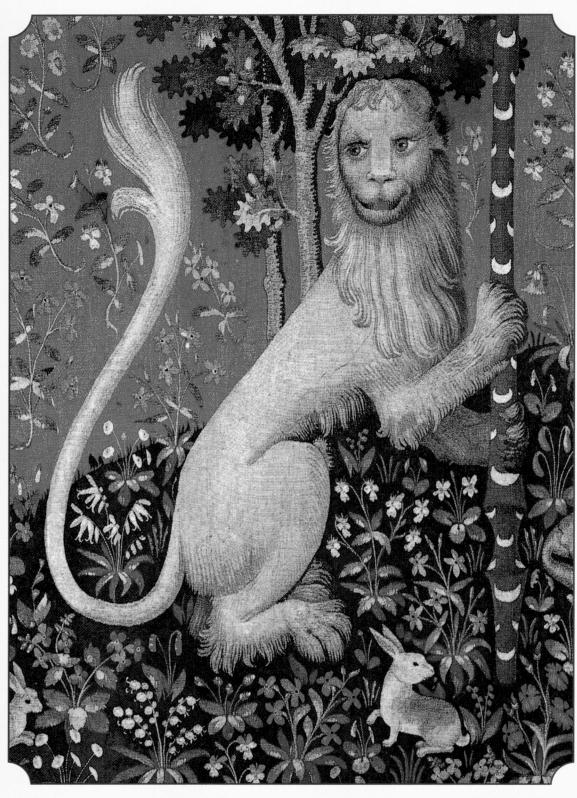

134 View, detail

and traumatic arrival of the unicorn in the presence of the Lady is
effectively identical with the unbidden and equally traumatic
arrival of the angel Gabriel before the Virgin Mary. The second is
the Hunt as an allegory of the Passion of Christ: the self-sacrifice
of the unicorn on behalf of Love parallels the sacrifice of Jesus in
the circumstances of his crucifixion. But the third is the Hunt of

the Unicorn as the lover's hunt for love — in religious terms, the fervent quest of the faithful for the Love of God.

But certainly in the ordinary mediaeval mind it was the secular aspects of the capture of the unicorn that were more to the fore. The theme was celebrated mainly as a metaphor for the lover overtaken, overcome, overwhelmed by affection for his beloved. In many of the works of art related to the theme, therefore, the final outcome that is represented is the unicorn alive and docile in a

135 View, detail

fenced garden, wearing around its neck the golden chain of matrimony that attaches it to the pomegranate tree of fecundity. This is pretty well the situation we saw in Chapter 3 in the Italian engraving in which the unicorn rests its head ecstatically in the Lady's lap while the Lady furtively brings up from beneath her a collar and chain attached to a tree to slip around its neck.

136 Hearing, detail

And in many depictions of this kind – as in the tapestries in
The Cloisters – the scene is set in a walled garden or in some
equally isolated location, such as an island – as in the Cluny
tapestries and in the mid- fifteenth-century miniature in Maître
François' *Wharncliffe Book of
Hours* (fig. 125), where, like
the second tapestry of The
Cloisters' series, the
surrounding river is fed from
a characteristic fountain that
has a secondary basin
encircling the main shaft, as
is to be found elsewhere in
mediaeval images as a
standard element in the
Garden of Love. In either
form, island or enclosed
garden, this represents the
hortus conclusus which has to
do with the Garden of Eden,

137 Touch, detail

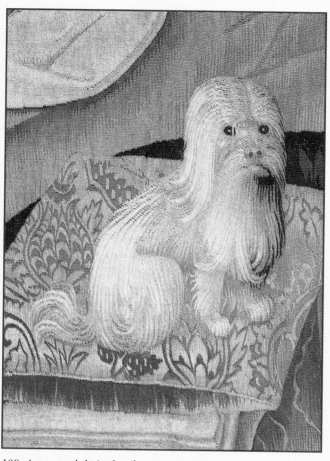

138 A mon seul désir, detail

with the Paradise of Islam, and with the Garden of Love – such as the one in which the stories of Boccacio's *Decameron* were told.

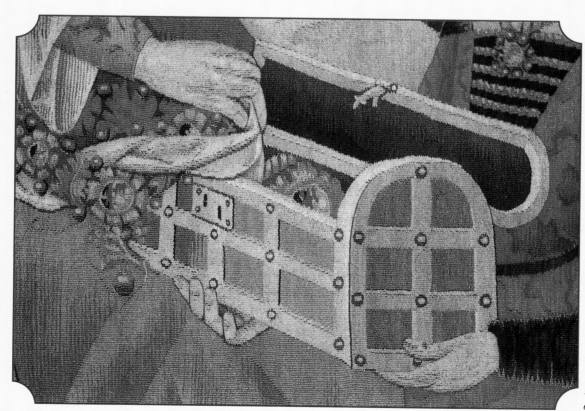

139 A mon seul désir, detail

BIBLIOGRAPHY

I Generalities

A. Erlande-Brandenbourg	L'art gothique, Paris, 1983
J. Heers	Précis d'histoire du Moyen Age, Paris, 1990
F. Joubert	Histoire de la tapisserie: en Europe, du Moyen âge à nos jours, Paris, 1995
D. Nicolle	The Hamlyn History of Medieval Life, London, 1997
Ch. Sterling	La peinture médiévale à Paris, 1300-1500, Paris, 1987
T. Voronova ; A. Sterligov	Western European Illuminated Manuscripts, Bournemouth, 1996

II On the tapestries The Lady and the Unicorn and The Hunting of the Unicorn

G. Büttner	The Lady and the Unicorn (transl. R. Everett), 1995
A. S. Cavallo	The Unicorn Tapestries at the Metropolitan Museum of Art, New York, 1998
A. Erlande-Brandenburg	The Lady and the Unicorn, Paris, 1989
M. B. Freeman	The Unicorn Tapestries, New York, 1976
F. Joubert	La tapisserie médiévale au Musée de Cluny, Paris, 1988
Y. Monin	Le message des tapisseries de la Dame à la licorne, Paris, 1990
P. Verlet; F. Salet	La Dame à la licorne, Paris, 1990
J. Williamson	The Oak King, the Holly King and the Unicorn: Myths and Symbolism of the Unicorn tapestries, New York, 1986